Sago Palm
19. June 19.
1876

Talipat Palm.
19. June.
1876

THE NATURAL HISTORY OF

EDWARD LEAR

For Bella
with Love
Happy #12 :)
From
Grandpa &
Onya

XO

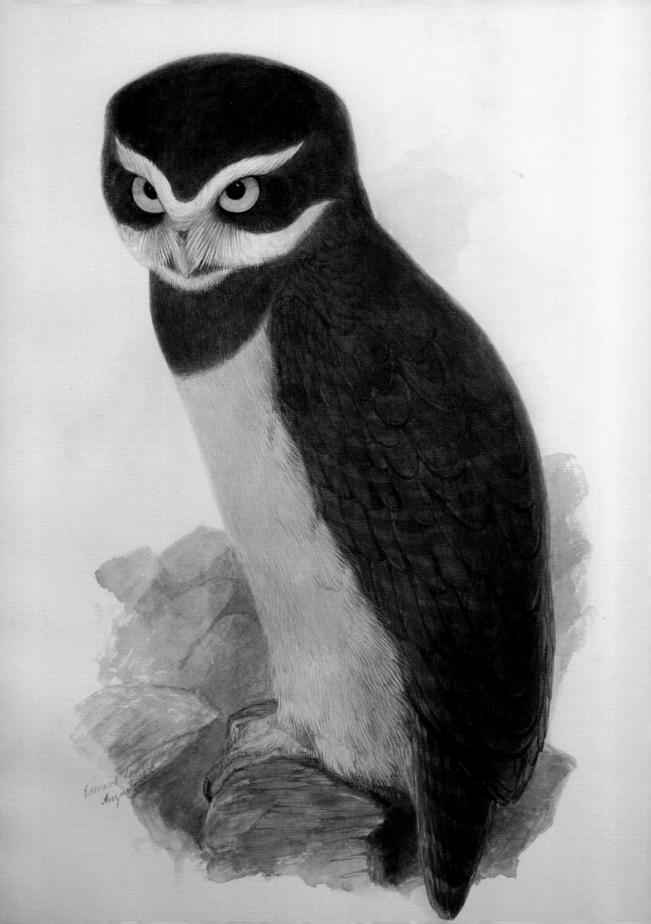

The Natural History of Edward Lear

(1812–1888)

ROBERT McCRACKEN
PECK

with a foreword by
DAVID ATTENBOROUGH

DAVID R. GODINE, *Publisher*
BOSTON

First published in 2016 by
David R. Godine, Publisher, Inc.
Post Office Box 450
Jaffrey, New Hampshire 03452

Library of Congress Cataloging-in-Publication Data

Names: Peck, Robert McCracken, 1952- | Attenborough, David, 1926-
Title: The natural history of Edward Lear (1812-1888) / Robert McCracken Peck;
with a foreword by David Attenborough.
Description: Jaffrey, New Hampshire : David R. Godine, Publisher, 2016. |
 Includes bibliographical references.
Identifiers: LCCN 2016016171 | ISBN 9781567925838 (alk. paper)
Subjects: LCSH: Lear, Edward, 1812-1888. | Natural history
 illustrators—Great Britain—Biography. | Natural history illustration. |
 Artists—Great Britain—Biography. | Poets, English—19th
 century—Biography.
Classification: LCCQH31.L424 P43 2016 | DDC 508.41—DC23
LC record available at https://lccn.loc.gov/2016016171

First edition
Printed in China

CONTENTS

FOREWORD

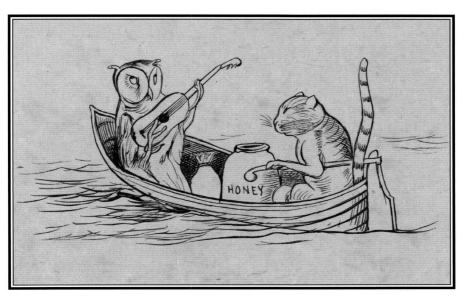

1. The Owl and the Pussycat, pen and ink, published in *Nonsense Songs, Stories, Botany and Alphabets*, 1871

THE FIRST OWL to lodge in my memory was the one that went to the sea in a beautiful pea-green boat (fig.1). As you may guess, I was young at the time. It was followed by even more extraordinary creatures – the Dong who found his way at night through the hills of the Chankly Bore by the light of his luminous nose; and the Pobble, who recklessly swam across the Bristol Channel and lost all his toes in the process. They, and many more equally engaging and fantastic creatures came, of course, from the imagination of a Victorian writer, Edward Lear. Were his poems to appear for the first time today, I suspect they might be called, perhaps rather portentously, surrealist. Instead, they are termed – maybe too modestly – as nonsense. But whatever they are called, they are strangely unforgettable and they remain as vivid in my mind today as they ever did.

For many years, I imagined that Lear's sole claim to fame rested with them. They are certainly enough to give him immortality. But in my twenties, I learned otherwise. I had started making natural history films for television, and one of the first took me to the South American forests of Guyana. When I got back home, I wanted a reminder of the wonders I had seen, so I bought a nineteenth century lithograph of one of the creatures that had delighted me most – a toucan. The bird is shown, head-on, its wings half-lifted in threat, glaring balefully at the spectator, in a posture strikingly different from the rather stilted, formal poses given to many birds in

[7]

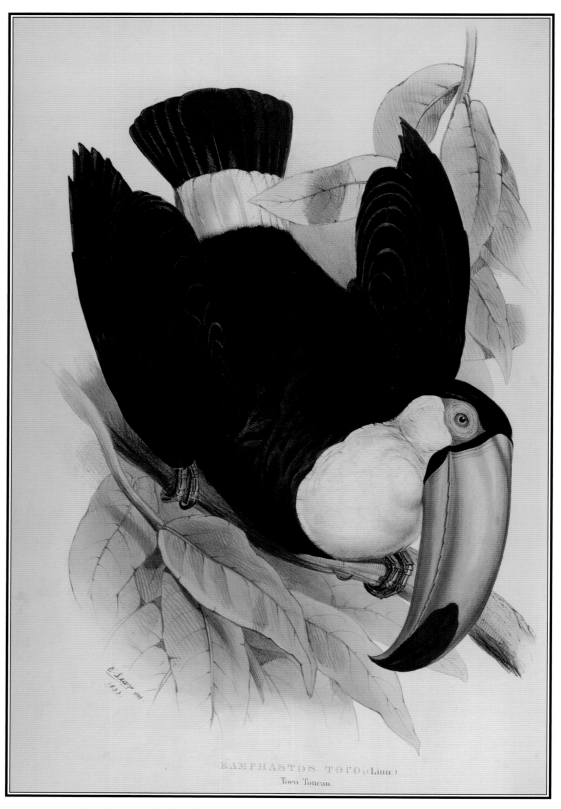

RAMPHASTOS TOCO, (Linn.)
Toco Toucan.

2. Toco Toucan (*Ramphastos toco*) dated 1833, hand-colored lithograph (plate 6) from John Gould's *A Monograph of the Ramphastidae, or Family of Toucans* (1833-1835)

prints of that period. This was the portrait not of a stuffed specimen, but a living creature. It was signed E. Lear and for the first time, I realized that the man who wrote *The Owl and the Pussy Cat* also drew superlative pictures of birds (fig.2). The print, and many others like it, came from huge folio-sized ornithological monographs which, in Victorian times, had stood in their richly-tooled morocco bindings on the library shelves of the aristocratic and wealthy. A century or so after their publication, however, many of these magnificent books were broken up so that their illustrations could be sold one at a time. From then on, I regularly leafed through the piles of such prints that in those days could be found in second-hand bookshops, always keeping an eye out for more carrying Lear's signature.

Before long, I flattered myself that I could recognise his hand, whether or not the print was signed, for young Edward Lear – and at this time he was still in his early twenties – scorned the use of a draftsman to transfer his designs to a lithographic stone for reproduction. He preferred to do that job himself. And the delight he took in sweeping his crayon across the stone to make broad bold strokes, or in taking a finer one in order to delineate tiny details, is almost palpable.

Eventually, I came across his portrait of a Barn Owl. I had always imagined that this was the kind of owl who, having left the pea-green boat, eventually married his fellow traveller the Pussy Cat in the land where the Bong-tree grows. Certainly, the sketch that Lear drew to accompany the verse, shows a bird with the wide feathered disc around each eye that is characteristic of that species. The lithograph I had found was also clearly and emphatically signed *E. Lear*. But the printed credits at the bottom made no mention of him.

They state that the illustration was designed and drawn by J. and E. Gould. John Gould was the publisher of the book from which the print had come and Elizabeth, his wife, was the artist who had drawn some of its less dramatic plates. Lear had drawn the rest. But was this particular contradiction just a simple mistake? Or did it reveal a fundamental conflict between publisher and artist? The answer to those questions and others are given later in this book. One possible consequence, however, was that soon after, Edward Lear, aged only twenty-five, left Britain for Italy, which became his base for the rest of his life.

Lear not only changed his home. He changed his profession. Putting natural history subjects behind him, he became a landscape painter. This was the time when it was common for wealthy young Englishmen to embark on the Grand Tour to visit the sights of Europe and inspect the remains of its classical past. Lear planned to provide these travellers with highly finished drawings, in pencil, watercolor and occasionally oils, of the sights they had seen. They would call at his studio in Rome – or, later, San Remo – and be shown a range of views that Lear had made on his own travels, each carefully numbered. They could then order a carefully worked-up version of Lear's sketch which they could take back as a detailed and accurate souvenir of the sights they had seen.

Although Lear had settled permanently in Italy, he still yearned to be recognized as an accomplished landscape artist in the land of his birth. So he also occasionally painted large compositions in oils that he sent back for exhibition in London. In their time, they were modestly successful, but as the decades passed, these more ambitious pictures that had been acquired by museums and art galleries, were one by one removed from view

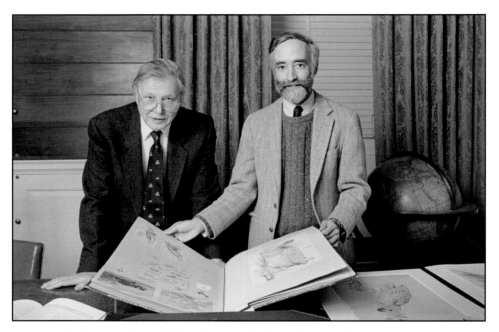

3. Sir David Attenborough *(left)* and the author *(right)* examining Edward Lear watercolors at the
Houghton Library, Cambridge, Massachusetts

and consigned, still in their massive gilt frames, to the galleries' store rooms. By the time he died, aged 76, he was largely forgotten as an artist.

After his death, the contents of Lear's studio were dispersed. As his heirs died in subsequent decades, Lear's belongings were sold. Among the possessions he had once had with him in Italy was an enormous chest of drawers which still contained his reference drawings, together with many other papers and sketches. I, as an Englishman, might have taken it for granted that this would have been acquired almost automatically by one of my country's art institutions. But not so. There were Americans with more discerning eyes, and that chest ultimately came to reside in Harvard University's Houghton Library.

As my interest in Lear grew, I started on the rather riskier business of buying some of his original drawings and, in due course,

I acquired a small watercolor of a parrot. My pleasure in it, however, began to fade and I started to doubt its authenticity. It was unsigned, for it was little more than a sketch, and eventually I realized that the only way to prove conclusively whether or not it came from Lear's hand was to look at other sketches he made of this or similar subjects. Such things might be in the Houghton Library. Fortunately I knew a young scholar, Robert McCracken Peck, who was already an authority on ornithological illustration in the United States and who, at that time, was a visiting research fellow at the Library. Thanks to him, I was able to visit the library. We went through Lear's sketches together and eventually gathered enough evidence to convince me – and even the man who had sold the Lear sketch to me – that it was not Lear's work after all and I got my money back.

But I also saw enough to realize that the

riches held by the Houghton Library had a great deal to tell about Lear that had not yet been published (fig.3).

Robert Peck has now studied them in detail. This book contains his findings. Over twenty years of careful research at Harvard and elsewhere he has discovered a great deal that is new and which will fascinate anyone with a love for Lear and for fine natural history illustration.

Most of Lear's animal drawings – of birds, mammals and reptiles – were made as scientific illustrations. Such documents have to meet one strict and particular requirement. They have to display the particular physical characteristics that will enable a scientist to identify the exact species portrayed. Other animal painters may have other ambitions – to convey the character and temperament of a particular living creature at a particular time. To excel in both skills is rare. And the ability to combine both aims in one picture is even rarer. Edward Lear was able to do so, and with such success that he may fairly be accounted one of the greatest of all natural history painters.

DAVID ATTENBOROUGH

INTRODUCTION

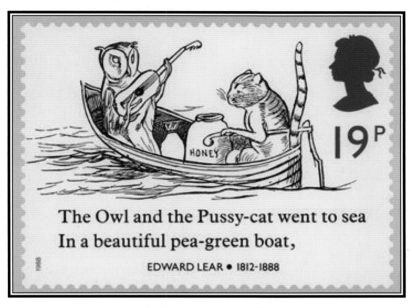

1. Edward Lear stamp, Royal Mail, 1988

IN 1988 THE BRITISH government honored the beloved artist, poet, and travel writer Edward Lear with a set of postage stamps featuring four of his whimsical ink drawings. These included a self-caricature of the bearded artist flying on improbably miniscule wings, a limerick illustration of a bonneted lady on whose hat a flock of imaginary birds is attempting to roost, a drawing of Lear's stub-tailed cat "Foss," and the wedding scene from his best-known poem, "*The Owl and the Pussy-cat*"(fig.1).

The affable Lear would have been pleased – and probably astonished – by his country's philatelic attention, but almost certainly disappointed by the Royal Mail's choice of images marking the centennial of his death. He considered the illustrated verse in his *Book of Nonsense* (1846), which ultimately earned him a place in Poet's Corner in Westminster Abbey, a sideline to his more serious focus: natural history and landscape painting. Although he ultimately came to enjoy his reputation as a nonsense poet, early in his career he feared that his child-focused flights of fancy would undermine his reputation in the scientific world and in the community of professional fine artists with which he wished to be associated. For almost twenty years, he hid his authorship of the nonsense writings and their accompanying illustrations with the pen-name "Derry-Down-Derry." By the time he was willing to reveal himself as their creator, they had already won him a devoted

MACROCERCUS ARARAUNA.

Blue & Yellow Maccaw.

⅚ Nat. Size.

2. Blue and Yellow Macaw (*Macrocercus ararauna now Ara ararauna*) dated December 1831, hand-colored lithograph (plate 8) from Edward Lear's *Illustrations of the Family of Psittacidae, or Parrots* (1830–1832)

following around the world.

Although Lear's contributions to science are almost forgotten today, for a period of time in the 1830s, he was a prolific painter of natural history subjects who earned near-universal praise for the accuracy, originality, and elegant style of his animated depictions of birds and other wildlife. His best remembered scientific contribution is his magnificent monograph *Illustrations of the Family of Psittacidae, or Parrots* (1830-1832), the first English natural history book to focus on a single family of birds, which he began to publish when he was just eighteen.[1] His depictions of "species hitherto unfigured" of that gaudy group of birds (fig.2) dazzled the world and established Lear as the artist of choice for many of the leading ornithological publishers in Britain in the 1830s and 1840s. In that golden age of color-plate books, an era still celebrated for the great volumes created by John James Audubon and John Gould, Lear created some of the most spectacular natural history illustrations ever published. He did so without the benefit of any formal training in art, and with neither independent funding nor institutional support. The original watercolors for his scientific paintings – many reproduced here for the first time – confirm Lear's place among the greatest natural history painters of all time.

During his brief but intense focus on natural history, Edward Lear met and worked with most of the leading naturalists of his day: Prideaux John Selby, Sir William Jardine, Thomas Eyton, Thomas Bell, and John Gould, to name just a few. He was in contact with many more. Whether or not he helped Gould, and his wife, Elizabeth, create some of the illustrations for Charles Darwin's report on the birds seen during the voyage of HMS *Beagle*, is unclear, but he was certainly close at hand during that exciting time in the history of exploration, savoring the thrill of discovery and helping to create the sumptuous reports that celebrated the finding of new species from around the world. His work put him at the heart of a vibrant natural history community in Great Britain just when the field was exploding and popular interest in the earth's flora and fauna was rapidly pushing other subjects to the sidelines. His insatiable curiosity, artistic talent, and remarkable zeal for hard work provided Lear with an intellectual passport into a rarified circle of scholars, explorers, collectors, and wealthy patrons at an important time in world history and a critical time in his life. With their encouragement and financial support, Lear would ultimately leave behind the grimy, smoke-filled streets of London to explore the glorious landscapes and light of Italy, Greece, Egypt, and India. Until he could make those journeys in person, he did so in his imagination, finding energy, life, and, ironically, freedom from the caged creatures at the London Zoo and elsewhere in the British Isles.

Artistic success did not come easily to Lear. Given his unsettled childhood, it is remarkable that he launched himself into such a challenging career and that he achieved so much success while still so young. Propelled by his ingenuity, work ethic, and natural artistic talent, Lear evolved from being a self-taught illustrator to a painting instructor to Queen Victoria, and from a shy and reclusive quasi-orphan, to a friend of millions of children and a source of joy for young and old alike. His ability to capture the life of his subjects would ensure him a lasting place among the great natural history painters of all time, while his knack for limericks, rhymes, and nonsensical verse would achieve for him the sort of literary immortality that few others share.[2]

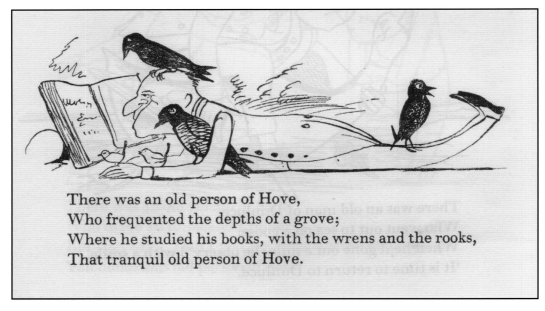

There was an old person of Hove,
Who frequented the depths of a grove;
Where he studied his books, with the wrens and the rooks,
That tranquil old person of Hove.

3. "There was an old person of Hove" first published in *More Nonsense, Pictures, Rhymes, Botany, Etc.*, 1872

In 1888, the year of Edward Lear's death, the English publisher Frederick Warne published a collection of his nonsense poetry illustrated with his iconic ink sketches of unusual people doing unlikely things. One of the pages showed "an old person of Hove, who frequented the depths of a grove; Where he studied his Books, with the Wrens and the Rooks, that tranquil old person of Hove"(fig.3).[3] While the man depicted, with his antiquated frock coat, slim figure, and small feet turned the wrong-way-round, does not resemble the rotund Lear of later years, the sketch captures the essence of the artist in his prime. As with any of Lear's nonsense, it is dangerous to attribute too much meaning to this poem, but it is easy to believe that the sketch, with its grinning figure surrounded by birds and reading a book whose illegible title page appears to read *The Works of Edward Lear* (Wor[ks] of Edward L), was

a symbolic self-portrait of the artist himself. Tranquil he was not, either in his youth or in later years, but he was fond of books and, for a while, immersed in birds. Thus, it is not surprising that he would have projected onto this imaginary character the feelings of confidence and repose that these two parts of his life represented.[4]

Birds appear regularly in Edward Lear's limericks, perching on noses (fig.4), nesting in beards (fig.5), and dancing quadrilles with humans who are sometimes punished for their avian affection (fig.6). While Lear's cartoons exude humor and affectionate empathy (figs.8, 9) his finished paintings of them are grand and ennobling (fig.7). Early in his adult life, Lear immersed himself in all things ornithological and mused that in his afterlife he was destined to take the form of a parrot. In his later years he preferred the company of a cat (fig.10).

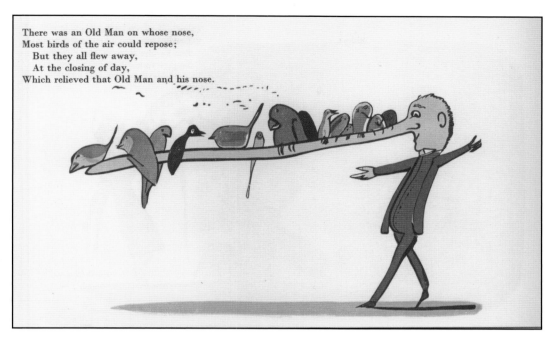

There was an Old Man on whose nose,
Most birds of the air could repose;
 But they all flew away,
 At the closing of day,
Which relieved that Old Man and his nose.

4. "There was an Old Man on whose nose…" published in *A Book of Nonsense*, 1846

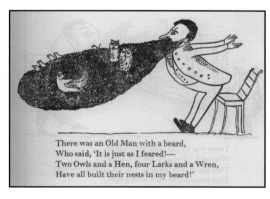

There was an Old Man with a beard,
Who said, 'It is just as I feared!—
Two Owls and a Hen, four Larks and a Wren,
Have all built their nests in my beard!'

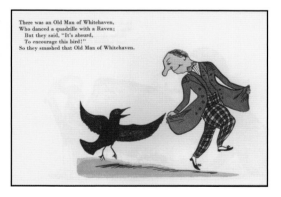

There was an Old Man of Whitehaven,
Who danced a quadrille with a Raven;
 But they said, "It's absurd,
 To encourage this bird!"
So they smashed that Old Man of Whitehaven.

5. "There was an Old Man with a Beard" from *A Book of Nosense*, 1846

6. "There was an Old Man of Whitehaven" from *A Book of Nonsense*, 1846

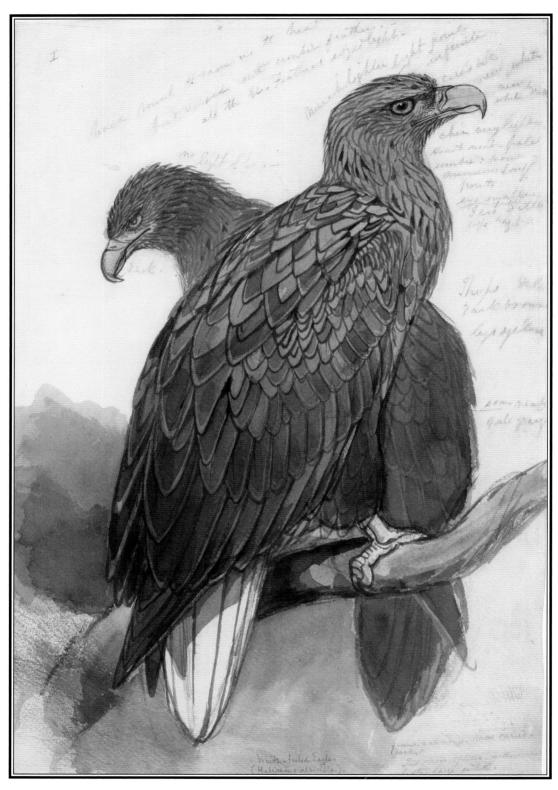

7. Study for White-tailed Eagle (*Haliaeetus albicilla*), ink and watercolor over graphite. This painting became the basis for plate 9 in John Gould's *The Birds of Europe* (1832-1837), vol. 1

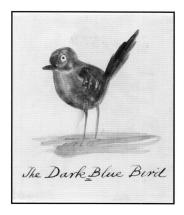 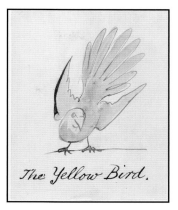

8. Dark Blue Bird, watercolor and ink, 1880 9. Yellow Bird, watercolor and ink, 1880

10. Phos [Foss], Edward Lear's cat, ink, July 15, 1875

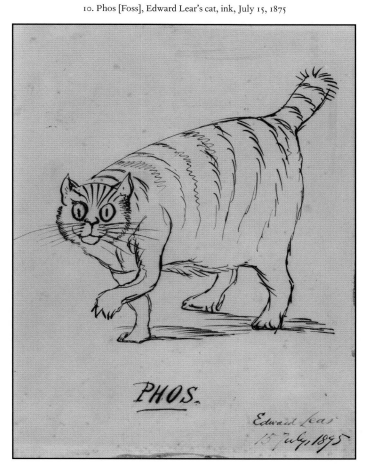

PART I

AN UNUSUAL LIFE:
LEAR'S CHILDHOOD AND EARLY
INTEREST IN NATURAL HISTORY

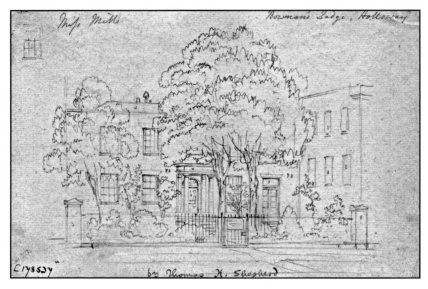

11. Bowman's Lodge, Edward Lear's childhood home outside of London
(drawn at a later date by Thomas H. Shepherd)

EDWARD LEAR WAS the twentieth of twenty-one children born to Jeremiah Lear, a London stockbroker, and his wife, Ann (née Skerrett), on May 12, 1812, in the village suburb of Upper Holloway, just north of London (not far from what is now Highgate).[5] The family appears to have been comfortably situated until Lear's father suffered a reversal of fortunes in the stock exchange in 1816. When the family was forced to vacate its elegant Georgian house, Bowman's Lodge (fig.11), most of the children were dispersed to live in separate households. Fortunately for Lear, he was adopted by his unmarried eldest sister, Ann (1791–1861),

who raised him as her own son from the age of four. Aside from a short stint at boarding school at the age of eleven, the young Lear received most of his education from Ann and another sister, Sarah (1794-1873), with whom he was also extremely close. This informal instruction suited Lear's non-conformist personality and, if anything, may have helped to stimulate his creative abilities and inherent curiosity. "I am almost thanking God that I was never educated [at a school]," he wrote when he was forty-seven, "for it seems to me that 999 of those who are so, expensively & laboriously, have lost all before they arrive at my age – & remain like Swift's Stulbruggs

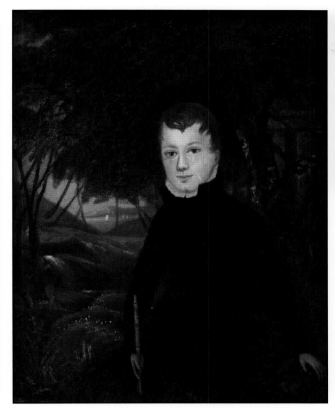

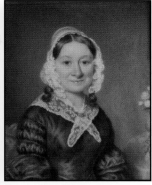

12. *(left)* Edward Lear at the age of nine, attributed to Ann Lear

13. *(above)* Ann Lear at about the age of forty, attributed to Edward Lear

— cut & dry for life, making no use of their earlier-gained treasures: — whereas, I seem to be on the threshold of knowledge ..."[6] It was a threshold he continued to move and expand throughout his long and productive life.

Ann Lear, twenty-one years older than her brother, was not only a loving foster parent, but, as a modestly talented artist in her own right, an inspiration and role model to her young ward, whose portrait she painted when he was nine years old (fig.12). He would, in turn, paint an affectionate portrait of her in later years (fig.13). Before coming into a small inheritance of her own, Ann may have augmented the family's income by selling stylized paintings of shells, birds, and flowers. With her encouragement, Lear found

that he too could earn money as a commercial artist. "I began to draw, for bread and cheese, about 1827," he recalled late in life, "but only did uncommon queer shop-sketches — selling them for prices varying from ninepence to four shillings: coloring prints, screens, fans; awhile making morbid disease drawings for hospitals and certain doctors of physic."[7]

While none of Lear's medical illustrations have survived, they were probably made to serve either as teaching aids or as records of unusual pathological symptoms being treated by private practitioners. Some might have been made to serve as illustrations in one or more medical journals, but, if so, because they would have been engraved for publication by other artists, Lear's name could easily

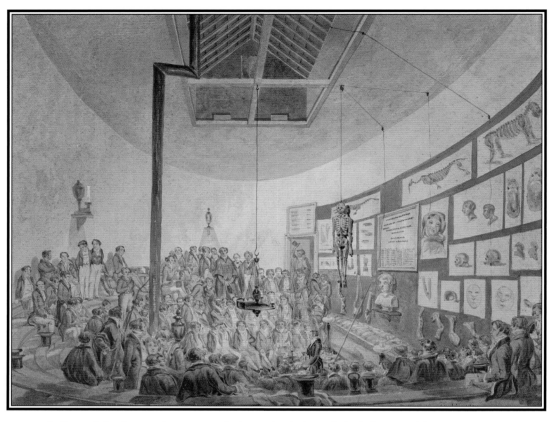

14. A medical lecture hall at the Hunterian Anatomy School in London displaying the kind of anatomical drawings Lear created to serve as teaching tools "for hospitals and certain doctors of physic" during his teenage years. (One of his illustrations could be in this picture.)

have been omitted from the final publication. More likely, his "morbid disease drawings" were displayed anonymously in one or more teaching halls to give young medical students a better understanding of injuries, malformations, or the physical effects of disease (fig.14).

Lear would have found ready clients for this anatomical work at any number of medical facilities around London, among them the Royal College of Surgeons (which hosted the Hunterian Anatomy School), the London Hospital (now Royal London Hospital), St. Bartholomew's Hospital (St. Barts), or Guy's Hospital.[8] In addition to earning money, such

commissions helped to introduce Lear to a basic understanding of anatomy and familiarized him with the world of science from the inside out – a privileged position he would enjoy throughout his illustrating career.[9]

Although her interests were neither medical nor commercial, Lear's sister, Sarah appears to have had almost as much influence on the artistic development of young Lear as Ann. An album of her paintings which has descended through the family reveals her formidable talent for botanical illustration (fig.15). Some of Edward's early paintings of plants are very similar in style to hers (fig.16). Annotations on the work of these

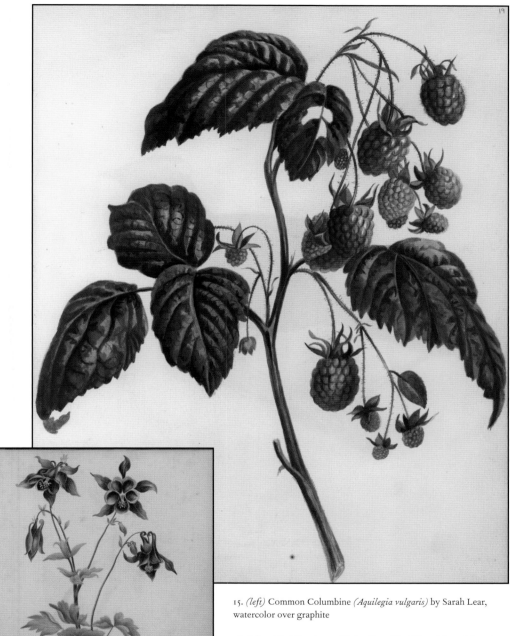

15. *(left)* Common Columbine *(Aquilegia vulgaris)* by Sarah Lear, watercolor over graphite

16. *(above)* Red Raspberry *(Rubus idaeus)* by Edward Lear, ink and watercolor over graphite

17. Oak-leaved Geranium (*Pelargonium quercifolium*) by Edward Lear, watercolor over graphite, signed and dated
Twickenham, June 18, 1828

siblings suggest that Sarah was the one to encourage her brother to paint living subjects from nature. Some of the paintings they made, most likely in each other's company, note specific places and dates, indicating an intent to document individual plants and their blooming times, or to catalog different botanical orders, families and genera, rather than to produce purely decorative paintings of the sort used on screens and fans (fig.17). While one form of painting would have informed the other, they were quite different in intent and execution.

Two surviving family albums from the late 1820s contain an interesting mix of natural history subjects by Ann, Sarah, and Edward Lear.[10] They include flowers, shells, insects, birds, and even a few fish. So similar in style are the many still lifes and whimsical, bird-filled landscapes in the albums that were it not for an occasional signature, it would be difficult to attribute many of these paintings to one or the other artist with certainty.[11] Some of the compositions in the books may represent the siblings' commercial work, including the kinds of "little drawings" Lear recalled selling "for anything he could get" to "stagecoach passengers in inn yards" at the age of fifteen.[12] Perhaps the albums were used to show potential buyers what the Lears were capable of producing.

With the exception of the botanical illustrations, a few somewhat stylized paintings of birds by Edward (all signed and dated 1831),

18. Red and Yellow (Scarlet) Macaw (*Macrcercus aracanga* now *Ara macao*), ink and watercolor over graphite

19. Birds in a landscape (Golden Pheasants) by Ann Lear, ink and watercolor over graphite

20. Imaginary birds in a landscape by a youthful Edward Lear, ink and watercolor over graphite

21. English porcelain by Spode with "fancy bird" decorations, early nineteenth century

and an animated Red and Yellow Macaw peering at the viewer from the trunk of a stunted tree (fig.18), most of the paintings in these albums are of imaginary subjects. The paintings feature flamboyant cranes, tufted hummingbirds, and extravagantly plumed pheasants, most of which bear only a passing resemblance to actual birds (figs.19, 20). The landscapes are equally exotic and stylized. They offer an uncanny foreshadowing of the tropical environments that Lear would be able to visit and draw in person much later in his career. These sun-drenched landscapes, populated with palm trees and colorful birds, may have provided Lear with a psychological escape from the cold, wet climate of England that he loathed and would eventually abandon in favor of warmer, sunnier landscapes abroad. These fanciful paintings, possibly the works he later dismissively characterized as "queer shop-sketches," thus provided both tangible and intangible support for the young artist as he built his confidence as a painter and an entrepreneur.

Many of these watercolor vignettes of birds, shells, and flowers are very similar to the decorations on certain ceramics manufactured in England from the late eighteenth century through the 1830s and 40s (fig.21).[13] Some Meissen porcelain and other imported tableware from the continent also used "fancy birds" patterns similar to the bird and landscape illustrations in the Lear albums. Could Ann and Edward have found the inspiration or even some specific sources for these paintings on one or more pieces of family china, given to them by their parents as keepsakes at the time of their departure from Bowman's Lodge? Such family heirlooms would have served as comforting reminders of the Lear family history and of a more affluent and secure time in Ann and Edward's lives.[14]

Another possible explanation for the similarity between the Lear paintings and decorations on some of the most expensive ceramics of the period is that Ann and Edward were creating illustrations, either on speculation or on commission, for one of the ceramic companies that were manufacturing such wares in Great Britain during Edward's teenage years. Perhaps both explanations are true. The relationship between the Lear illustrations and the decorations on English and continental ceramics of the period is only circumstantial, but it is so close that a mere coincidence of convergent design seems almost impossible.[15]

A conspicuous contrast to the heavy stencil work and imaginary bird and landscape paintings that dominate the early albums are a pair of beautifully rendered lithographs of

22. Study of a macaw head and feathers, hand-colored lithographs, cut and mounted

23. Two Red-faced Lovebirds (*Agapornis pullaria*), ink and watercolor over graphite

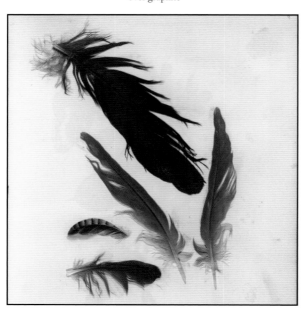

24. Composition with feathers, watercolor over graphite surrounded by actual feathers

the head of a macaw accompanied by a number of finely delineated feathers (fig.22).[16] This arresting study not only reflects a change in Lear's approach to bird painting, from his eldest sister's fanciful style to his own distinctive focus on reality, but also serves as an example of his early experiments with lithography, a reproductive technique that he would fully master by the end of his teenage years.

The head vignettes and the feathers that are pasted near them were drawn on stone, printed with black ink, hand-colored, cut out, and then glued to the album pages. Elsewhere in one of these albums we see this process in reverse: an original watercolor of a pair of small green parrots that served as the starting point for another of Lear's lithographic experiments (fig.23).[17] A third page in this same album has four actual feathers glued beside a single painted one (fig.24), further documenting Lear's transition from drawing fictional subjects to recording firsthand observations of living birds.[18]

While neither of the matching albums is dated, watermarks in the paper indicate that the books were made in 1827, the year Lear and his sister Ann took up residence together in a modest flat at 38 Upper North Place, Gray's Inn Road.[19] The three dated paintings in one of the albums (a Javanese peacock, an Angolan vulture, and a Brazilian caracara), and part of a lithographic print that Lear created in the fall of 1831, suggest that the albums were in use over a period of at least four years.[20] It is almost certain that the feathers and living bird studies were made at the London Zoo, which Lear began to frequent soon after it opened to visitors in 1828. A watercolor study of a Black-capped Lory, just one page away from the pasted feathers, is noted as having been painted "at the Zoological Society."

Lear's fascination with feathers — and the

birds from which they came – is reflected in a number of paintings he made during this period that only came to light in 2012.[21] One of these includes a trompe l'oeil rendering of the artist's calling card to which he has proudly written his new address in a different colored ink (fig.25). The brilliant red and black feather that lies on top of the card is from the throat of a Siberian Rubythroat (*Luscinia calliope*), a bird not native to the British Isles. It is most likely that Lear obtained it at the London Zoo.[22] The larger, translucent feather that balances the picture is from a native jay (*Garrulus glandarius*). The young artist might have picked it up during his frequent walks through Regent's Park, or possibly on one of his regular visits to the countryside home of his sister Sarah, who, following her marriage in 1822, moved to Arundel in Sussex.[23]

Two animal studies in one of these youthful albums relate to an unsuccessful commercial venture that Lear appears to have launched after establishing an informal relationship with the London Zoo.[24] Several others relate to the parrot monograph for which he would become so well known.[24] Before examining either of these publications, however, it is necessary to understand Lear's relationship with that institution that became such an important part of his personal and professional life in the 1830s.

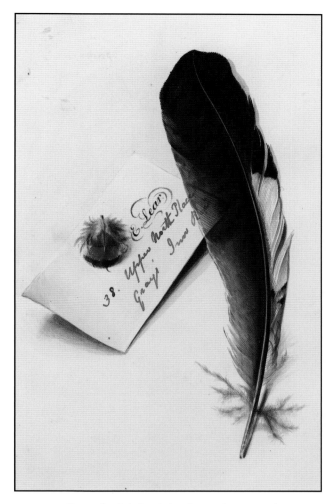

25. Calling card with feathers, ink and watercolor over graphite

OPENING THE CAGES:
EDWARD LEAR AND THE LONDON ZOO

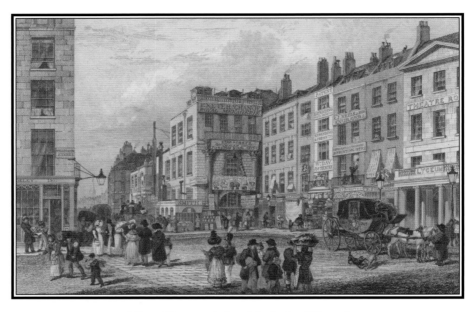

26. Exeter 'Change on the Strand, hand-colored lithograph

ALTHOUGH we think of most zoos as having been formed for the purpose of entertainment and education, the London Zoo's mission was somewhat different and, at least at the beginning, far more focused on scientific research than popular amusement. The 1825 prospectus of the Zoological Society states that its founders had two principal goals. The first was "to introduce...new varieties, breeds, or races of living Animals, such as Quadrupeds, Birds, Fishes, &c. which may be judged capable of application to purposes of utility, either in our Farm Yards, Woods, Wastes, Ponds, or Rivers." The second was "to assist ...the general study of Zoology by [establishing] a Museum of prepared specimens."[26]

While some of the zoo's early supporters continued to promote the first goal of the institution,[27] that objective soon gave way to a more popular focus on exotic animal displays. The academic side of the zoo, supported by its museum of preserved specimens, continued for many years in consort with its better known public side. Its scientific collections eventually surpassed in size and scope the zoological section of the British Museum.[28] From 1828 to 1838 these collections were under the care of an accomplished taxidermist named John Gould (1804–1881), who would come to play a very important role in Lear's life.[29]

Had Lear been interested in simply seeing and drawing wild animals, there were many other places he could have found them in

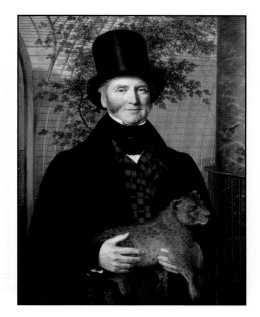

27. Edward Cross with lion cub by Jacques Laurent Agasse, oil on canvas, 1838

London. The Royal Menagerie at the Tower of London had been a repository of wild animals since the reign of King John (1199-1216).[30] In Lear's day it was a popular public attraction boasting an impressive array of beasts, representing sixty different species and nearly three hundred animals.[31] When Edward T. Bennett published a popular guide to the Tower Menagerie in 1829, he described species residing there that ranged from a Bengal Lion to a Virginian [Great] Horned Owl.[32] This eclectic menagerie was hyperbolically described by another contemporary writer as containing "one of the finest collections [of wild animals] in the universe."[33]

The Royal Menagerie, the oldest in Great Britain, was but one of several such accumulations of wild animals on display in London during Lear's youth. An even larger and more conspicuous one was Cross's Menagerie (formerly Pidcock's and then Polito's) on view on the second floor of a large commer-

cial building in the Strand known as "Exeter 'Change'" (fig.26).[33] Here Lear could have seen everything from lions, tigers, and an elephant to eagles, vultures, and an ostrich for the cost of two shillings. The famous collection was open from nine in the morning until nine at night and enticingly advertised as "the grandest National Depot of Animated Nature in the World...the greatest assemblage of curiosities ever collected together since the days of that primeval collector of natural curiosities, Old Noah."[35] The artists George Stubbs, Jacques Laurent Agasse, John Frederick Lewis, and Edwin Landseer all made paintings of the animals they saw there, including a young lion cub that Agasse portrayed in the arms of the menagerie's popular proprietor, Edward Cross (1774-1854) (fig.27). A painting of a leopard by Lear, contained in a small album Lear presented to one of his art students in the late 1820s (fig.28), may have been painted at the Exeter 'Change, for the species is listed on a handbill advertising the animals on view there at the time.[36]

The most famous and beloved resident of Cross's Menagerie was a five-ton Indian elephant named Chunee. In March 1826, it went berserk and had to be put down.[37] Its gruesome, protracted execution, which required violent spearings and more than 150 shots from a hastily assembled civilian and military firing squad, was the talk of the town for

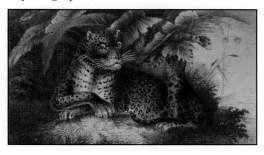

28. Leopard (*Panthera pardus*), ink and watercolor over graphite

months, and remained in the consciousness of the city for many years (fig.29). Charles Dickens, an exact contemporary of Lear's, wrote about the episode a decade after it occurred: "The death of the elephant [at Exeter 'Change] was a great shock to us; we knew him well; and having enjoyed the honor of his intimate acquaintance for some years, felt grieved – deeply grieved that in a paroxysm of insanity he should have so far forgotten all his estimable and companionable qualities" as to require his execution.[38] Though he did not write about it, Lear may well have been affected in the same way. After fifteen years of prominent display in the capital, Chunee had become a part of the experience of many children who lived in or visited London in the 1820s. Chunee's violent end, widely publicized and illustrated in the popular press, would have left an indelible impression on a

boy as interested in nature and as sensitive as Edward Lear.

Within two years of Chunee's demise, the Exeter 'Change itself was slated for demolition to accommodate the widening of the Strand as part of the same urban renewal project that resulted in the creation of Trafalgar Square. When the time for their relocation arrived, the exotic residents of the menagerie were ceremoniously paraded a short distance to new quarters in the King's Mews, Charing Cross, roughly the location of today's National Gallery.[39] Edward Lear may have witnessed this colorful parade. He would certainly have heard and read about it.[40]

Slightly removed from the congestion of downtown London, the nascent Zoological Society in Regent's Park offered a more serene and cerebral form of entertainment than either the Tower Menagerie or Cross's Me-

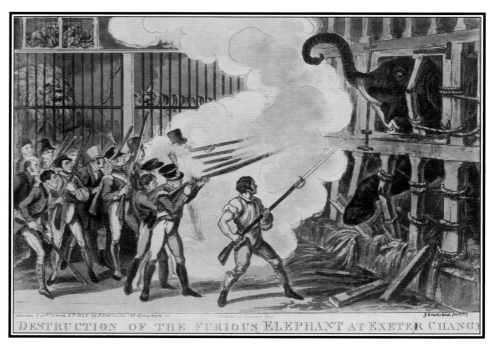

29. The execution of Chunnee at Exeter 'Change, hand colored engraving, 1826

[34]

nagerie at the Exeter 'Change (fig.30). There were exotic birds and animals to be seen there, to be sure, but there were also the interesting added dimensions of research and education, for the Zoological Society had been conceived by a group of knowledgeable and well-financed amateur naturalists, including Sir Stamford Raffles (the former administrator of the East India Company and founder of Singapore), as an international center for the study of wild animals; a place of national pride through which England could demonstrate its political and economic reach and show off its intellectual accomplishments through research on its specimen-based inventory of the natural world. The society's prospectus went to some length to explain the need for such an organization and to differentiate it from the existing, commercial menageries in London, which, it implied, were attractions without social merit: "It would well become Britain to offer another, and very different series of exhibitions to the population of her metropolis; namely, animals brought from every part of the globe to be applied either to some useful purpose, or as objects of scientific research, not of vulgar admiration."[41]

According to social historian Harriet Ritvo, Raffles's interest in establishing the Zoological Society went well beyond his personal interest in wildlife. He wished to have the gardens serve as a showcase for England's imperial success. According to Ritvo, "The maintenance and study of captive wild animals, simultaneous emblems of human mastery over the natural world and of English dominion over remote territories, offered an especially vivid rhetorical means of reenacting and extending the work of empire." Thus the animals on display at the zoo were "not just to serve as a popular symbol of human domination, but also a ... precise and elaborate figu-

ration of England's imperial enterprise."[42] There was clearly an important educational component to the zoo as well. In contrast to the public menageries, which served as places of entertainment for the masses, the founders of the Zoological Society intended their institution to involve a well-educated, wealthy, and socially distinguished clientele who would find the society's collections uplifting and useful to society.

Lear was quick to realize that the zoo could offer him not just a source of appealing subjects for his pencil and brush, but also an opportunity to secure illustration commissions from the naturalists and wealthy patrons associated with the society. As it grew in size and reputation during the 1830s, the society acquired many new and interesting natural history specimens from around the world. Within three years of its founding, the society's museum was already housing six hundred mammals, four thousand birds, one thousand reptiles and fish, one thousand testacca (shells) and crustaceans, and thirty thousand insects.[43] Artists were needed to record these creatures, both dead and alive, for the scholarly publications emanating from the society, and Lear was only too happy to fill that role.

Although the Zoological Society reserved access to its collections to members and their guests (part of its exclusive appeal), Lear appears to have gained admission through the help of a family friend.[44] Whether he paid the one-shilling admission fee required of most nonmember visitors is not known. Perhaps his personal connections, or the illustrational work he was able to do for the society, freed him from this expense. In any case, the zoo offered a wonderful new world for Lear. He was especially besotted by the parrots he saw there, and decided to paint as many of

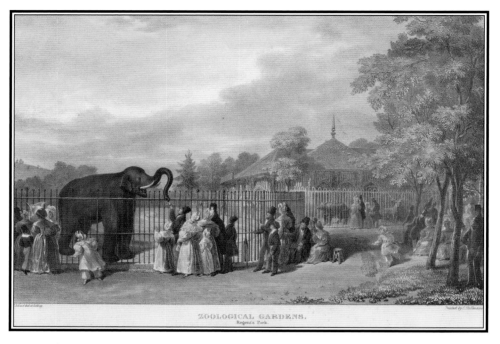

30. The Zoological Gardens in Regents Park (London Zoo), by George Scharf, hand-colored lithograph, 1835

31. The bear pit at the London Zoo by George Scharf, hand-colored lithograph, 1835

them as he could. In June 1830 he formally applied for – and received – permission from the society's council to make drawings of all the parrots in its collection for the purpose of creating a book on the subject.[45] For the next several years he would be a frequent visitor to the newly built animal houses and aviary in Regent's Park (fig.31). He also frequented the society's administrative headquarters at 33 Bruton Street, where the balance of its live birds and animals, as well as its preserved specimens, were kept.[46] This level of access was quite remarkable for a person of Lear's age, lack of academic credentials, and relative lack of social status. When William Swainson (1789-1855), a well-known animal dealer, widely published author, and popularizer of natural history, applied for similar "unrestrained" access to the society's bird collections while writing an essay for a "national work," on avian classification, his request was denied.[47] In defiance of the society's decision, Swainson surreptitiously entered its museum with his friend, the American naturalist John James Audubon (1785-1851). To Swainson's embarrassment, he was discovered by one of the society's officers and prevented from taking notes on the Sumatran birds he had come to see. It was a humiliating rebuke for which Swainson never forgave the society or its council.[48] Swainson was not the only one prevented from using the society's collections. John Edward Gray (1800-1875), a curator of natural history collections at the British Museum and a future collaborator with Lear on a number of publications, complained of similar discrimination.[49]

Lear's experience was quite different. With the blessing of the society's secretary, Nicholas Aylward Vigors (1785-1840), Lear could come and go whenever he liked. He was even allowed to remove some of the birds from their cages for closer examination. Perhaps he was more likable than the irascible and slightly eccentric Swainson. He was certainly less political and posed no threat to the administrative hierarchy of the new and still evolving society. Because Vigors had recently published a scholarly paper on the classification of parrots, he may have found a common bond with the young artist who was attempting a book on the subject.[50] In any case, Lear's early acceptance by the powerbrokers at the London Zoo provided a wonderful opportunity for him and helped pave the way for his rapid rise to success.[51]

With the help of several interested keepers, who would sometimes hold the birds and assist him in measuring their various parts, Lear created a dazzling set of pencil and watercolor studies of the parrots at the zoo (figs.32, 49). Using these as his starting point, and with instruction from Charles Hullmandel (1789-1850), England's most accomplished lithographer, Lear learned how to redraw each picture onto a lithographic stone

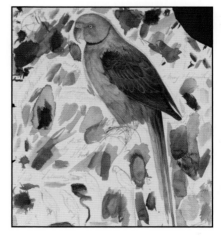

32. Study of a Pigeon Parakeet (*Paleornis columboides*), now known as the Malabar Parakeet, or Blue-winged Parakeet (*Psittacula columboides*), ink and watercolor over graphite. This image was used by Lear as plate 31 in *Illustrations of the Family of Psittacidae, or Parrots* (1830-1832)

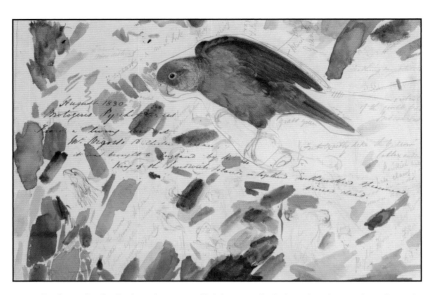

33. Study of a Sandwich Island Parakeet, now called the Grey-cheeked Parakeet (*Brotogeris pyrrhopterus*),
ink and watercolor over graphite, August 1830 "from a living bird at Mr. Vigors…It was brought to
England by R… King of the Sandwich Islands" For unknown reasons, Lear never included
this bird in his parrot monograph

and print it for wider distribution. Ultimately, he would create forty-two hand colored plates that would comprise his book *Illustrations of the Family of Psittacidae, or Parrots: The Greater Part of Them Species Hitherto Unfigured*. The book was issued in parts between 1830 and 1832, with the formal title page, dated 1832, included with the final part (the twelfth of an originally planned fourteen).

Although he found the process of lithography difficult (later referring to it as "the old enemy" and "this lampblack & grease work"),[52] Lear became extremely skilled at it. He must have been elated by the chance to shift his artistic focus from the lifeless subjects of the hospital ward that had occupied his middle teenage years to the far more appealing and vital occupants of the zoo. No longer peddling hack work to unappreciative travelers or making "morbid disease drawings" for "certain doctors of physic," by the summer of 1830 Lear was reveling in the

company of beguiling birds.[53] He was also beginning to attract the admiration of some of the country's most distinguished and influential naturalists with his work.

Within the next few years, Prideaux John Selby (1788-1876), Sir William Jardine (1800-1874), Edward T. Bennett (1797-1836), Thomas Bell (1792-1880), Thomas C. Eyton (1809-1880), John Gould (1804-1881), and Lord Stanley, the thirteenth Earl of Derby (1775-1851) – a who's-who of Great Britain's scientific establishment, all of whom were involved in one way or another with the zoo – would each enlist Lear's help in illustrating books. The society itself would also commission Lear to create illustrations (beginning in 1833) to accompany papers in which newly discovered species of birds and animals were being described for the first time.[54] The hardworking Lear eagerly took on all of these commissions, even as he worked to create a book of his own.

EDWARD T. BENNETT

34a., b. Title pages for Edward T. Bennett's two volume guide to the London Zoo, *The Gardens and Menagerie of the Zoological Society Delineated* (1830-1831)

EDWARD T. BENNETT, one of the founders and a long-time officer of the Zoological Society, was among the first to enlist Lear's help in delineating the residents of the zoo (figs.34a, b). It is not certain how or when the two men first came into contact with each other. It may have been when Lear began visiting the zoo (around 1828), although it is possible that their relationship predated that. As a surgeon associated with Middlesex Hospital and with a private practice in Bulstrode (now Welbeck) Street in London, Bennett may have been one of the "doctors of physic" for whom Lear made medical drawings. Perhaps it was Bennett who first invited Lear to come to Regent's Park. In any case, the two men quickly developed a good working relationship that would continue throughout Lear's association with the zoo.

In addition to having a distinguished medical and teaching career, Edward Bennett was the author of a very successful book on the animals in the Tower Menagerie, which contained dozens of lively wood engravings by William Harvey (1796-1866), a stu-

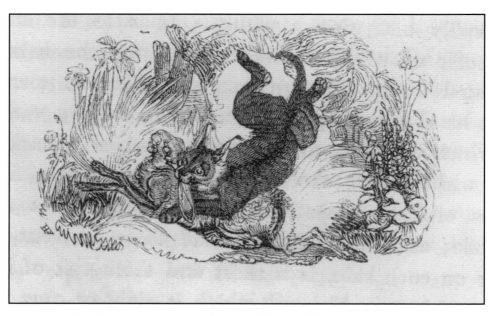

35. Wild caracal (*Felix caracal*, now *Caracal caracal*) and rabbit by William Harvey, wood engraving from
Edward T. Bennett's book *The Tower Menagerie* (1829)

dent of the renowned British wood engraver
Thomas Bewick (1753-1828).[55] Lear copied
at least one of Harvey's illustrations from
Bennett's book, adding both color and an ex-
panded forested landscape, to create his own
interpretation of Harvey's endpiece vignette
of a caracal (a wild cat) leaping on a rabbit
(figs.35, 36). Perhaps by improving on Har-
vey's illustration, Lear was trying to demon-
strate his drawing skills to Bennett in hope of
obtaining a commission as an illustrator for
his next book.[56]

Capitalizing on the popular and critical suc-
cess of his Tower Menagerie guide, Bennett
embarked on a similar book about the inhabit-
ants of the London Zoo at the end of 1829.
Whether as a charitable gesture toward Lear,
or because he really needed his help, Bennett
gave the young artist an opportunity to show
off his talent. Contained in *The Gardens and*

36. Wild caracal (*Caracal caracal*) and rabbit
(after Harvey) by Edward Lear, ink and
watercolor over graphite, circa 1829

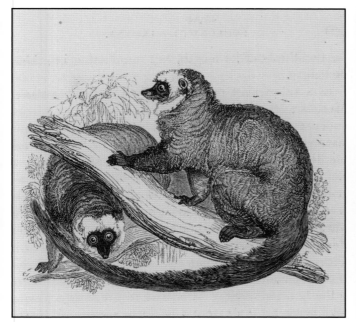

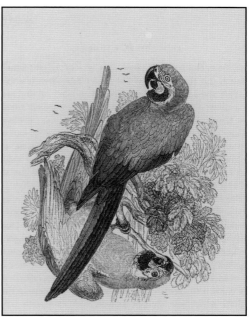

37. White-fronted Lemurs (*Lemur albifrons*), now known as the White-headed Lemur (*Eulemur albifrons*) from Edward T. Bennett's book *The Gardens and Menagerie of the Zoological Society Delineated*, vol. 1 (1830-1831), wood engraving. Note the EL monogram at the lower right identifying this as the work of Edward Lear.

38. Blue and Yellow Macaws (*Macrocercus ararauna*, now *Ara araruana*), from Edward T. Bennett's book, vol. 2, wood engraving. This illustration also contains a subtle EL monogram.

Menagerie of the Zoological Society Delineated (1830-1831), edited by Bennett, and to which Bennett, Vigors, and others contributed substantive text, are two wood engravings that show Lear's animated drawing style and bear his distinctive *EL* monogram. These black and white illustrations depict a pair of White-fronted Lemurs (fig.37) and two Blue-and-Yellow Macaws (fig.38).[57] There is no mention of Lear in the text or front matter of either volume of the book. The title page credits only William Harvey as the book's illustrator, though it does acknowledge that the engraving firm responsible for engraving Harvey's illustrative vignettes was "assisted by other artists."[58] Presumably this phrase included Lear, who must have been invited to fill some gaps in Harvey's illustration list. He may have volunteered his services for the book in an effort to become better known, or perhaps he was paid a modest fee by Bennett and so was considered "work for hire" not deserving more public recognition. In either case, having his pictures appear in such an important and popular publication must have been pleasing to Lear. It was also strategically useful, for whether or not he received public recognition for his work, his involvement with the project enabled him to build a publishing resume and effectively immerse himself in the world of natural history study that was beginning to center on the zoo. Lear's relationship with Bennett must have been more than merely contractual, for Bennett was one of three people to nominate him for associate membership in the Linnean Society in November 1830, thus providing Lear with yet another critical boost of his career.[59]

AN UNFINISHED PUBLICATION:
LEAR'S LOST PORTFOLIO

Part I.

Price Plain 5
Proofs on India 7.6

Sketches of Animals

in the

ZOOLOGICAL

Gardens.

Drawn from Life & on Stone by

E. Lear.

Published by R. Ackermann, 96, Strand, London.

39. Wrapper or title page for Lear's *Sketches of Animals in the Zoological Gardens*, circa 1829, lithograph

ALTHOUGH LEAR ultimately achieved his greatest success by allying himself with the scientific goals of the zoo's founders, he recognized the educational, artistic, and commercial opportunities that were presented by the public's growing fascination with the zoo's displays. While he was working on E.T. Bennett's book about the

animals in the zoo, or perhaps even earlier, he decided that he could produce a portfolio of his own life drawings that would appeal to the public's appetite for exotic wildlife and the recreational pleasures associated with visiting the society's beautiful "gardens" in Regent's Park. The only surviving parts of this ambitious project are some preliminary studies at Harvard and four lithographic prints in the Zoological Society's archives. The latter include a wrapper (or cover sheet) and three uncolored plates for a now-forgotten project that appears to have been Lear's first attempt at publishing a book of his own creation.[60]

The wrapper Lear created to present *Sketches of Animals in the Zoological Gardens Drawn from Life & on Stone by E. Lear* uses half a dozen different letter forms, embel-

lished with a vignette of birds and mammals gathered together in a "peaceable kingdom" tableau (fig.39). The composition for this illustration is based on a small wash drawing that is contained in one of the two youthful albums discussed earlier (fig.40).

Unfortunately, neither the preliminary sketch nor the wrapper are dated, but the childlike nature of the drawings in the vignette, the context of the watercolor study for it within the album, and evidence on the wrapper itself combine to verify this as an early effort, undertaken at the same time, or possibly before, Lear began to work on his parrot monograph.

Charles Hullmandel, who would assist Lear with the printing of the plates for his parrot book and a number of other publica-

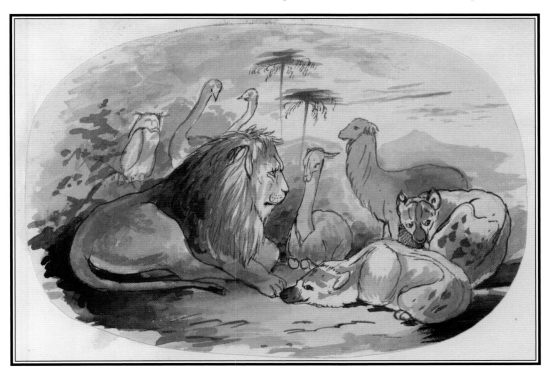

40. Lear's preliminary study for "peaceable kingdom" vignette used on the wrapper or title page of his portfolio of plates of animals from the zoo. Ink wash over graphite

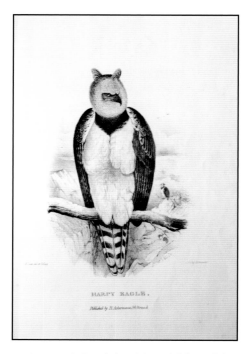

41. Harpy Eagle (*Harpia harpyja*), Lear's lithograph for
Sketches of Animals in the Zoological Gardens

tions, is acknowledged as the printer of Lear's *Sketches*, while the well-established firm of R[udolph]. Ackermann, at "96 Strand," is identified as the publisher. The company may have commissioned Lear to produce the illustrations for the book, but, given Lear's youth and lack of previous experience at the time, it is much more likely that Lear had employed the firm to assist him with the book's marketing and distribution, a common practice with self-published offerings of this kind. The name and address of the publisher, as printed on the wrapper, allows us to date the work with certainty between 1827 and 1832, for the company was not located at 96 Strand until 1827, and used the name "R. Ackerman" only until 1832.[61] Since the zoo was not opened to visitors until April 1828, and since most new Ackerman publications after 1829 were cred-

ited to "R. Ackerman & Co.," the prints for the planned portfolio were probably created between 1828 and 1829, just prior to Lear's launch of his parrot monograph.[62]

Lear's publishing project, so optimistically begun with a promise of multiple "parts" of the portfolio on plain paper (for five shillings) or thinner, more highly finished "India" paper (for seven shillings, sixpence per part), appears not to have garnered enough public response for success. Three lithographic prints – a sleeping lion, a Harpy Eagle, and a polar bear – and the illustrated wrapper in which they were to have been distributed are all that survive of the projected publication (figs.41, 42, 43). Perhaps they are all that ever existed. Nor are there more than a few studies in all of Lear's surviving artwork that relate to this publication. Of these, the most directly

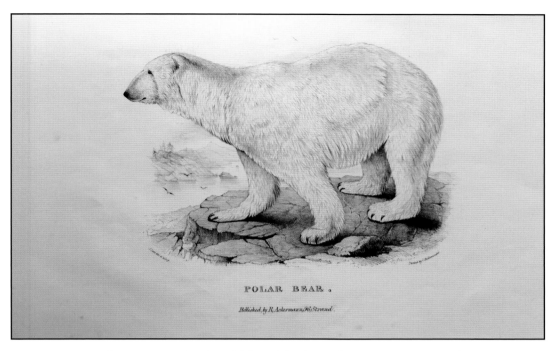

42. Polar Bear (*Ursus maritimus*), Lear's lithograph for *Sketches of Animals in the Zoological Gardens*

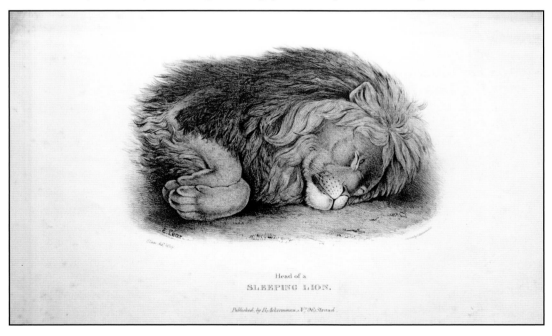

43. Sleeping Lion (*Panthera leo*), Lear's lithograph for *Sketches of Animals in the Zoological Gardens*

related are the wrapper vignette, described above, and a faint pencil outline of a stylized polar bear, an exact match, in reverse, of the finished lithograph.[63] Another, smaller sketch, of the same polar bear, undated, was cut out and pasted into one of the two youthful albums previously discussed.[64] A pencil study of the head of a roaring lion in a Lear family album in Scotland, may also be related to his *Sketches of Animals* portfolio, though its hostile attitude stands in contrast to the more docile cat he eventually chose to publish.[65]

Since Lear's diaries from this period no longer exist, we may never know the genesis of his *Sketches of Animals* project, or why it failed. Perhaps there was not enough public interest in the offering to make it profitable, or perhaps Lear found that he did not have the time or interest to create the drawings the book required. In any case, partly through his own initiative (his parrot book), and partly through the commissions he was receiving from others, Lear's artistic career was beginning to take a more scientific, less popular direction. Not until he began publishing illustrated travel books, in 1841, or his nonsense rhymes and drawings, in 1846, did Lear again attempt a publication intended for the general public.

Had he persisted with his *Sketches* and been able to market them effectively, Lear might well have achieved success as a popular illustrator of animals and thereby secured a degree of financial independence, but the audience for such a work was both diffuse and elusive. Far less so was the group of amateur naturalists with whom Lear had begun to as-

sociate through the zoo. Although fewer in number, these passionate, prosperous collectors, breeders, and lovers of exotic wildlife constituted a more easily identifiable support base for a publication tailored to their specific interests.

It did not take Lear long to realize that he was not alone in his admiration of the rare, intelligent, and conspicuously beautiful members of the parrot family that had attracted his attention at the zoo. And so, sometime late in 1829 or early 1830, in a remarkable show of confidence – or naïveté – Lear began to produce a series of illustrations of parrots that he would issue in groups of three or four to a small number of subscribers from 1830 to 1832. The resulting publication launched Lear's decade-long career as a serious scientific illustrator and established his place among the best natural history painters of all time.

An extraordinary achievement for anyone, and especially for one so young and inexperienced as Lear, *Illustrations of the Family of Psittacidae, or Parrots* has earned a well-deserved place in the hierarchy of ornithological bibliography. To understand the significance of the book to Lear's career, it is better to see it in the broader context of all of his natural history work than as a single publication. Because of its self-published nature and the long period of time required for Lear to complete it (1830-1832), *Illustrations of the Family of...Parrots* was, of necessity, created in consort with a wide range of other illustration projects. It will be discussed in association with them in the pages that follow.

THE ZOOLOGY OF CAPTAIN
BEECHEY'S VOYAGE

44. Silhouette of Edward Lear as a young man, cut
paper, artist unknown

MAKING STUDIES OF living (and sometimes deceased) birds for his planned monograph on parrots, and learning how to translate original watercolors into lithographic prints consumed much of Lear's attention in 1830. Even so, he somehow found time to create paintings for others during this period. The first large commission he received was for illustrations of the scientific discoveries made during a Royal Navy expedition to the Pacific Ocean. Although the project did not generate the public acclaim he might have expected (due to a series of events beyond Lear's control), at the time he received the commission, it provided an important boost to his fledgling career as an illustrator by validating his professional credentials, reinforcing his scientific and artistic aspirations, and providing a source of badly needed income (fig.44).[66]

In the decades immediately following Great Britain's victory over Napoleon (the celebrations for which constituted one of Lear's earliest memories),[67] the British government and a handful of private and corporate patrons sent a large number of naval expeditions around the world (forty to the High Arctic alone) in an effort to solidify what the Admiralty claimed to be Great Britain's rightful domination of the sea. These activities helped to employ hundreds of otherwise superfluous navy personnel and vessels in the relatively peaceful period that followed the Napoleonic wars. They also stimulated an

unprecedented interest in the natural history of the new areas being explored.

One of the ships employed in this heady era of exploration was HMS *Blossom*, whose crew, during a three-year voyage (1825-1828) under the command of Captain Frederick W. Beechey (1796-1856), crossed the Pacific Ocean and passed through the Bering Straits. The base Beechey created at Kotzebue Sound in present-day Alaska was the northernmost base established by any British, European, or American expedition up to that time. There, Beechey and his men were supposed to meet John Franklin (1786-1847) and William Edward Parry (1790-1855), whose ships, it was hoped, would reach the waiting British expedition from the Atlantic side of North America by way of the Northwest Passage. The efforts of the latter two voyages, like so many expeditions to the High Arctic, ended in frustrating failure.

Beechey's voyage, by contrast, was a notable success, for in addition to surveying some of North America's uncharted northwestern coast, he and his crew were able to visit California, Tahiti, and Pitcairn Island (where he met and interviewed the last survivor of the *Bounty* mutineers), all the while making natural history observations and collections.

Following in the great tradition of Captain Cook, Beechey expected to publish a well-illustrated narrative of the expedition, including a detailed account of his scientific discoveries, on his return to England. Toward this end, he enlisted the help of several of England's leading naturalists including John Richardson, N. A. Vigors, John Edward Gray, the Rev. William Buckland, and Edward T. Bennett, each of whom was invited to write a section of the expedition report.

We do not know which of these authors may have recommended Lear to illustrate the

45a. Black-throated Magpie-jay or Collie's Magpie-jay (*Pica Colliei* now *Calocitta colliei*), circa 1830, colored lithograph after Lear by J.C. Zeitter (plate 7) from *The Zoology of Captain Beechey's Voyage* (1839)

volume. Certainly all of them knew of Lear and his interest in taking on such an assignment. It could have been Edward Bennett, the zoo's assistant secretary, with whom Lear was already working on the guide to the birds and animals in the zoo. It might have been Nicholas Vigors, the energetic secretary of the Zoological Society from its founding until 1833. Vigors was well acquainted with Lear through his parrot studies at the zoo's aviary. He was also a private collector of parrots who allowed Lear to paint several of the birds that he kept at his house at 16 Chester Terrace in Regent's Park (fig.33).[68] Lear had already met most of the other authors through the tight network of like-minded naturalists associated with the zoo and through his own independent research on parrots.

Making twelve bird and two mammal plates for *The Zoology of Captain Beechey's Voyage* (figs.45a,b) gave Lear the opportunity to showcase his talent to all of these men

and to the other leading naturalists of the day, all of whom wished to learn about the expedition's discoveries and how they were being described and illustrated. Many, if not all, of the contacts Lear made or further cultivated through the Beechey book project later played important roles in advancing his career as a scientific illustrator.

None of the plates Lear created for Beechey's *Zoology* is dated, nor do any of the original paintings for them appear to have survived, so it is impossible to examine them for notes, but circumstantial evidence and the style of the illustrations suggests that they were made no later than 1830. Some may have been made the year before, when Lear was just seventeen.[69] Publishing illustrations in a work of national and international importance at such an early age would have been an amazing coup for the young artist. Unfortunately, despite his timely completion of the commission, his illustrations of Beechey's discoveries would not be published for almost a decade.[70]

To the extreme frustration of Captain Beechey, and probably to Lear as well, one of the book's invited contributors was so delinquent in submitting his part of the text that the book's prompt publication was subverted.[71] By the time the missing essay was completed and the various parts of the book were reassembled and brought to press, it was 1839 and the discoveries of the expedition were stale news, long since superseded by other expeditions and more exciting discoveries, including those of Charles Darwin (1809-1882) from the voyage of HMS *Beagle*, the results of which began to appear in print in July 1838.[72]

To compound the injury of its delayed publication, by 1839 Lear must have been embarrassed by his contributions to *The Zoology of Captain Beechey's Voyage*, for by the time

45b. Elegant Quail (*Ortyx douglasii* now *Callipepla douglasii*) circa 1830, colored lithograph after Lear by J.C. Zeitter (plate 11) from *The Zoology of Captain Beechey's Voyage* (1839)

they finally appeared in print, his talent had far outdistanced the primitive illustrations he had created a decade earlier. What had been impressive plates for a teenager were far below the quality of work Lear ultimately achieved. Had they been published in 1830 or 1831 as originally planned, they might have done Lear's reputation some good. By 1839, however, they could only have damaged it.[73] Fortunately, by that time Lear's focus was on landscape painting and he had no desire to continue pursuing his career as a scientific illustrator. It is not clear whether Lear, then living in Rome, was even aware of the book's publication. He does not mention it in any of his surviving letters or diaries.

While doing nothing to burnish his status as a natural history artist, the relatively amateurish quality of Lear's illustrations for *The Zoology of Captain Beechey's Voyage* represents an important early milepost in his artistic growth and maturation. When one com-

pares the Beechey illustrations (fig.45a, b) to the best plates in his *Illustrations of the Family of…Parrots* (figs.2, 48, 50, 58, 59, 84, 91, and 93), both groups of images having been created within one or two years of each other, or other work that he created in subsequent years (figs.61, 62, 65), it is hard to believe they were made by the same person.

Most of this disparity is simply a reflection of Lear's growth as an artist, but part of it can be attributed to the nature of his subjects. It was standard procedure on protracted exploring expeditions for the accompanying naturalists to preserve specimens by skinning them or pickling them in spirits.[74] It was the artist's responsibility to bring them back to life on paper by fleshing out their emaciated corpses, reconstructing any missing parts, imagining the color of such fugitive parts as eyes and areas of exposed skin that change quickly after death, and, based on careful observations of related species, reanimating the subject with a typical posture, gesture, or pose. Lear's ability to bring preserved specimens to life with watercolor and brush would grow over time, but the Beechey illustrations were among the first in which he had to re-

construct preserved specimens this way. By contrast, the parrots he was studying at the zoo and in private collections around England were living, breathing, moving subjects with personalities as different and distinct as humans'. "I am never pleased with a drawing unless I make it from life," Lear wrote at the time, and repeated frequently throughout his natural history painting career.[75] The wisdom of this approach is evident in the work he created. At this early period in his career, however, there were even some live subjects that Lear did not get quite right. He simply needed time to hone his skills. What is remarkable is that he improved so quickly.

If one reviews the prints in *Illustrations of the Family of…Parrots* in the order in which Lear created them, as opposed to the taxonomic order in which he suggested they should be arranged when bound as a book, one can see a dramatic progression in the quality of his work (see Appendix 1). Much of this improvement can be attributed to his growing maturity and assurance as an artist. Some is also due to his increasing confidence as a lithographer.

LEAR AND LITHOGRAPHY:
APPLYING TECHNOLOGY TO ART

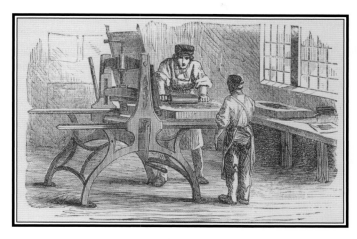

46a. Lithographic press

LEAR'S EARLIEST PUBLISHED illustrations in Edward Bennett's book on the London Zoo and Beechey's *Zoology* were translated from his original drawings and paintings to prints by professional engravers working on metal or wood. Lear did not have the equipment, supplies, or training to do this work himself, nor could he afford to hire the specialists needed to make engravings for his own, self-published books.[76] It was therefore incumbent upon him to find a printing technique that he could master himself to create the plates for his zoological *Sketches* portfolio and for *Illustrations of the Family of…Parrots*. Lithography became Lear's medium of choice.

When lithography was introduced to Great Britain from Germany and France in the early nineteenth century, its champions promoted the process as a less expensive and potentially more creative printing technique than had

been available until that time. Unlike engraving, which requires great technical skill and the mastery of specialized tools (to cut lines into a metal plate from which the final prints are pulled), lithography allows an artist to create his or her own print without needing specialized training or an intermediary.[77] In lithography, artists can use tools with which they are already familiar: crayons or "chalk" for half-tone effects, and ink applied with a pen or brush for line and solid work. With these simple instruments, without having to engage another artist or technician to translate their original drawings onto a metal plate (or the end grain of a hard wood block in the case of a wood engraving), artists can draw directly onto a piece of fine grained limestone from which, with the help of a press, their visual creations can be transferred quickly and relatively easily to paper (see fig.46a).

Although mastering the art of lithography

1. The image is drawn or copied directly onto a prepared limestone tablet using waxy pencils or crayons.

2. A solution of gum arabic and nitric acid is brushed onto the stone. It penetrates the non-image-bearing pores of the limestone, ensuring these areas will repel oil-based printing inks.

3. The original drawing is wiped off using turpentine. A water-repelling (hydrophobic) film remains on the previously drawn area of the stone.

4. The stone is wet, and an oil-based ink applied. The ink is accepted by the hydrophobic parts of the stone that hold the original image and is repelled by the rest of the stone.

5. A damp sheet of paper is evenly pressed onto the stone. The paper picks up the ink from the stone as a mirror image of the original drawing.

6. Color is applied either by hand on a sample or pattern plate prepared by the artist. The finished print is often highlighted with egg white to achieve a lustrous finish.

46b. Diagram of lithographic process

requires training and a great deal of practice, the concept is relatively simple: oil attracts oil, while oil and water do not mix. When an artist draws on a limestone printing block with a greasy crayon, wherever the crayon is applied, the pores of the limestone become filled with pigment. The stone is then saturated with water. Where there are crayon marks, the water is repelled; where there are none, the water soaks into the surface of the stone and that area becomes repellant to ink. Thus, when the lithographic stone is rolled with an oil-based printer's ink, the areas where there is drawing become inky and the empty areas remain ink-free. When a sheet of paper is pressed against a prepared stone, the paper absorbs the ink from the stone's surface. The resulting print is a mirror image of the original drawing (fig.46b). With copperplate engraving, the plate must be carefully inked and the smooth parts wiped clean, a time-consuming and labor-intensive process. With lithography, since the ink never adheres to the blank parts of the image, there is less time and labor involved with readying the printing surface for the press.

Another of lithography's advantages over engraving is that it is a more durable process. With copperplate printing, each time the plate is inked and run through the press, the sharp edges of the engraved lines are diminished, thus reducing the crispness of the printed image. Ultimately the plate is so degraded through the printing process that it must be re-engraved or abandoned. The lithographic stone, by contrast, offers a flat or "planographic" surface, which is never degraded by the pressure of the press. If too much pressure is used in the printing process, the stone can crack, rendering it useless, but if this does not happen and the stone is properly handled, it will remain useable almost indefinitely. When the desired number of prints has been made from a lithographic stone, the surface of the stone can be sanded off and used again. Copperplates, by contrast, must be melted down and recast before they can be reused.

Lear was fortunate in having as his teacher of lithography the man who had literally written the book on the process in England. Charles Hullmandel (1789–1850) was the author of *The Art of Drawing on Stone* (1824 and subsequent editions), a well-illustrated and highly influential how-to manual that was accepted in England as the definitive treatment of the topic through most the period of Lear's involvement with lithography. Although there is no surviving correspondence between them, it is clear from other references in Lear's letters that the two men became good friends. Lear writes of entertaining Hullmandel and taking care of him when he was ill in 1837.[78]

Hullmandel's effectiveness as a teacher is evident in Lear's increasingly capable handling of the technique. Glued to the back of one of his parrot studies[79] is a printed sheet that documents some of Lear's earliest experiments with how a lithographic stone would record a range of drawing techniques. On it Lear has used different drawing instruments (pen, brush, pencil, and crayon) and different shading methods to see how effectively each might convey his creative intent (fig.47). The experimental print contains sketches of a running bison, a leaping lion and a pair of large cats (lions?), jumping kangaroos, a vulture, a stag, an owl, and some more fully finished drawings of imaginary ruins, a dog's head, an eye, a foot, some feathers, and a headless parrot. Some of the subjects are drawn in a style reminiscent of sketches that appear in his earliest surviving sketchbooks.[80]

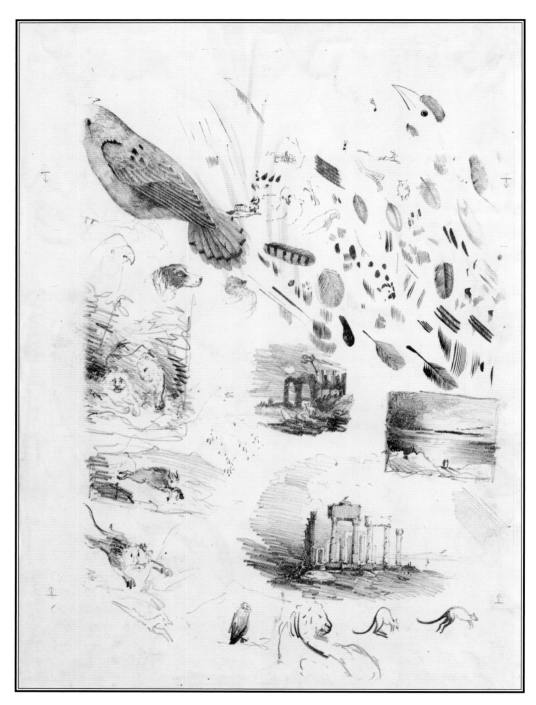

47. Lear's lithographic experiment, circa 1829

In an unintended testimonial to Lear's effectiveness in using lithography to reproduce his experiments with fidelity, no less a connoisseur than Philip Hofer, the curator of printing and graphic art at Harvard who was responsible for assembling the world's largest collection of Lear drawings and paintings at Houghton Library, interpreted this print as a page of original pencil and ink drawings and described it as such in his landmark book on Lear, *Edward Lear as a Landscape Draughtsman* (1967).[81] What Hofer saw as original drawings are, in fact, a young artist's early experiments with a printing technique that he would quickly master and utilize with great effect over the next fifty years.

As Lear learned how to use lithography to capture the look of an original drawing, he was often his own harshest critic. An early print he made of a Purple-naped Lory (*Lorius domicella*) bears Lear's disparaging inscription "my first lithographic failure."[82] Elsewhere on the print, Lear has noted that it was made "from the living bird at Bruton Street." This suggests that he may have taken the lithographic stone to the Zoological Society's offices in order to make his drawing directly from a bird living there. If so, this may have been the part of the experiment that he considered a failure, for working with the heavy stone in such a setting would have been extremely cumbersome and would have limited his freedom to capture the appearance of his animated and constantly moving subject. His evident dissatisfaction with this early experience may have encouraged him to make his subsequent studies on paper and then copy them to lithographic stone in a more conducive location.

Lear does not record where he worked on most of the lithographs for his parrot book, but it seems most likely to have been at Hullmandel's workshop at 49 Marlboro Street,

where he would have had ready access to Hullmandel's advice and where the prints were ultimately produced. It was probably also there that the printed sheets were hand-colored by a professional colorist named Gabriel Bayfield (1781-1870) following original watercolors and pattern plates created by Lear (fig.48).[83]

Ultimately, Lear became so successful at lithography that his professional advice on the process was sought by the Society for the Encouragement of Arts, Manufacture & Commerce (now the Royal Society of Arts).[84] The

48. An uncolored "pull" of one of the illustrations in Lear's parrot monograph with Lear's note approving the toning of the lithographic ink. Similar "pattern plates" with color added would have been created for guidance to the professional colorists who prepared the plates for distribution to Lear's subscribers.

society is listed as a subscriber to Lear's parrot book, but it is not clear whether it paid for the publication, or whether it was a gift from Lear. In any case, Lear must have been flattered, and probably a bit surprised, when the society asked his opinion on the suitability of a certain kind of paper for transferring writing to lithographic stones.[85] Since Lear had never done that, he referred the society to Charles Hullmandel for a more experienced opinion.[86]

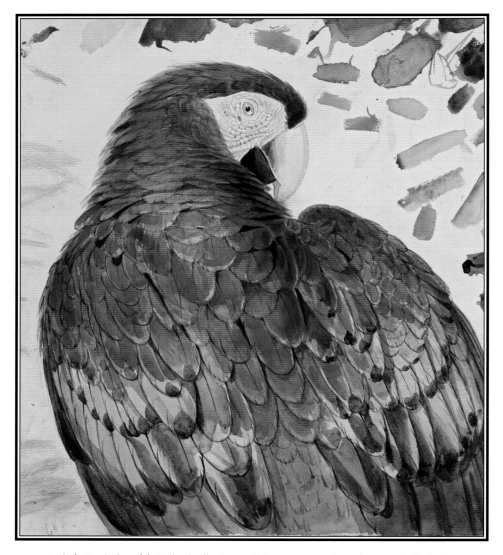

49. Study for Lear's plate of the Red and Yellow Macaw (*Macrcercus aracanga*), now known as the Scarlet Macaw (*Ara macao*),watercolor over graphite

WE GET SOME sense of the scale of Lear's parrot enterprise – and his struggle to keep it going – from a few of his surviving letters from the 1830s. In October 1831, after he had distributed parts of his book to subscribers in groups

of three or four plates per month for about a year, Lear wrote to a book dealer named Charles Empson, whom he addressed as "my sole distributor of *Psittacidae* in the Northern regions." In his letter he explained some of the details – and challenges – of his publication. "I have lately had many sets [of the book's plates] to colour," he wrote, "& have with difficulty supplied my subscribers as wanted – but my colourer is hard at work …Only 175 prints have been taken of each drawing – & when those 175 copies are subscribed for, my work stops – for already the Lithographic plates have been erased!"[87]

By this Lear meant that as he completed each lithographic image on stone, he would make 175 prints of it. Prints that did not meet his high standards were discarded or recycled with their unprinted side repurposed by Lear for use as high-quality drawing paper. When a sufficient number of acceptable (i.e., perfect) black-and-white impressions were made, Lear ground his "drawing" from the stone (a rented item) and returned it to Charles Hullmandel, or drew another parrot on it to serve as another illustration. "My reasons for so soon destroying my drawings were these," he explained, "though I dare say they don't appear so rational to anyone but myself: I was obliged to limit the work – in order to get more subscribers – & to erase the drawings [from the lithographic stones] – because the expense is considerable for keeping them on, & I have pretty great difficulty in paying my monthly charges, – for to pay colourer & printer monthly I am obstinately prepossessed – since I had rather be at the bottom of the River Thames – than be one week in debt – be it never so small."[88]

Lear told Empson that "I manage everything myself," meaning that, in addition to creating the images and supervising their printing and coloring, he was also the one finding subscribers and filling the orders, all from the crowded quarters of the upper floor Gray's Inn Road flat that he shared with his sister Ann. "Should you come to town," he warned Empson, "I am sorry that I cannot offer you a home pro tempore – pro trumpery indeed it would be, if I did make any such offer – for unless you occupied the [fire] grate as a seat – I see no probability of your finding any rest consonant with the safety of my Parrots – seeing, that of the six chairs I possess – 5 are at present occupied with lithographic prints: – the whole of my exalted & delightful upper tenement in fact overflows with them, and for the last 12 months I have so moved – thought – looked at, – & existed among Parrots – that should any transmigration take place at my decease I am sure my soul would be very uncomfortable in anything but one of the Psittacidae."[89]

Despite his cramped quarters, Lear was able to do extraordinarily fine drawings at home. In his letter to Empson he casually mentions that "a huge Maccaw is staring me now in the face as much as to say – 'finish me' – but I guess the poor animal must remain minus a body & one wing for some time to come"(fig.49).[90] Within a few weeks, while juggling at least four other illustration projects, Lear would complete the referenced portrait, which was to become one of his most famous and often reproduced illustrations – the *Red and Yellow Macaw* (fig.50).[91]

When the British ornithologist William Swainson (1789-1855) received this picture as part of his subscription, he wrote Lear to say that he considered the macaw "equal to any figure ever painted by [Jacques] Barraband or [John James] Audubon, for grace of design, perspective, or anatomical accuracy" – high praise indeed from one of England's best known

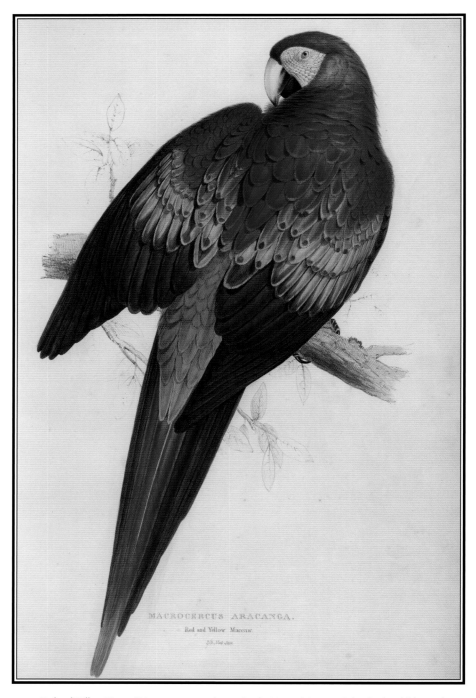

MACROCERCUS ARACANGA.

Red and Yellow Macaw

¾ Nat Size

50. Red and Yellow Macaw (*Macrcercus aracanga*), now Scarlet Macaw (*Ara macao*), hand-colored lithograph
(plate 7) from Lear's *Illustrations of the Family of Psittacidae, or Parrots* (1830-1832)

and most knowledgeable ornithologists.[91]

Even before seeing Lear's *Red and Yellow Macaw*, another of England's leading ornithologists, Prideaux John Selby, praised his parrot monograph plates as "beautifully col-ored & I think infinitely superior to Audubon's in softness and the drawings as good."[93] His comments were based on only the first twelve parrot plates issued by Lear. The best were still to come.

BIRD DEPICTIONS DEAD & ALIVE: ORNITHOLOGICAL ILLUSTRATIONS BEFORE LEAR

So what was it that made Edward Lear's parrot book such a success? A big part of it was the subject matter. Of all birds, parrots are among the most appealing to humans, not just because of their beautiful colors and their ability to adapt to life in captivity, but because of their well-known ability to mimic the sound of the human voice. Lear's book came at an important time in British history, for with the close of the Napoleonic wars, the country was going through an economic expansion coupled with a growing national interest in natural history.

Lear was among the very first people to produce a natural history book based on the scientific relationships between its subjects, rather than their geographic origins (which, with some of the parrots he illustrated, were still unknown). John Gould would later produce successful monographs on hummingbirds, toucans, and partridges, and other authors would create lavishly illustrated books on other bird families in subsequent decades, but before Lear's monograph on parrots, most successful publications had grouped birds together by their place of origin (e.g., Mark Catesby's *Natural History of Carolina, Florida, and the Bahama Islands*, 1731-1743, or Thomas Pennant's *Arctic Zoology*, 1784-1787); by their taxonomic relationships (George-Louis Leclerc, Comte de Buffon, *Histoire Naturelle, Générale et Par-* *ticulière*, 1749-1788), or simply by their novelty (e.g., George Edwards's *Natural History of Uncommon Birds*, 1743-1751, or William Swainson's *Zoological Illustrations*, 1820-1823).[94]

Lear wanted his pictures to be large enough to have impact, but he did not aspire to reproduce his birds life-size, as Prideaux John Selby did in his multi-volume *Illustrations of British Ornithology* (1818-1834), and, more famously, John James Audubon did in his "double-elephant-folio," *The Birds of America* (1827-1837). Those two books featured hand-colored copper engravings that made the life-sized depictions of their subjects possible. Had the lithographic stones Lear used in his book been big enough to contain life-sized macaws, they would have been too heavy to move, and too large for the existing presses to accommodate them. As it was, Lear pushed the technological limitations of the still-evolving art of lithography to the limit, working with stones that were big enough to be impressive, but small enough to move. The so-called "imperial folio" size that he adopted would ultimately become more or less standard for ornithological monographs right up to the present day.[95]

Although the practice was by no means common, Lear was not the first to draw from living birds. When publishing his illustration of a "Green and Red Parrot from China" in

51. "Green and Red Parrot from China" (probably an Eclectus Parrot (*Eclectus roratus*) from New Guinea or Australia) by George Edwards, hand-colored engraving from Edward's book *Gleanings of Natural History* (1758), vol. 5

Gleanings of Natural History (1758), for example, George Edwards noted that the bird "is now living [AD 1754] and is the property of Mrs. Kennon, midwife to Her Royal Highness the Princess of Wales" (fig.51). In addition to boasting of his royal connection and affirming his authority in depicting the bird from life, Edwards went on to proclaim his precedence at presenting it to science. "I believe it hath never till now been either figured or described," he wrote with the same justifiable pride Lear would claim for many of his illustrations.[96]

In the eighteenth century, the term "painted from life" did not always mean painted from a living subject. The phrase more often referred to painting from an actual specimen (dead or alive), rather than copied from an al-

ready existing painting or print (as was common in earlier times). In the preface to his book *A Natural History of Birds* (1731-1738), whose subtitle boasted that it was *Illustrated with Copper Plates Curiously Engraved From The Life and Exactly Coloured by the Author,* Eleazar Albin (c. 1680-1742) explained that he had "used all possible Care to come near to the Life in every particular Bird, and have represented to every one's View the great Variety and Beauty of Colours of each, with the nearest Approach to Nature that Art is capable of, having made all the Drawings from each Bird itself, and not from any other Drawing or Copy."[97] English aviculture being far less advanced in Albin's day than in Lear's, Albin had relatively limited access to living specimens.[98] Nor was he particularly concerned about not having seen the birds in their natural habitat, as long as he could see the birds themselves. "As for the Paintings, they are all done from the Life," he insisted in his preface. And yet in the text that accompanies each plate it is clear that "the very Birds themselves, which I had always by me at the Time," were, in fact, bird skins, not living specimens.[99] "This bird was shot by Consul Sherrard in a River of Smirna," wrote Albin about one of his kingfisher plates. "[It] was brought over by him preserved in Spirits of Wine, from which I made a drawing exactly like the Bird."[100]

The relatively lifeless appearance of Albin's birds becomes evident when comparing them to some of the same subjects as they were drawn by Lear a century later. While a few of the engraved plates made by his daughter show more convincing, life-like postures,[101] most of Albin's own illustrations have the stiff and lifeless appearance of the skins on which they were based. Even when he had the opportunity to work from living

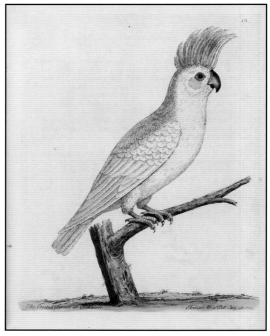

52. "Blew Maccaw" (Blue and Yellow Macaw (*Macrocercus araraua*) 1737 by Eleazar Albin, hand-colored engraving from Albin's book *A Natural History of Birds* (1731-1738), vol. 3

53. "Crested Parrot or Cockatoo" (Yellow-crested Cocka-too (*Cacatua sulphurea*)) by Eleazar Albin, hand-colored engraving from Albin's book *A Natural History of Birds* (1731-1738), vol. 3

birds, as with the Blue-and-Yellow Macaw (fig.52) and the white cockatoo (fig.53), Albin seems to have been so used to drawing dead specimens that he failed to note the difference.

Although Albin's book was relatively scarce, even when newly published,[102] it is quite likely a book Lear would have seen at some point in the 1830s, for it was among the very first color-plate books devoted to birds to be published in Great Britain and, as such, would have been a coveted reference work in the libraries of one or more of his patrons. The other ornithological books to which Lear may have had access at the London Zoo, Knowsley Hall, the estate of the thirteenth Earl of Derby, and elsewhere – books by George-Louis Leclerc, Comte

de Buffon (1707-1788), John L. Latham (1740-1837), George Edwards (1694-1773), Edward Donovan (1768-1837), Thomas Pennant (1726-1798), Coenraad Jacob Temminick (1778-1858), and others – like Albin's, contained illustrations that were based almost entirely on study skins. Readers would have expected nothing else, for while the subjects were usually posed in plausible lifelike postures, they were conceived as representative examples of a species, rather than as portraits of individual birds. In this early period of scientific discovery and classification, a bird's behavior, habitat, and personality were often unknown or of little interest to readers, compared to the details of its physical reality. Illustrations were conceived as supplementary visual vouchers

for the written descriptions required to establish the existence of individual species.

As so often happens with ambitious projects attempted by the very young, when Lear embarked on his great parrot monograph, his inexperience may have been the secret of his success. His lack of academic training, his unfamiliarity with publishing, and his relative naiveté in the field of scientific illustration had the serendipitous effect of freeing him from the confines of existing traditions. Since his previous experience with commissioned work had been to draw particular tumors and deformities for medical purposes, he naturally applied the same methodology to birds, painting every bird that he encountered not as a generic "type," as was the norm, but as an individual. The outsized personality and loud voices of his subjects literally cried out for individual attention. Thus his parrots – and later his other subjects – seem to live in his lithographs in a way that similar subjects had rarely done in the illustrations that preceded them. If Lear had been formally trained, or had grown up surrounded by the bird books of the eighteenth and early nineteenth centuries, his unique, uninhibited approach to drawing birds and other natural history subjects might have been stifled.

BARRABAND'S PARROTS

WHILE LEAR'S *Illustrations of the Family of...Parrots* caused great excitement among British naturalists, it was not the first work on the subject. That honor was claimed by the sumptuously produced *Histoire Naturelle des Perroquets* (1801-1805) by François Levaillant (1753-1824). It contained 145 exquisite hand-colored engravings based on the extraordinary paintings of the French artist Jacques Barraband (1768-1809) (fig.54).[103] Barraband's previous experience as a designer at the Gobelins tapestry factory and an artist creating naturalistic decorations for Sevres porcelain, gave him an aesthetic that was very different from Lear's. Working with the eye of a designer, Barraband's illustrations celebrated sensual textures, vivid colors, and fluid designs, rather than the earthiness of the birds themselves. Where Lear saw ruffled feathers (as in his *Blue and Yellow Macaw*, figure 2), Barraband saw smooth, sleek ones. Where Lear emphasized motion and even flight, Barraband focused on the monumentality and stability of his subjects. While Lear's birds are perky and slightly impish in personality (a bit like Lear himself), Barraband's are stately, elegant, and dignified.

Levaillant and Barraband's parrot book, and the other fine books on which these two men collaborated, were part of a golden age of bibliographic and scientific achievement in France. Although some individual subscribers helped to support these undertakings, it was ultimately the patronage of Napoleon Bonaparte that made them possible. Through such spectacular projects, Napoleon hoped to outshine his royal predecessors and dazzle the world with France's greatness.

By the time Lear came on the stage, the military, political, and economic superiority of France had been superseded by a quickly growing British Empire. With this change came a parallel shift in scientific dominance. England's hard-won gains on the world stage and its resurgent economy led to an era of domestic prosperity and a surge in domestically produced natural history books that rivaled their French predecessors. Lear's natural artistic ability and innovative approach to painting natural history subjects came at just the right time and in just the right place for him to flourish as a scientific illustrator. He could never have developed such a successful career had he been born even a decade earlier, or in a different part of the world.

On a global scale, his circumstances may have been auspicious. On a smaller, personal level, they were challenging. With no steady employment or predictable patronage, Lear's financial situation was tenuous. His security depended on his self-directed initiatives and his ability to respond quickly to outside commissions. And yet, somehow he managed not just to survive, but to succeed as a freelance illustrator.

Given the chaotic state of his living space, as described in his letter to Charles Empson, one wonders how Lear was able to create such masterpieces, and how his long-suffering sister found any space for herself. Little wonder the two of them were eager to move to larger quarters. By the spring of 1832, Lear was living at 61 Albany Street in Regent's Park, not far from the Zoological

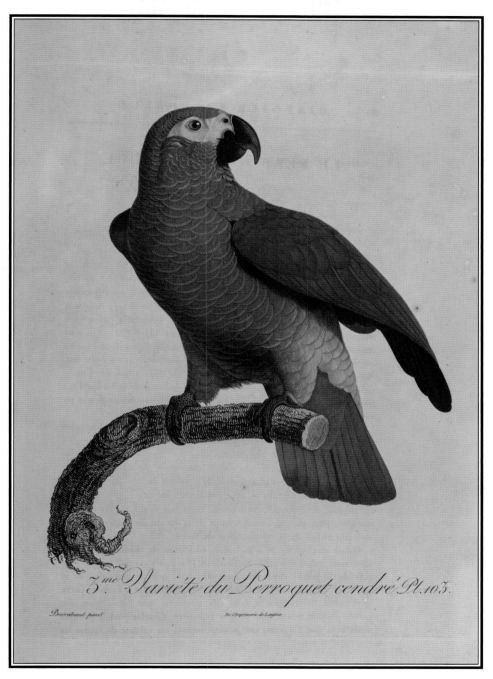

54. African Grey Parrot (*Psittacus erithacus*) by Jacques Barraband, hand-colored engraving from François Levaillant's book *Histoire Naturelle des Perroquets* (1801-1805)

Gardens.[104] There he quickly added living creatures to the complexity of his life, reporting to a young friend that "I have now living 2 Hedgehogs, all sorts of mice – weasels – Bats &c & every beast requisite [for a book on British quadrupeds] but a Pine Marten."[105] As Lear issued the plates for his parrot book in "numbers" or "parts," three or four prints at a time, he packaged them in paper wrappers that were themselves illustrated with parrots (figs.56, 57). Even though his address changed during the two years it took to produce *Illustrations of the Family of...Parrots*, all of the wrappers give his address as 38 Upper North Place, Gray's Inn Road. Not so on the title page of his book, issued in 1832, which gives his much more fashionable address in Regent's Park.[106] This is because he printed the wrappers at the beginning and part way through the project, but designed and printed the title page at the very end, along with the book's dedication page ("to The Queen's Most Excellent Majesty"), a subscribers list,

55. Edward Lear as he appeared in the mid 1840s, daguerreotype

56. Paper wrapper (uncolored lithograph) for Lear's *Illustrations of the Family of Psittacidae, or Parrots* (1830-1832)

57. Paper wrapper (uncolored lithograph) for Lear's *Illustrations of the Family of Psittacidae, or Parrots* (1830-1832)

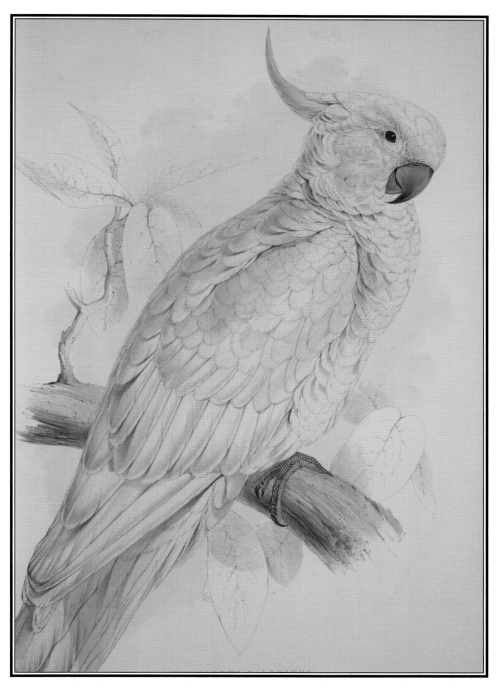

58. Greater Sulphur-crested Cockatoo (*Plyctolophus galeritus*), now Sulphur-crested Cockatoo (*Cacatua galerita*), hand-colored lithograph (plate 3) from Lear's *Illustrations of the Family of Psittacidae, or Parrots* (1830-1832)

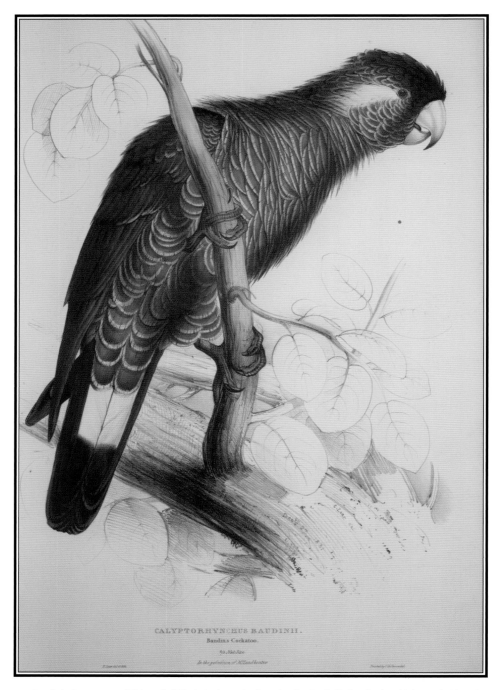

CALYPTORHYNCHUS BAUDINII.
Baudin's Cockatoo.

59. Baudin's Cocatoo, now White-tailed Black Cockatoo (*Calyptorhynchus baudinii*), hand-colored lithograph (plate 6) from Lear's *Illustrations of the Family of Psittacidae, or Parrots* (1830-1832)

and a list of plates specifying the order in which Lear wanted the pictures to appear when the collection was bound in book form.

It is no accident that the most spectacular pictures – most of the ones he created last – were recommended for placement at the beginning of the book. Thus, in opening a bound copy of *Illustrations of the Family of…Parrots,* one is treated to a sequence of his strongest images – cockatoos and macaws and some of the most animated and lifelike parrots – within the first few pages (figs.58, 59; see also 2, and 50). The more sedentary and less competently drawn early images – those issued at the beginning – appear toward the rear of the book.

Because the wrappers were usually discarded by the owners before the books were bound, very few survive. Fortunately enough do to show that there were actually two wrapper designs, both of which were made by Lear as stand-alone lithographs. The reason for the change is that part way through the publication Lear was able to secure the important patronage of Queen Adelaide (1792–1849), the German-born wife of King William IV, and was granted permission to dedicate the publication to her. This he proudly announced on the top of each wrapper after the royal patronage was received in the spring or summer of 1831, and, of course, on the title page and dedication page, both of which he issued only after he was ready to bring the publication to a close in 1832.[107]

The surviving wrappers show that, right up until the time he stopped work on the book, he was promising to provide his subscribers with "14 Numbers" or parts. Lear explained his decision to terminate the project ahead of that goal (with only forty-two plates instead of the expected fifty) in a letter to Sir William

Jardine in January 1834:

> Respecting my Parrots – there is much to say: – no more numbers will be published by me – the 12th [part or number] – which you have, being the last. Their publication was a speculation which – so far as it made me known & procured me employment in Zoological drawing – answered my expectations – but in matters of money occasioned me considerable loss. I originally intended to have figured all the Psittacidae – but stopped in time; neither will there be – (from me) any letterpress [i.e., accompanying text].[108]

The early cessation was not a surprise to those who knew Lear. He had expressed his inclination to abandon the project as early as October 1831. "I have just nine and twenty times resolved to give up Parrots & all," he wrote Charles Empson on the publication of his twenty-ninth plate, " – & should certainly have done so – had not my good genius with vast reluctance just 9 and 20 times set me a going again. – *Opportet vivere* [It is necessary to live]."[109] Because his subscribers paid him in installments as they received the successive parts or numbers of the book, not in advance, Lear was under no financial obligation to complete all fourteen of the parts indicated on the wrappers.

Lear had been pleased to be able to find 125 subscribers for his book, but soon after beginning the project discovered that not all of them were reliable patrons. He had trouble getting some of them to pay for the prints he was sending them. This must have contributed to his decision to give up the publication before exhausting the subject. Even when his subscriptions were filled, this left him with an inventory of fifty unsold sets of prints and a debt

he could not repay. He explained his situation to his friend George Coombe in April 1833:

> You have often – I dare say – heard me express a wish to get rid of the copies of Parrots which I had still unsold, – the little chance I stood of gaining many fresh subscribers after my regular (& for my age – large) connexion [sic] was well [canvassed?], (unless I could have afforded to employ some one for the purpose) was much against my now disposing of them, and I was considerably in debt still for their printing, they were always before me like a great nimbus or nightmare or anything else very disagreeable & unavoidable, which prevented my feeling very pleasured in whatever I under took.[110]

What Lear saw as a financial and psychological drain, Lear's future employer John Gould saw as a business opportunity. Recognizing the quality of Lear's publication and seeing the financial strain the book was creating for him, the entrepreneurial Gould, in March 1833, bought all of Lear's remaining prints (about fifty full sets or 2,100 individual prints).[111] Lear had originally asked seventy pounds for the inventory, but Gould countered with an offer of fifty pounds, sweetening the pot with an invitation to pay Lear's expenses on a working trip to Europe where Gould planned to study rare birds in zoos, museums, and menageries, and to solicit subscribers for his own books.[112] Intrigued by the prospect of "seeing so much of the world for nothing," and with relief that he would no longer have to find individual buyers for what remained of his parrot monograph, Lear accepted Gould's offer.[113]

AMONG THE LIONS:
LEAR'S PLACE IN THE NATURAL
HISTORY COMMUNITY OF HIS DAY
◄ JOHN GOULD ►

60. John Gould by T. H. Maguire, lithograph 1849

LEAR HAD KNOWN GOULD for as long as he had been visiting the zoo, for Gould had been serving as principal curator and chief taxidermist since the time of the zoo's founding (fig.60). The two men, though very different in personality, shared interests in both natural history and publishing. Gould was, as Lear described it, a person "with whom I have always been by circumstances very much allied."[114]

At about the same time Lear was launch-ing *Illustrations of the Family of...Parrots*, Gould, with the help of his wife, Elizabeth, was publishing a color-plate book of his own: *A Century of Birds Hitherto Unfigured from the Himalaya Mountains* (1830–1833). Unlike Lear's book, Gould's offered accompanying text describing each of the birds figured in scientific terms. What his book lacked was the power of Lear's dramatic illustrations.

Recognizing the superior nature of the plates in Lear's parrot book, Gould was hap-

py to assume control of them. "I have some idea of finishing them myself," he wrote William Jardine.[115] Although he never completed Lear's work, Gould did successfully sell the rest of the copies Lear provided him. He also captured some of Lear's talent by engaging the younger artist to instruct his wife in painting and lithography and to create plates for several of his own lavish ornithological publications. These included *The Birds of Europe* (1832–1837), to which Lear ultimately contributed 68 of the 449 plates (figs.7, 61, 62), and *A Monograph of the Ramphastidae, or Family of Toucans* (1834), for which Lear made ten of the thirty-four illustrations.[116]

Lear had a complex relationship with Gould, a man of a more modest social background and eight years his senior. He admired Gould's ornithological expertise and commercial acumen, but disliked his hard-driving personality. In letters of the 1830s, when Lear was in Gould's employ, he described his employer to others as always behaving "in the most handsome & grateful manner to me."[117] In later life, however, Lear came to believe that he had been unfairly exploited by Gould, whom he characterized as "kindly and coarse,"[118] "singularly vulgar and odious,"[119] and "a harsh and violent man…unfeeling for those about him."[120]

Lear felt differently about Gould's wife, Elizabeth, née Coxen (1804–1841), with whom he collaborated (unacknowledged) on many illustrations for Gould's books and to whom he taught the finer points of ornithological illustration. "[Gould] owed everything to his excellent wife, & to myself," noted Lear in later years, "without whose help in drawing he had done nothing."[121] One tangible token of the close relationship Lear developed with Mrs. Gould is a small study of her pet vole that is pasted into one of his

family albums (fig.63).[122] While a certain Victorian formality is reflected in his identifying notation, "portrait of Mrs. Gould's pet," Lear's access to such an intimate part of her life hints at the affection they may have felt for each other.

Lear's observation about John Gould's artistry was probably justified. The younger artist did help Elizabeth Gould improve her skills as a bird painter, and he did provide some of the strongest plates for Gould's *The Birds of Europe* and *A Monograph of the Ramphastidae, or Family of Toucans*. But what his critical comment fails to acknowledge is that Gould's books were successful not only because they were beautifully illustrated and sumptuously produced, but also because they provided something that Lear was unable to offer in his – scientific content.

With the exception of his first book, *A Century of Birds Hitherto Unfigured from the Himalaya Mountains* (1830–1833), for which the Zoological Society's secretary, Nicholas Vigors, provided the text, all of Gould's subsequent forty volumes on birds and mammals offered substantive content written by Gould himself. Though self-taught in the field of ornithology, the one-time taxidermist was able to glean enough information from the existing scientific literature and from knowledgeable informants to turn his books into primary sources of information that were as valued for their content as they were admired for their illustrations.[123] Lear's parrot monograph, while arrestingly beautiful in its presentation, was frustratingly devoid of scientific information.

Unlike Gould, Lear had no credentials or even aspirations in the field of science. With the help of others, he did his best to identify the birds he painted with common and scientific names, but even these sometimes proved

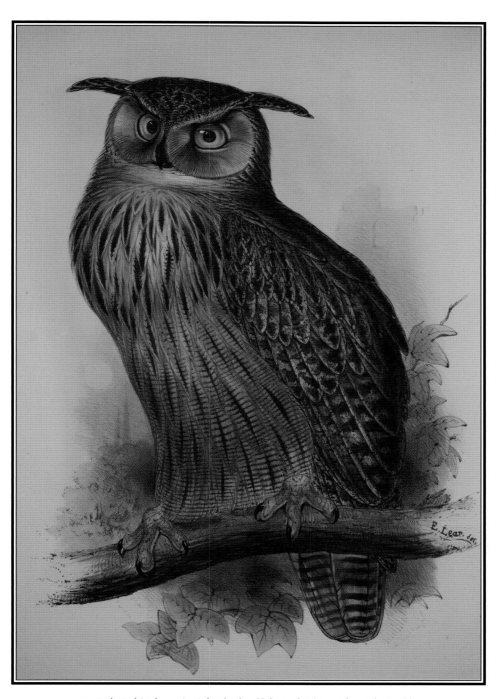

61. Eagle Owl (*Bubu maximus*), hand-colored lithograph (plate 37) from John Gould's
The Birds of Europe (1832-1837), vol. 1

FLAMINGO.

62. Flamingo (*Phoenicopterus ruber*) now known as Greater Flamingo (*Phoenicopterus roseus*), hand-colored lithograph
(plate 287) from John Gould's *The Birds of Europe* (1832-1837), vol. 4

63. "Mrs. Gould's pet" (a Short-tailed Field Vole, *Microtus agretis*), ink wash over graphite

inaccurate because so little was known about the birds he was depicting.[124] In one case, the contemporary dearth of scientific knowledge worked in Lear's favor. A bird he misidentified on plate 9 in *Illustrations of the Family of...Parrots* as a Hyacinthine Macaw (*Macrocercus hyacinthinus*), today known as a Hyacinth Macaw (*Anodorhynchus hyacinthinus*), turned out to be a previously undescribed species. Since Lear was the first to depict it (probably from a skin, not a living specimen), his long-time friend Charles Lucien Bonaparte (1803–1857), the scientifically knowledgeable and accomplished nephew of the Emperor Napoleon, decided to name it *Anodorhynchus leari* or Lear's Macaw, in his honor in 1856 (fig.64). For more than a century after Lear drew it, no one knew where or whether a wild population of the species might be found. Finally, in 1978, a small group of the birds was found living in the semi-arid "caatinga" area of northeastern Brazil. It was probably never a common bird, but aggressive capture of the species for the pet trade, and a degradation of its natural habitat have reduced the population of wild Lear's Macaws to dangerous levels. Today

the entire population of the species is believed to be less than one thousand individual birds.[125]

Because of Lear's shy nature and inherently likable personality, his admirers have long pointed to his unacknowledged work for John Gould as evidence of Lear's innocence being exploited by his blindly ambitious and ruthless employer, but the story is more complex than it first appears. It is true that four of the sixty-eight plates made by Lear for Gould's *The Birds of Europe* (1832–1837) are credited to "J. and E. Gould" and not to Lear, who actually drew them and whose name appears in the body of prints themselves (fig.65), but this could be explained by the scale, pace, and complexity of Gould's production schedule and the number of people who were involved with making the plates for his book.[126] Lear was, at that time, a salaried employee of Gould's and so, by the common practice of the day, not necessarily entitled to individual recognition (as with his work for Edward Bennett).

What is remarkable is not that he was denied credit for four of his plates in *The Birds of Europe*, but that he is fully credited for the other sixty-four illustrations that he created

64. Study of a Lear's Macaw (*Anodorhynchus leari*), misidentified by Lear as a Hyacinthine Macaw (*Macrocercus hyacinthinus*) when he published it as plate 9 in *Illustrations of the Family of Psittacidae, or Parrots* (1830-1832), watercolor over graphite

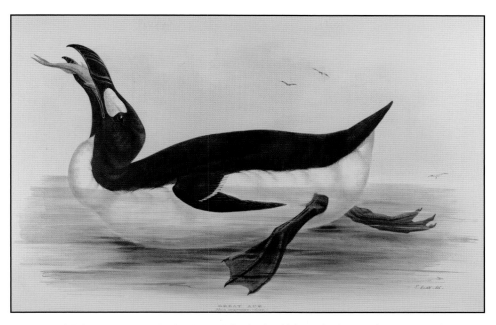

65. Great Auk (*Alca impennis*, now *Pinguinus impennis*), hand-colored lithograph (plate 400) from *John Gould's The Birds of Europe* (1832-1837), vol. 5. This is one of several original illustrations by Lear in Gould's book that bear the credit line "Drawn from Nature and on Stone by J. & E. Gould."

for Gould's book, and that his contribution is acknowledged in the preface.[127] With Lear's growing reputation for excellence, Gould must have recognized the advantages of having Lear's name associated with the work, although he did fail to fully acknowledge his contribution to *A Monograph of the Ramphastidae, or Family of Toucans* (1833–1835). There Lear's name appears in association with each of the ten lithographic illustrations he created for the book, but nowhere in the text (fig.66, see also fig.2 on page 8).[128]

Was it a slight felt from this seeming lack of appreciation or acknowledgment of his work that prompted Lear's harsh assessment of his former employer toward the end of his life? Certainly in the 1830s and even the 1840s and 1850s, the correspondence between Lear and Gould seems cordial, even friendly, with Lear frequently asking Gould for more

lengthy replies to his own long letters. Had he resented him from the start, it seems hard to believe he would have made such an effort to keep in touch, especially after he had moved away from the field of natural history illustration. Still, it is probably correct that Gould was never very warm or personal in his dealings with Lear or any of his other employees (most of whom he continued to address by their surnames even after years of employment). To Gould, an artist like Lear, no matter how talented and likable, was simply a cog in a large commercial wheel, someone to help him with his publications, not a person to be singled out for praise or public recognition. His lack of response to many of Lear's letters, while probably explained by his heavy work load, was nonetheless hurtful to Lear and reflective of the insensitive attitude Gould had toward those who worked for him.

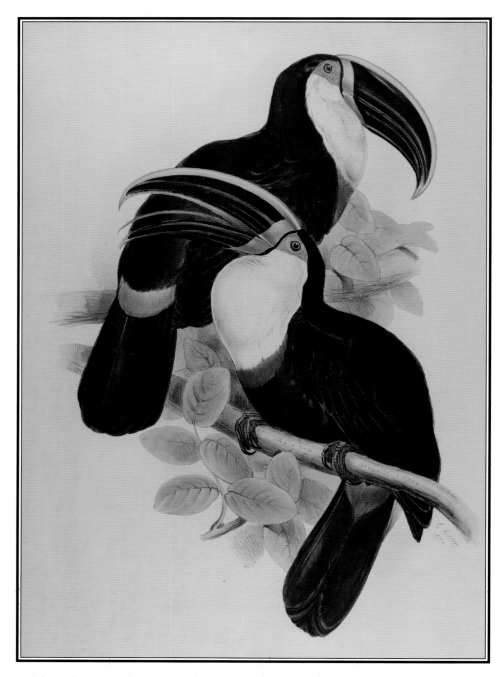

66. Culminated Toucan now known as Cuvier's Toucan (*Ramphastos cuvieri*) dated 1833, hand-colored lithograph (plate 1) from John Gould's *A Monograph of the Ramphastidae or Family of Toucans* (1833-1835). In the second edition of this book (1854), Lear's plate was copied by Henry Constantine Richter and credited to Gould and Richter with no mention of Lear

The close working relationship between Edward Lear and John Gould, as well as Gould's assumed "ownership" of the images created by Lear when he was in Gould's employ, has created some confusion among art scholars unfamiliar with the ornithological literature. One longstanding source of confusion is a set of eight lithographed and hand-colored bird head vignettes that are cut and pasted to a single sheet of paper held by the Department of Prints and Drawings at the Victoria and Albert Museum (fig.67) that several Lear scholars have posited are early lithographic experiments by Lear.[129] This is not correct. While the heads are certainly mirror images of ones originally created by Lear, these are not lithographic "trial runs," as several authors have proposed, nor are they images with which Lear was unhappy and decided not to use. They are, in fact, a subset of the seventy-two head vignettes that were published by John Gould in *A Synopsis of Birds of Australia and the Adjacent Islands* (1837–1838). Three of the heads on the Victoria and Albert Museum sheet – and another similarly cut out and pasted on a separate sheet at Knowsley Hall – were copied (in reverse) from the heads of birds in Lear's *Illustrations of the Family of... Parrots* for use by Gould in the *Synopsis*.[130] The other heads on the sheet, including some of parrots, have no connection to Lear. These were among the many new images created by Elizabeth Gould for use in Gould's book.

It is quite likely that Lear had nothing to do with creating the head portraits that were copied from his earlier work, for by 1837, when Gould's *Synopsis* was published, Lear was already moving away from ornithological illustration and was focusing his artistic energies on landscape painting. Since the rights to the parrot images were owned by

Gould (he had acquired them, along with the unsold plates for *Illustrations of the Family of...Parrots*, in March 1833), he considered them his property to use as he wished. And so, probably, without even asking Lear, Gould arranged to have the heads of the four Australian birds he needed from Lear's parrot monograph copied onto fresh lithographic stones (the lithographic stones used in the printing of Lear's book having long since been erased). They were then printed in black and white and hand-colored for use in Gould's book. Why the eight heads were subsequently cut out and pasted on the sheet that is now in the Victoria and Albert Museum may never been known, but the cutting out and rearranging of images in albums was not uncommon during this period. Large collections of cut-and-pasted bird illustrations were made by several of Lear's friends and associates, including John Gould himself.[131]

67. Clipped montage of hand-colored lithographs (some by Edward Lear) from John Gould's *A Synopsis of Birds of Australia and the Adjacent Islands* (1837-1838)

68. William Jardine by T. H. Maguire, lithograph 1849

69. Prideaux John Selby by T.H. Maguire, lithograph 1852

J OHN GOULD WAS ONE of Lear's most regular and demanding sources of commissions for illustrations during the 1830s, but he was by no means the only one taking advantage of Lear's talents. At about the same time Lear began to work for Gould, the naturalists Sir William Jardine (1800–1874) and Prideaux John Selby (1788–1867) (figs.68, 69) commissioned Lear to create some of the plates for their own handsomely produced *Illustrations of Ornithology* (1825–1839).[132] Lear's introduction to Jardine was arranged by Nicholas Vigors, his old friend from the zoo.[133] The relationship proved to be a mutually beneficial and satisfactory one.

As Jardine and Selby got to know Lear and appreciate his ability to bring birds to life on paper, they commissioned him to make other illustrations for them, including a painting of a Great Auk to serve as the basis for Selby's plate of the species in *Illustrations of British Ornithology or Figures of British Birds* (1834) (figs.70a, b).[134] He also made three paintings for Sir William Jardine's *Illustrations of the Duck Tribe* (1835–1839).[135] Lear made some similar duck paintings for Thomas Campbell Eyton (1809–1880), six of which were published in Eyton's *A Monograph of the Anatidae, or Duck Tribe* (1838).[136]

The largest number of illustrations Lear was ever commissioned to undertake for use in a single publication were those he made between 1834 and 1836 for the *Naturalist's Library*. This was a popular series of forty small volumes on varying natural history subjects edited by William Jardine. The illustrations Lear created for this work included two cats,

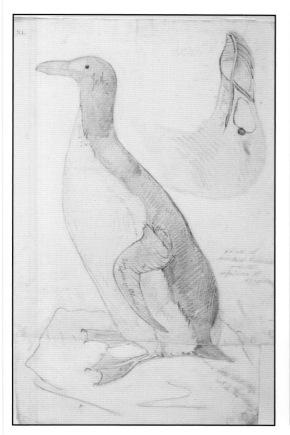

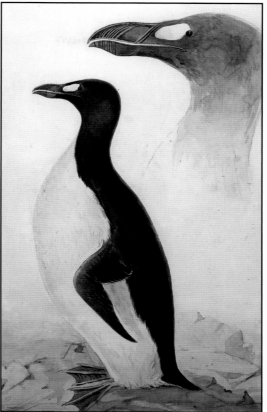

70a. Lear's graphite study of a Great Auk from a preserved specimen at the British Museum, 1831

70b. Great Auk (*Pinguinus impennis*), for Prideaux John Selby's book *Illustrations of British Ornithology or Figures of British Birds* (1834), ink and watercolor over graphite, 1831

thirty-one pigeons, and thirty-one parrots (figs.71, 72, 73). All were printed from Lear's original watercolors by Jardine's brother-in-law, the talented Scottish engraver William Lizars (1788–1859), who also printed the first ten plates for John James Audubon's *The Birds of America*. Lizars considered Lear the finest painter with whom he had ever worked. "Lear's drawings are nature," he wrote, "and all others Pottery-ware."[137]

Although the *Naturalist's Library* volumes with which Lear was involved were published in 1834 (cats), 1835 (pigeons), and 1836 (parrots), it is clear from surviving correspon-

dence that Lear began working on illustrations for the series as early as 1833.[138] For the parrot volume, it had been Jardine's hope simply to reuse some of the images Lear had created for his own monograph on the family a few years before. Lear correctly suspected that John Gould would not approve the creation of a competitive publication on the subject since he then held the remaining parts of Lear's parrot book. Instead, Lear proposed creating new images for Jardine using his existing life studies as the basis for his work (fig.74). In January 1834, he wrote Jardine:

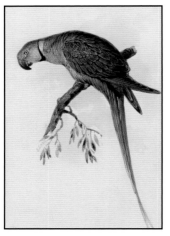 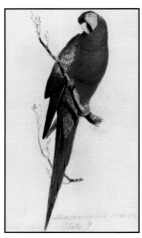 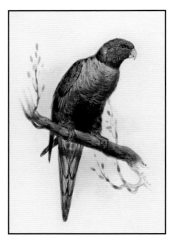

71. Moustached Parakeet (*Palaeornis alexandri*), created to serve as an illustration for William Jardine's *Naturalist's Library* (1834-1836), watercolor over graphite

72. Red and Yellow Macaw (*Macrcercus aracanga*), now Scarlet Macaw (*Ara macao*), created to serve as an illustration for William Jardine's *Naturalist's Library* (1834-1836), watercolor over graphite

73. Swainson's Lorikeet (*Trichoglossus swainsonii*) created to serve as an illustration for William Jardine's *Naturalist's Library* (1834-1836), watercolor over graphite

Concerning the request you make that I would allow these [existing parrot plates] being copied – I have no power to either refuse or comply – since I have sold all right in the volume to Mr. Gould. ... Supposing Mr. Gould should object to my Psittacidae being copied, – I believe I may add that from possessing a vast number of sketches from living Parrots I should be able to furnish you with drawings at a rather less charge than I make for quadrupeds at present. It is my habit, at the time I was publishing – to sketch almost every parrot that came in my way – & I thus obtained many figures of said species. Were there any considerable number required, I would make finished drawings for £1.0.0 each, both on account of the references I have by me, & because Parrots are my favourites & I can do them with greater facility than any other class of animals.[139]

Lear astutely pointed out to Jardine that by commissioning new work from him (as opposed to reusing old images) he would have a better chance of capturing the hundred or so people who already owned Lear's parrot book as customers for his own. These potential buyers, "most of them zoological people," Lear correctly surmised "would prefer original figures to duplicates."[140] A small study of a cockatoo in the margin of one of his preparatory drawings for his own monograph shows how Lear was able to alter his angle of vision and the posture of the bird to create "new" images from old, thus giving the *Naturalist's Library* plates the originality Jardine's subscribers were looking for (fig.75).

In light of his later abandonment of natural history as a primary subject for his pencil and brush, it is easy to think of Lear as a talented illustrator who was simply applying his skill to scientific subjects to bring in the revenue he needed to survive, but the level of technical detail that appears in his corre-

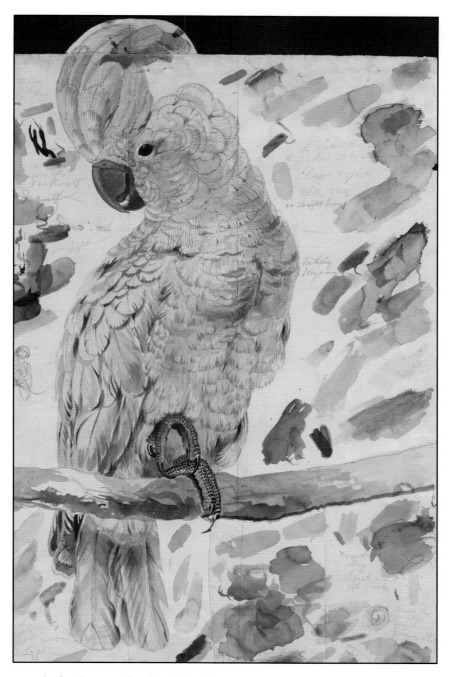

74. Study of a Salmon-crested Cockatoo (*Plyctolophus rosaceus* now *Cacatua moluccensis*) with paint samples, used for plate 2 in *Illustrations of the Family of Psittacidae, or Parrots* (1830-1832). After using these masterful studies to create the plates for his own book, Lear retained them as references for future work

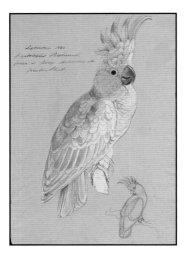

75. Two studies of a Lesser Sulphur-crested Cockatoo (*Plyctolophus sulphureus*), now Yellow-crested Cockatoo (*Cacatua sulphurea*), ink and watercolor and graphite, September 1830. Lear used the larger watercolor study as the model for plate 4 in his parrot monograph. The smaller, pencil study, possibly drawn at a later date, became the basis for his illustration of the same species in William Jardine's *Naturalist's Library* which was published six years later.

spondence with Jardine and Selby during the 1830s indicates that he had become an active part of the scientific community. "I am very anxious to see this publication," he wrote Jardine about the latter's soon-to-be published parrot volume. "And particularly, Sir William, I hope you will clear up several demi-groups which are at present very obscure – P[sittacidae] viridis – the Genus Brotogeris – & the white winged Parakeet – Murinus & others are among those I allude to."[141] Such attention to scientific classification issues and technical nomenclature was unusual for illustrators of the period and reflects Lear's familiarity with the ornithological taxonomy of his day, at least with regard to the parrot family.

Jardine and Selby were very pleased by the illustrations Lear created for their books, exchanging delighted comments between themselves about their quality. "What a de-lightful set of drawings Lear has made of the Pigeons," wrote Jardine to Selby in August, 1834. "Charles [Biggs (1803–1846), Selby's son-in-law] is quite in raptures with them, the attitudes selected [are] all so good and natural, the colouring so free and at the same time so delicate and chaste. I do not think I ever saw feathering so well depicted."[142]

The success of Lear's work was enhanced by the cooperation he received from the people he had befriended during his time moving between private and public aviaries in London and elsewhere. He acknowledged this help in a letter to Jardine: "I send you [paintings of] the following Columbidae," he wrote, listing the five pigeon paintings accompanied by his letter. "The first of these I drew from a living specimen at Cross's Surrey gardens – the 2nd from life also at the Park. The remaining 3 from skins good naturedly lent me by Gould – who for liberality might set an example for not a few of the Zoologists who squabble over the name of a skin & refuse to let the world see its likeness. It is very fortunate that I can procure specimens of the birds you name – instead of drawing from figures."[142] Despite Lear's later comments about Gould, it is clear from this reference that the older naturalist was of enormous help to Lear at a time when he needed it the most.

The Cross to whom Lear refers in this letter was Edward Cross, the proprietor of the menagerie in Exeter 'Change in the Strand, who formed the Surrey Zoological Gardens in Kennington in 1829. This highly successful establishment became a rival to the Zoological Society's gardens in Regent's Park. Though somewhat more difficult to get to than the London Zoo, it had almost as many exotic birds and mammals, all of which its affable proprietor was happy to make accessible to Edward Lear.

⧼ THOMAS BELL ⧽

76. Thomas Bell by T. H. Maguire, lithograph 1852

ANOTHER IMPORTANT patron and mentor to Lear was Thomas Bell, a dental surgeon at Guy's Hospital (fig.76). Bell was a popular teacher who was able to bridge the gap between theory and practice. In 1829 he published a comprehensive textbook entitled *The Anatomy, Physiology and Diseases of the Teeth*. It was reprinted in Britain in 1835 and published in the United States in 1837. Because of his pioneering application of scientific methods to solve dental problems, Bell is generally considered the founder of dentistry as a separate branch of medicine in Great Britain. He was the first practitioner to consider teeth as living structures.

But Bell's interests went well beyond dentistry and diseases of the teeth. He also became a leading authority in several fields of natural history, leading to his election to the Royal Society in 1828, and his appointment as a professor of zoology at King's College London from 1836 to 1861. Bell wrote the herpetological volume for the *Zoology of the Voyage of HMS Beagle* (1843), edited by Charles Darwin, and a number of widely cited monographs on mammals, crustaceans, and reptiles. As president of the Linnean So-

ciety of London, he presided over the famous meeting of July 1, 1858, at which Charles Darwin's and Alfred Russell Wallace's papers on natural selection were read.

Bell was among the earliest of the scientific establishment to encourage Lear's talents as an illustrator. He may have been one of the medical doctors for whom Lear made drawings early in his career. However, despite their friendship, which lasted until the end of Bell's life, he, like Edward Bennett, was guilty of using some of Lear's work without giving him the recognition he deserved. When he published *A History of British Quadrupeds* in 1837, Bell credited two other artists with the illustrations.[144] Edward Lear's own copy of the book, presented to Lear "with the author's affectionate regards," belies such a claim.[145] In it, Lear has noted seven illustrations for which he was responsible. "Drawn from life by me, Edward Lear" or a similar statement has been written in pencil beside the wood-engravings of the Greater Horseshoe Bat, the Hedgehog, the Common Shrew, the Water Shrew, the Ferret Weasel, and the Brown Rat (fig.77).[146] Confirming his claims of authorship, Lear's original watercolors of several of these subjects, posed in the same manner as they appear in Bell's book, survive (figs. 78, 79).[147]

Given the close relationship that clearly existed between Bell and Lear (the latter sought the former's advice on whether or not he should sell his remaining parrot monograph plates to Gould), it is curious that the older naturalist did not give Lear credit for the illustrations he created for *A History of British Quadrupeds*. Bell was much more generous in granting Lear credit as the lithographer for a large monograph on turtles, *A Monograph of the Testudinata*, which he published in eight parts between 1832 and 1836 (fig.80). In this highly acclaimed work, described by

historian Kraig Adler as "the single most outstanding collection of turtle illustrations ever produced," Lear's name appears prominently on the plates, alongside that of the illustrator, James De Carle Sowerby (1787–1871).[148] A few surviving watercolors of turtle shells suggest that Lear may have contributed original illustrations to Bell's work (fig.81).[149] These, and a pair of swimming turtles that Lear painted for Lord Derby (Lord Stanley prior to 1834) (fig.82), confirm that he would have been capable of doing all of the plates for Bell's book entirely on his own, had he been invited to do so. No record survives to indicate who recommended Lear to be the one to translate Sowerby's original paintings onto lithographic stone, but since Charles Hullmandel did the printing of the plates, it might well have been he who suggested it.

Bell was pleased both with the quality of Lear's work, and with the speed with which he performed it. When the project began to bog down because of Sowerby's heavy workload, Bell may have regretted inviting Sowerby to be his principle illustrator. He cited Lear's efficiency in hope of inducing greater speed in Sowerby's work: "I am sorry to trouble you again," he wrote his lethargic illustrator in March 1832, "but I really must urge you the finishing of as many tortoises as possible very soon, as Lear has almost overtaken you [in creating the lithographs], and I am getting anxious to begin the work – and cannot venture to make even my intention public until a fair prospect exists of bringing it [the book's parts] out with regularity."[150] Had he invited Lear to do the original illustrations, and not just the lithographs, Bell might have been able to bring his book to completion during his lifetime. As it was, only twenty-four pages of introduction, eighty-two pages of text, and forty plates were issued before

INSECTIVORA. *ERINACEADÆ.*

Genus, *Erinaceus.* (Linn.)

Generic Character.—Middle incisive teeth very long, standing forward ; the upper ones cylindrical, apart : grinders ₄:₄: body covered with spines : tail very short.

HEDGEHOG. URCHIN.

Erinaceus Europæus.

Specific Character.—Ears less than half the length of the head ; spines not longer than the head.

Echinus sive erinaceus terrestris,	RAY, Syn. Anim. Quad. p. 231.
Erinaceus Europæus,	LINN. Syst. Nat. p. 75. DESMAR. Mammal. p. 147. sp. 229. FLEM. Brit. An. p. 7. JENYNS, Brit. Vert. p. 19.
Le Hérisson,	BUFFON, Hist. Nat. VIII. p. 28, t. vi.
Common Urchin,	PENN. Brit. Quad. I. p. 133.
Hedgehog,	SHAW, Gen. Zool. I. p. 542, t. cxxi.

DEPRIVED by its structure of all means of attacking its enemies, of defending itself by force, or of seeking safety in flight, this harmless animal is yet endowed with a safe-

77. Lear's copy of *A History of British Quadrupeds* (1837) by Thomas Bell in which Lear documents his authorship of the otherwise unattributed illustrations.

78. European Hedgehog (*Erinaceus europaeus*), ink and watercolor over graphite, original illustration for Thomas Bell's
A History of British Quadrupeds (1837)

79. Water Shrew (*Sorex fodiens*), ink and watercolor over graphite. Study for one of Lear's illustrations in Thomas Bell's
A History of British Quadrupeds (1837)

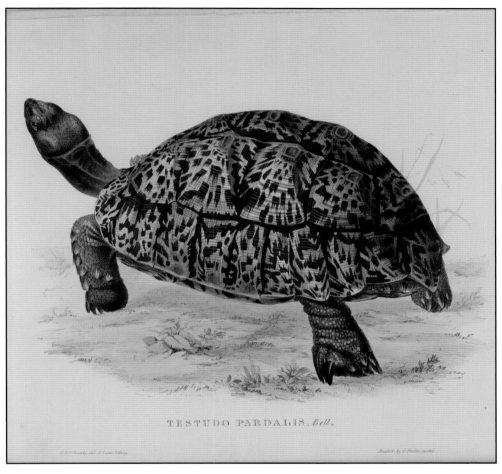

TESTUDO PARDALIS, *Bell.*

80. Leopard tortoise (*Testudo pardalis*, now *Stigmochelys pardalis*) hand colored lithograph (plate 1) from Thomas Bell's
A Monograph of the Testudinata (1832-1842)

the publisher, Highley, went bankrupt. Some twenty-one additional plates had been prepared by Lear, and printed by Hullmandel, but were not issued until almost forty years later when Highley's remaining stock was purchased by the London publisher and print dealer Henry Sotheran. Under a new title, *Tortoises, Terrapins, and Turtles*, and with a new sixteen-page text by John Edward Gray, Bell's book with Lear's lithographs was finally published in its entirety in 1872.[151]

81. Study of the lower carapace of a Radiated Tortoise (*Testudo radiate*, now *Astrochelys radiata*), ink and watercolor over graphite, August 1831

82. Nile Soft-shelled Turtle (*Trys argus* now *Trionyx triunguis*), watercolor over graphite, reproduced (as plate 4) in *Gleanings of the Menagerie and Aviary at Knowsley Hall* (1846)

A CURIOUS BEAST

83. Study of a Rock Hyrax (*Procavia capensis*), ink and watercolor over graphite, April 1832

BECAUSE OF THE SCARCITY of Lear's own written records about his early interest in natural history illustration, his biographers and art historians have attempted to document his evolution as an artist by citing the circumstantial evidence found within his early drawings. One of the most appealing and frequently referenced studies is a watercolor of a Rock Hyrax (*Hyrax capensis*) (fig.83).[152] Although not immediately evident, this evocative painting has a direct connection to Thomas Bell, as the animal in question was owned by him and kept in his private menagerie until he deposited it at the London Zoo.

In his pioneering monograph on Lear, *Edward Lear as a Landscape Draughtsman*, the art historian and Lear collector Philip Hofer singled out the painting for special attention, not because of its scientific importance, but because Hofer thought it would help reveal Lear's evolution as an artist. He wrote:

> Among the albums of Lear drawings at Harvard, willed by the artist to Sir Franklin Lushington, his heir and executor, is one which contains a number of very early sketches. These are of all types and subjects, but one is of special interest here. It is a finished watercolor drawing of a small animal (*Hyrax capensis*) in the margin of which Lear 'doodled' a self-portrait pencil sketch. Below it he has written: 'Sketched at 17. Drew…April 13, 1832.'[153]

Hofer went on to explain that this inscription provided evidence of Lear having drawn the first sketch in 1829, when Lear was seventeen, and then completed the drawing three years later, when he was twenty.

Hofer's interpretation of the inscription on

the hyrax watercolor was repeated and reinforced by Susan Hyman, who called it "Lear's first datable animal drawing," noting that the gap between when Lear "sketched" the picture (presumably 1829) and "drew" (i.e., finished) it (1832) "reveals something of Lear's methods. He first made a sketch with penciled colour notes and later, sometimes after a long interval, 'drew' or completed it with watercolour washes, tracing his penciled notes in ink."[154] Further investigation of the Lear hyrax reveals that this was far from Lear's earliest animal painting and that the gap in time between his sketch and his finished painting was a matter of months, not years.

The subject of the study was a creature of sufficient rarity in nineteenth-century England to be traceable as an individual animal in the scientific literature. The accession records of the Zoological Society reveal that there was only one Rock Hyrax exhibited at the zoo between 1828 and 1863. This is certainly the one that Lear painted. It was a single male, presented "temporarily" to the zoo on June 6, 1832, by Thomas Bell. Unfortunately, after a summer of display at "the gardens," the animal died in the zoo's "winter repository for smaller animals," on November 30, 1832.[155]

With this information in hand, the interpretation of Lear's inscription takes on new meaning. Thomas Bell, it turns out, lived at 17 New Broad Street, as noted on the subscription list for Lear's parrot monograph. This is evidently where Lear sketched the animal on April 13, seven weeks before Bell turned the animal over to the zoo. The full inscription on the preliminary study reads: "Sketched at 17. New Broad Street April 13,

1832." Hofer and others misinterpreted the "17" as an age, not an address, misunderstood the British address punctuation as a period between sentences, and misread the "New" as "Drew." The final version of the painting, which came on the art market in 1993, is dated August 20, 1832, just four and a half months after the initial sketch and three months before the animal's demise.[156]

So significant was Thomas Bell's hyrax that, within days of its death, Sir Richard Owen (1804–1892), curator of anatomical collections at the Royal College of Surgeons' Hunterian Museum and England's leading anatomist, presented to his fellow members of the Zoological Society a detailed, five-page account of the autopsy he performed on the animal. This paper was subsequently published in the *Proceedings* of the society.[157]

Since the painting was made by Lear without any expectation of the animal's imminent demise, it was almost certainly made for Bell's personal enjoyment and not to accompany Owen's post-mortem publication, which was, of course, unanticipated at the time the portrait was made. It was one of many such paintings Lear was making for his friends and patrons during this period, most of which were widely dispersed by the artist and are now in public and private collections in Great Britain, Australia, Canada, and the United States. Although he never enjoyed drawing mammals as much as birds, complaining in a letter to Sir William Jardine that mammals were "so much more trouble than birds & require so much more time," the hyrax study and other mammal paintings from this period show that he was equally skilled at both subjects.[158]

LEAR DOWN UNDER:
AN UNUSUAL INTEREST IN AUSTRALIA

84. Brown's Parakeet (*Platycercus pileatus*) now known as the Northern Rosella (*Platycercus venustus*), hand-colored lithograph (plate 20) from Edward Lear's *Illustrations of the Family of Psittacidae, or Parrots* (1830-1832)

AMONG THE MANY mammals Lear painted, a disproportionately large number were of species from Australia. Several of the birds he featured in his parrot family monograph are of Australian origin (fig.84), as are a number of other birds he was commissioned to illustrate for John Gould, Sir William Jardine, and others.[159]

85. Red-necked Wallaby (*Macropus rufogriseus*), ink and watercolor over graphite, September 1835

86. Brush-tailed Possum (*Trichosurus vulpecula*), ink and watercolor over graphite, August 1834

But it was the mammals from Down-Under that seem to have especially attracted his attention.[160] He painted a surprisingly large number of Australian mammals during his short period of immersion in wildlife art. From kangaroos to possums and bettongs to quolls, Lear masterfully captured the strange new animals that were then just coming to the attention of European and English naturalists (figs. 85, 86).[161]

We can safely assume that most of his living subjects came either from the Zoological Society, or from one or more of the private menageries in England to which he had access. "I do not feel competent to undertake quadrupeds," he wrote William Lizars in 1834, "unless I draw them from *life*."[162] Knowsley Hall was an especially fruitful source for Australian subjects as Lord Derby had a large number of mammals from that continent on his grounds and in his menagerie. A masterful graphite and watercolor study by Lear of an Eastern Gray Kangaroo (*Macropus giganteus*) (fig. 87) is probably of an animal that was part of a herd of free-ranging kangaroos that the thirteenth Earl of Derby kept at Knowsley Hall as part of his long-running effort to develop new sources of meat for domestic consumption.[163] Lear's multi-part sketch, which also includes studies of some of the geese on the estate, shows a resting kangaroo from several different angles, suggesting the relaxed and easy access Lear had to his subject.

Lear's lively painting of an Eastern Quoll (*Dasyurus viverrinus*) (fig. 88) was also made from a living specimen at Knowsley Hall, though, unlike the kangaroo, this high-strung carnivore was almost certainly a caged specimen in the Earl's menagerie.[164] The detailed inventories of the animals that were kept in Lord Derby's menagerie and at the London Zoo enable us to source many, but not all, of Lear's paintings. Where in Great Britain did he find a living Tasmanian Devil (*Sarcophilus harrisii*), or the skin of the rare (and now extinct) "Tasmanian Tiger" or Thylocene (*Thylacinus cynocephalus*)?[165] Perhaps he found these on one of his drawing trips to the continent. Unfortunately, he fails to record the sources of his inspiration.

It is unclear why Lear painted so many Australian subjects. Some, like Lord Derby's Eastern Quoll, were private commissions from the owners of these highly valued specimens. Could others have been commissioned for a book on Australian fauna that never came to be?[166] Or were they simply creatures whose colors, shapes, fur texture, and behaviors Lear found appealing? Whatever the reason he made them, they number among his finest natural history paintings.

In his popular collection of limericks and illustrated children's verse, Lear celebrated the exoticism of foreign lands. He enjoyed the sounds of their names, the idiosyncrasies of their national costumes, and the curious natures of their native plants and animals. He played with these both visually and linguistically. Some of his surviving letters suggest that he was intrigued and amused by the "upside-down" possibilities of antipodean life,[167] but strangely, except for one poem about a duck and a kangaroo, he made not a single reference to Australia in any of his publications. Portugal, Spain, France, Italy, Turkey, Sweden, Norway, Russia, India, Chile, Ireland, Greece, Nepal, and even Jamaica all make appearances in his limericks, but never did he reference Australia or any of its cities in any of them, despite the enormous rhyming potential of Sydney, Adelaide, Brisbane, Melbourne, Hobart, and Perth. Such a conspicuous absence might lead one

87. Study of an Eastern Gray Kangaroo (*Macropus giganteus*) and geese from Knowsley Hall,
Graphite with watercolor highlights on gray paper

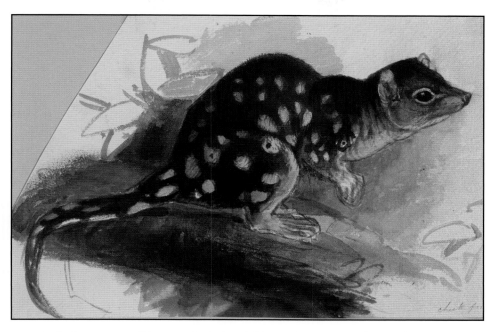

88. Study of an Eastern Quoll (*Dasyurus viverrinus*), probably painted at Knowsley Hall, watercolor over graphite

89. "inditchenous beestes of New Olland," ink and graphite, circa 1834

paintings he made of Australia's wildlife demonstrates that quite the opposite was true.

An undated manuscript by Lear (probably from about 1834) shows some cartoonlike sketches of a number of Australian mammals. The page of drawings, entitled "Portraits of the inditchenous beestes of New Olland" includes several kangaroos or "Boomers," noted as being "6 feet high," a Platypus, a porcupine, a Tasmanian Devil, a wombat, and a number of other wild and domestic animals (fig.89). Clearly Lear is having fun with the exotic nature of the island's indigenous fauna.[168] In his formal watercolor studies of these animals, he is far more reverential, ennobling many of the same creatures he spoofed in his drawing with portraits that compare favorably with any of his best birds. One of his watercolors of a Tasmanian Devil (*Sarcophilus harrisii*), painted in February 1834 (fig.90), is so close in posture and color-

to conclude that Lear had no interest in life Down Under, but the spectacularly beautiful

[97]

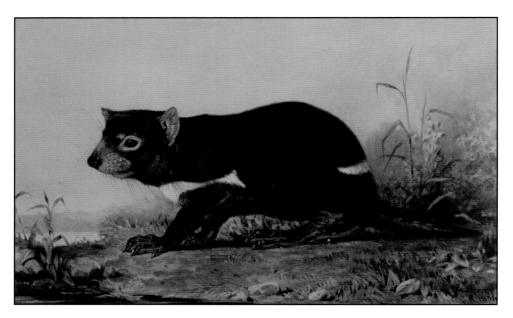

90. Tasmanian Devil (*Sarcophilus harrisii*), ink and watercolor over graphite, February 1834

ing to the one in his sketch, that they seem likely to have been made at the same time.[169]

Lear's most direct link with Australia came through his one-time employer, John Gould, who lived in Australia from 1838 to 1840 while gathering information and specimens for a seven-volume masterwork on the birds of that continent.[170] Lear was fascinated by Gould's ambitious immersion into field research on that remote continent, and perhaps a bit envious. He wrote Gould several long letters in which he asked about both the wild and human life there. In a missive dated October 17, 1839, he good-naturedly teased his humorless friend by asking him why he continued to "walk topsy-turvy so long – for everybody knows that the people in the Antipodes, being on the other side of the world, must necessarily have their heads where their heels should be." [171]

By the time Gould returned to England and was ready to commission the plates for his book, Lear had given up his scientific illustration in favor of landscape painting. He was living in Italy and was not available for new commissions. This did not prevent Gould from using two of Lear's already existing paintings in *The Birds of Australia* (1840-1848). The plates he selected were of a pair of cockatiels (*Nymphicus novae-hollandiae*), drawn by Lear more than a decade before for his parrot monograph from living specimens in a London aviary (fig.91), and a Spotted Cormorant (*Phalacrocorax punctatus*), which Lear based on two preserved specimens at the British Museum and the United Service Museum in London.[172]

When Gould published his three-volume work on the mammals of Australia (1845-1863), he was either unaware of Lear's earlier mammal paintings, or unable to access them. In any case, none of the 182 colored lithographs in that great work have any connection to Lear.

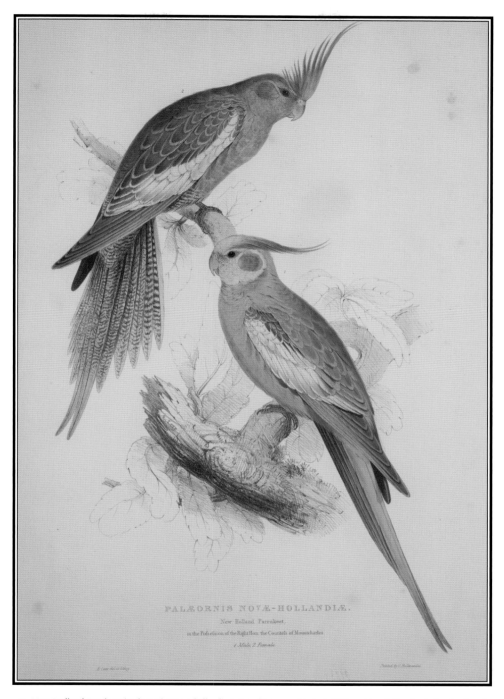

PALÆORNIS NOVÆ-HOLLANDIÆ.

New Holland Parrakeet.

in the Possession of the Right Hon. the Countess of Mountcharles

1 Male 2 Female

91. New Holland Parakeet (*Palaeornis novae-hollandiae*), now known as Cockatiel (*Nymphicus hollandicus*), hand-colored lithograph (plate 27) from Edward Lear's *Illustrations of the Family of Psittacidae, or Parrots* (1830-1832)

THE EARL AND THE PUSSYCAT:
LEAR'S ASSOCIATION WITH
LORD DERBY

92. Edward Lear's most important patron, the 13th Earl of
Derby, as he appeared in 1837 in an oil portrait by William
Derby. One of the rolls of paper at the Earl's side is inscribed
"Drawings, Nat. History by Edward Lear"

URING MOST OF THE 1830s, John Gould, Sir William Jardine, Thomas Bell, and others kept Lear extremely busy with their illustration commissions ("I am up to my neck in hurry and work from 5 a.m. till 7 p.m. without cessation," he wrote to a friend in 1833),[173] but Lear's single most significant patron was the thirteenth Earl of Derby (Lord Stanley prior to 1834). It was on his behalf, during six or seven years (ca. 1831–1837) of intermittent but intense activity at Knowsley Hall, the earl's estate near Liverpool, that Lear created many of the finest natural history paintings of his career. It was also during his frequent visits to Knowsley Hall that Lear created many of the endearing limericks and other illustrated nonsense verse for which he is so well known today.

The thirteenth Earl of Derby (fig.92) was

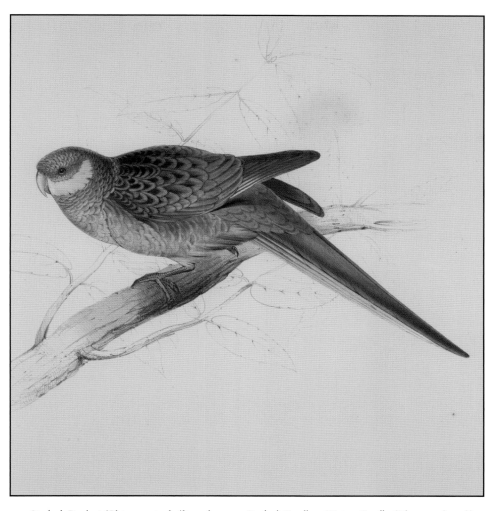

93. Stanley's Parakeet (*Platycercus stanleyii*) now known as Stanley's Rosella or Western Rosella, (*Platycercus icterotis*), hand-colored lithograph (plate 24) from Edward Lear's *Illustrations of the Family of Psittacidae, or Parrots* (1830-1832)

the most generous and influential patron of the natural sciences in Great Britain during the second third of the nineteenth century. As president of the Linnean Society (1828–1834) and of the Zoological Society of London (1831–1851), he was acutely aware of all that was going on in the scientific world. He had the interest and financial resources to establish a private menagerie and aviary that exceeded in size and importance that of the London Zoo and at the time of his death was described as "the most complete and important private zoological collection in the world."[174]

Despite their significantly different stations in life, a mutual interest in parrots is almost certainly what first brought the wealthy patron and the talented artist into contact with each other. To Lear's great delight and good fortune, Lord Stanley became one of

the earliest and most important patrons of *Illustrations of the Family of...Parrots*, lending his prestige and influence to Lear's efforts by allowing his name to be included in the roster of the book's subscribers.[175] Additional subscribers included an eclectic group of academics, amateur naturalists, and collectors. Some provided in-kind services in lieu of cash. Others provided financial backing. A few made their own live or mounted parrots available to Lear for inclusion in his book.[176]

Lord Derby's patronage was extremely important for Lear, not only because it helped to stabilize the artist's previously fragile economic condition and gave him the opportunity to secure and expand his reputation as a natural history painter, but also because it did much to boost his self-confidence as a painter and as a person. The earl's generosity as a patron and a friend eventually enabled Lear to move on to a life of travel and landscape painting outside of England.

The earliest surviving record of personal contact between Edward Lear and the thirteenth Earl of Derby (then Lord Stanley) was in February 1831, when Lear personally delivered part 4 of his monograph,[177] but their introduction may have occurred earlier.[178]

Whether or not the earl was in residence at the time, Lear appears to have made his first trip to Knowsley Hall in the summer of 1830, for there are at least two Lear parrot studies from Knowsley that are dated in July of that year.[179] Although Lear did not use these particular studies as the basis for plates in his parrot monograph, he did include two of Lord Stanley's birds among the "species hitherto unfigured" in his book: the Stanley Parakeet (now known as Stanley's Rosella or the Western Rosella, *Platycercus icterotis*) (fig.93), and the Red-capped Parakeet

(now known as the Red-capped Parrot, *Purpureicephalus spurius*). Seeing these birds in print may have inspired Lord Stanley to commission Lear to do more painting at Knowsley Hall, where his living collections of wildlife were already considered unrivaled for the number, rarity, and beauty of the species they contained.[180]

The Knowsley menagerie, which Lear came to know intimately, would eventually include several thousand specimens representing 619 different species of birds alone. Among these were 114 species of parrot, 52 species of game birds, 51 species of raptor, and 60 species of wildfowl.[181] The outdoor facilities in which the birds and animals were kept, and where

94. Stanley Crane (*Scops paradisea*, now *Anthropoides paradisea*), watercolor over graphite, 1835. This picture was later lithographed by J. W. Moore and used as plate 14 in *Gleanings of the Menagerie and Aviary at Knowsley Hall* (1846)

95. Indian Crying Thrush (now known as the Hwamei Laughing Thrush, *Garrulax canorus*) with other birds and pencil notes, watercolor over graphite

Lear spent so much of his time painting from life, eventually covered an area of 170 acres and required a staff of thirty to maintain. The living creatures were complemented by an extraordinarily comprehensive natural history library (much of which remains in the Hall today), and a collection of mounted and preserved birds and mammals which numbered almost 20,000 specimens by the time it was dispersed in 1851.[182]

Since it would have been impossible for Lear to paint everything in the collection, he was probably asked to create a visual record of the species (living and dead) that had been the most difficult to obtain or were considered the most important by Lord Derby and his aviary manager, John Thompson (ca. 1811–1859). Subjects such as the Stanley Crane, named in honor of its owner, were obvious choices (fig.94).[183] Others were less so, and had to be carefully selected from the many possible subjects in the earl's collection. For every finished painting he created for Lord Derby, many of which are still owned by the Derby family, Lear made one or more sheets of life studies. These he either discard-

ed or, more often, saved for his own future reference.

One such study, dated "Knowsley, June 24, 1835," reveals Lear's working methods.[184] It is a drawing of what Lear called *Garrulax linensis*, an Indian Crying Thrush (now known as a Hwamei Laughing Thrush, *Garrulax canorus*), a brown bird with a yellow bill, pink legs, and a blue-and-white eye patch surrounding a grey-green eye (fig.95). Lear has augmented a detailed rendering of this primary subject with marginal posture studies of other birds and notes to himself about how to capture the elusive colors of the living bird. At the top of the page he has written "this bird must be more graceful" and "make the head smaller." Elsewhere he has instructed himself to make the "eye greener," the tail area "brighter," the legs a "pale shiny flesh-horn colour," the throat "more olive-mottled," and the "plumes very silky." In his final version of the painting, still at Knowsley Hall, Lear has incorporated all of his own instructions, but has, of course, left out the many pencil and ink sketches that make the preliminary study such a revealing window

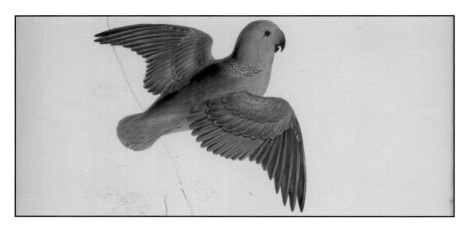

96. Collared Parakeet (*Psittacula torquata*) now known as Guaiabero (*Bolbopsittacus lunulatus*), hand-colored lithograph (plate 40) from Edward Lear's *Illustrations of the Family of Psittacidae, or Parrots* (1830-1832). The awkward head position suggests that Lear probably drew this from a dead specimen.

into the artist's working methods.

Lear's ability and self-confidence as an artist appear to have coalesced just as he issued the final plates for his monograph on parrots and received his first commissions from Lord Stanley. While many of his paintings from this period still remain unpublished, his *Blue and Yellow Macaw, Red and Yellow Macaw,* and *Greater Sulphur-crested Cockatoo,* plates 8, 7, and 3 in *Illustrations of the Family of... Parrots* (figs.2,50, 58), give dramatic evidence of his skill at capturing on paper both the appearance and character of living subjects. These lithographs, and the watercolors on which they are based, combine a thorough grasp of avian anatomy and feather structure with an evocative infusion of personality.[185] All were made possible by Lear's close and protracted contact with his living subjects. His paintings of just one year earlier seem stiff and lifeless by comparison (see, for example, his plate of a flying Collared Parakeet (*Psittacula torquata*), plate 40, (fig.96), or the Red-fronted Parakeet (*Psittacula rubrifrons*), plate 41 in *Illustrations of the Family of... Parrots*). They are adequate as diagnostic il-

lustrations and better than the work of most of his contemporaries, but a far cry from the masterful achievements of Lear's later plates.[186]

That Lear's artistic improvement as a natural history artist coincides with his first prolonged visits to Knowsley Hall may not be entirely coincidental, for the visibility and prestige of Lord Stanley's patronage, combined with the critical success of his *Illustrations of the Family of...Parrots,* must have given the young artist an enormous boost of self-confidence. Lord Stanley's invitation to Lear to visit Knowsley at this time was auspicious in another way as well. There was a serious outbreak of cholera in 1832 in a part of London that Lear regularly frequented. His prolonged visits to Lancashire, therefore, may have done more than change his life; they may have saved it as well.

Lord Stanley's commissions – and those received from Gould, Bell, Selby, Jardine, and others – gave Lear the first taste of financial security and independence he had ever known. The young artist, who, by his own account, had been "turned out into the world,

97. Knowsley Hall, near Liverpool, the principal seat of the Earls of Derby, where Lear spent extended periods of time during the 1830s

literally without a farthing – & with naught to look to for a living but his own exertions," was now being paid as much as three pounds per painting by Lord Stanley, for whom he was drawing "very frequently."[187] This was a time when Lord Stanley was willing to pay five pounds for a breeding pair of Golden Pheasants, ten guineas for a Snowy Owl sent live from Nova Scotia, and fifteen pounds for two guans "including the living specimen" from a London dealer.[188] During the same period, an annual income of £125 (less than three pounds per week) was considered respectable for a working family with children.[189]

Lear appreciated the opportunity to create paintings for Lord Stanley. Nevertheless, it took him some time to adjust to living and working at one of the grandest estates in England (fig.97). Despite the large number of people employed by the earl ("between 20 & 30 servants wait at dinner," Lear noted [190]) and the perpetual presence of his many house guests, relatives, and friends, Lear felt isolated and out of place in the long-established, but to Lear unfamiliar, social hierarchy that controlled life at Knowsley. "I think my stay

here will make me burst to have some fun," he wrote to a friend during one of his working visits to the estate. "Consider, I have no creature of my own grade of society to speak to."[191] Sometimes he made cartoons on the edges of his bird paintings and invented silly stories to entertain the children of the household or to relieve the tension he felt working in such an austere setting.

Although initially intimidated by the formality of life at Knowsley Hall, Lear was soon made to feel at home there, moving from the housekeeper's dining room to that of Lord Derby's family in 1835.[192] Following an extended visit in 1836, he recorded his change in feelings about life at the estate:

> I never remember passing so happy a
> consecutive 6 weeks as I did this year at
> Knowsley: the breaking up of the party
> was a regret to all – & knowing that I could
> not meet with better fun - or better friends
> elsewhere – I did not set out [on a long-
> anticipated sketching trip] with all the
> alacrity with which a tourist ought to begin
> his journey.[193]

As much as he enjoyed his time at Knowsley Hall and the financial security of Lord Derby's patronage, by 1836 Lear also felt a growing desire to move beyond the increasingly repetitive routine of delineating caged birds and mammals. Troubled by poor eyesight from an early age, he found the close work required for scientific illustration particularly taxing. He also found the cold, damp weather in London and Liverpool depressing and detrimental to his fragile health. He began to long for a warmer, sunnier climate and other subjects for his brush.

While honing his skills as a lithographer with Charles Hullmandel in London, Lear had met several artists whose extended painting trips to Europe and the Middle East had whetted his own appetite for travel and ignited a long-held ambition to become a landscape artist.[194] Although it was in Lord Derby's best interest to keep Lear in England working on natural history projects (both at the Zoological Society and at Knowsley Hall), he recognized Lear's need for personal and artistic growth. Ultimately, he and a number of his friends and relatives, including his nephew, Robert Hornby (1805–1857), would underwrite a two-year study trip to Italy for Lear (1837–1839). Before doing so, however, the earl helped Lear to explore a very different travel plan.

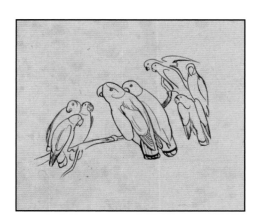

JOHN JAMES AUDUBON AND A HOPED-FOR VENTURE TO AMERICA

98. The American naturalist John James Audubon in an
engraving after an 1826 portrait by John Syme (1795–1861)

AMONG LORD DERBY'S wide range of associations in the natural history world was the American artist John James Audubon, with whom the earl had enjoyed a cordial relationship since 1826 when the artist had come to Liverpool to seek support for an ambitious publishing project (fig.98). Lord Stanley subscribed to Audubon's massive color-plate book, *The Birds of America*, the following year. Audubon, in return, arranged to procure specimens of American birds and mammals for the earl's aviary, menagerie, and museum in Lancashire.

Lear also knew Audubon and his family.[195] As fellow artists and habitués of the London Zoo, the two men's lives had intersected on a number of occasions. Audubon admired Lear's painting so much that he bought a copy of *Illustrations of the Family of...Par-*

rots, despite the high price of the book and his own severely limited financial situation.[196]

Whether it was Edward Lear or Lord Derby who first developed the idea that Lear might accompany Audubon on a natural history and painting expedition through the United States is not known, but in 1835 they jointly approached the American naturalist with such a proposal. Audubon, always eager to please his patrons, now found himself in an awkward situation. He wished to accommodate Lord Derby's request, but he did not want to have Lear's company imposed upon him for a working expedition. Audubon may have viewed "our young friend, Mr. Lear" as not only an encumbrance to his own travels, but also as a potential rival in the increasingly competitive market for ornithological illustration.[197] In a carefully worded letter to Lord

Derby, Audubon professed his "pleasure" at the idea of having Lear join him, but then went on to enumerate the difficulties such a journey would entail.[198] He warned of miles of travel by foot and by water, "scanty fair," much of it "procured by the gun or fishing line," and of "many nights [sleeping] on the ground."[199] He closed his letter by pointedly mentioning that "a young Englishman whom I took during my last voyage to the Floridas proved particularly inadequate to the task."[200]

Audubon had crafted his response with three objectives in mind. He wished, first, to reinforce his own reputation as the intrepid and indefatigable "American woodsman." He also wanted to assure Lord Derby of his continuing loyalty, but, in the end, he wished to splash enough cold water on the proposal to dampen Lear's interest in pursuing the idea further. He evidently was successful. While friendly relations continued among all parties concerned, none of the three men ever made mention of the idea again.

Audubon could not have played his hand better, for Lear's health, never robust, was now suffering from the cold and damp of the British climate. The very medical conditions that argued against his staying in England also argued against his accompanying Audubon on a rigorous trek through southeastern North America. Lear's doctor urged him to find a warm, dry climate in which to live and work. "I am strongly advised by the medical folk to go to a climate where less east wind &

cold may prevail than in this horrible one," he wrote in early 1837, "– to take precautions ere it be too late."[201] Rome, warm, sunny, and a thriving center for artistic studies, seemed the perfect choice. And so, with financial backing from Lord Derby, Robert Hornby, and "no less than 30 friends of very different families & connexions," Lear traveled to the Eternal City in the fall of 1837.[202] "I am going to put in practice a long nursed dream of studying for two years at Rome," he wrote a friend to explain his plan. "Tho great as may be the benefit I may derive as to my profession, my health both needs & may expect a greater."[203] Lear's relocation to Italy was an unqualified success. Although he professed homesickness for his family and friends in England (including those at Knowsley Hall), Lear was more than happy to escape the "profoundly horrible" climate of his homeland and the grueling demands of commissioned illustration.[204] In the liberating atmosphere of Italy, both his health and his skills at rendering landscapes improved together.

As he embarked on this new phase of his artistic career, Lear left behind an impressive list of scientific publications, and a large number of superb natural history paintings. Lord Derby alone owned more than one hundred of Lear's bird and mammal portraits. The earl would publish a selection of seventeen of these in a book entitled *Gleanings from the Menagerie and Aviary at Knowsley Hall* some nine years after Lear's departure (fig.99).

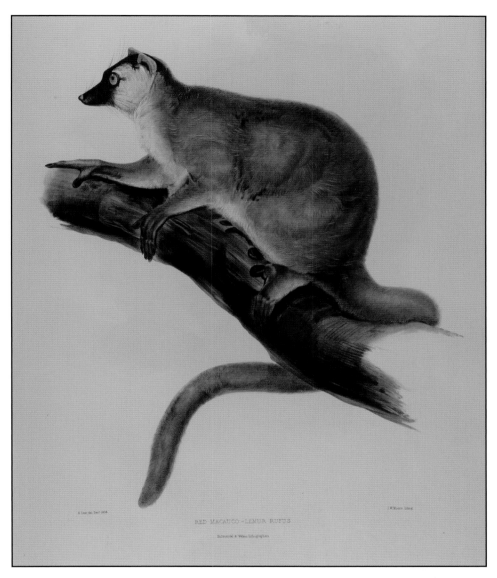

99. Red Macauco (*Lemur rufus*) now Red Lemur (*Eulemur rufus*), hand-colored lithograph after Lear (plate 3) from *Gleanings of the Menagerie and Aviary at Knowsley Hall* (1846). The original painting was made by Lear in December 1836. The lithograph is by J. W. Moore.

100. John Edward Gray by T. H. Maguire, lithograph 1851

UNLIKE THE PLATES FOR Lear's parrot monograph, which the artist created himself by drawing directly on lithographic stone, the plates for *Gleanings* were transcribed from Lear's original watercolors by another artist, J. W. Moore. Lear was by then out of the country and no longer interested in working on scientific publications. The selected illustrations were printed in sets of one hundred, each by the lithographic firm of Hullmandel & Walton, with whose principal, Charles Hullmandel, Lear had worked closely since the start of his life as an illustrator. Each plate was hand-colored by Gabriel Bayfield, the same colorist who had helped Lear with the plates for his parrot monograph. Thus, though it lacked Lear's personal supervision, *Gleanings* was very much a continuation – and in some ways a culmination – of his career as a natural history artist.

The "Whiskered Yarke," "Piping Guan," "Eyebrowed Rollulus," "Eyed Tyrse," and several of the other species depicted in this privately published folio boasted common names one might expect to find in the nonsense writings of Lewis Carroll or of Lear himself, but the meticulous accuracy of the plates and the detailed descriptions of each bird and mammal, written by John Edward Gray, leave no doubt that *Gleanings* was a serious scientific publication. Because a number of the species depicted and described were new to science, *Gleanings* has achieved a lasting place in the scientific literature.

Edward Gray (fig.100), who served as keeper of the zoological collections at the Natural History section of the British Muse-

um in London from 1824 to 1874, was among the most influential professional naturalists of his day.[205] Lear had known and worked with him since the beginning of his own career as a natural history painter. (Gray was the tardy author who had delayed the publication of *The Zoology of Captain Beechey's Voyage*, for which Lear had created his earliest commissioned illustrations.) In helping Lord Derby choose which of the many paintings in his collection would be best to include in the book, Gray was inclined to favor Lear, not only because he liked him personally, but also because he admired his painting and considered his work superior to that of any of the other artists who had been given comparable commissions by the earl. Originally, Lord Derby wanted to combine Lear's illustrations with those of Benjamin Waterhouse Hawkins (1807–1894), an experienced artist who had been hired to paint most of the larger animals in the menagerie and park.[206] Gray argued against this idea for fear that Lear's drawings were so good they "might make Hawkins' look worse than they really are if mixed together."[207] He advised instead that the artists' work be published "in two separate works of equal rank and appearance, one coming out a year after the other."[208] Lord Derby agreed.

The edition of *Gleanings* featuring Lear's work (seven mammals, nine birds, and one reptile) now ranks, along with Lear's *Parrots*, as one of the rarest and most desirable color-plate books of the nineteenth century. It was published in 1846, the same year as Lear's two-volume travel book, *Illustrated Excursions in Italy*, and *A Book of Nonsense*. The concurrent publication of these three very different books tangibly illustrates the disparate nature of Edward Lear's life. Because *Gleanings* was privately printed for Lord Derby, it was never available for public purchase. All of the surviving copies were given to their first owners by either Lord Derby or Edward Gray. [209]

Following the book's publication, John Gould wrote to Lord Derby to ask how he could obtain a copy. Whether to curry favor with his patron, or because he truly believed it, the taciturn naturalist was uncharacteristically effusive about Lear's illustrations in *Gleanings*. "You are aware, my Lordship, that I have ever been an admirer of Mr. Lear's drawings," he wrote, "but these are, in my opinion, far superior to anything previously published by him."[210] Impressed by Gould's enthusiasm for the book, Lord Derby sent him his last remaining copy of the volume, pleased that he could "thus oblige one, who has often obliged me."[211]

AN ARTIST IN MOTION:
LEAR AS A TRAVELER

101. Nile with Water Buffalos, oil on canvas, no date

AFTER a decade of relative stability, working on the details of feathers, fur, and vertebrate anatomy, Lear found the spontaneity of travel and landscape painting refreshingly liberating. "It is impossible to tell you *how* & *how enormously* I have enjoyed the whole autumn" he wrote John Gould after a two-month sketching trip through the Lake District of northern England in 1836.[212]

Lear was ideally suited to travel. A keen observer with an eye for detail, a lover of solitude and quiet, and a person with no familial responsibilities, he was at his most creative when traveling alone or with a close friend, immersing himself in new places and experiences. While his sister Ann was alive, he wrote her long letters describing what he saw.[213] He also wrote to his wide circle of friends and, less often, to the surviving members of his far-flung family. On all of his trips he captured with pencil and brush the visual delights of his experiences, recording with field sketches the subtle effects of changing light and perspective on the landscape. These he would hold, not just as tangible records of his travels, but as sources of inspiration for larger, more finished works in both watercolor and oil.

Because of his family's compromised financial condition, Lear did not have an opportunity to travel as a child or during his

adolescent years. His first trip to Europe was with John Gould in the early 1830s (probably 1831), during which the two men visited Holland, Switzerland, and Germany.[214] When Gould offered to cover his expenses on their trip, Lear jumped at the chance to "see so much of the world for nothing," but this was a strictly working trip for Lear, not a vacation.[215] Nor was it much of a pleasure, if his later memories of it are any indication. The trip was taken as part of a contractual agreement Lear had made with Gould when the older man purchased the unsold prints from his parrot monograph.

Lear must have taught himself to speak French or learned the language from one of his sisters, for it was that skill that caused Gould to invite him to Europe. There Gould wished to use him as an interpreter while he met with scientists and potential patrons. "Gould can't speak French – I can – & he also

wanted a companion," wrote Lear succinctly of the invitation.[216] Always a harsh taskmaster, Gould undoubtedly worked Lear hard on this trip, an experience Lear later looked back upon with regret as the occasion when he committed to work for Gould on illustrations for *The Birds of Europe*. "About 1830 I think, or earlier, perhaps 1828," he wrote in 1860, "I went with him [John Gould] to Rotterdam, Berne, Berlin and other places, – but it was not a satisfactory journey; – and at Amsterdam we laid the foundation of many subsequent years of misery to me."[217]

Traveling on his own, or with friends, and for the purpose of recording the landscape rather than specimens for Gould, was a far more pleasurable experience for Lear, who, by the late 1830s, was ready to begin a new chapter in his artistic career. He did not give up his interest in birds and mammals, but rather relegated these subjects to the role

102. Temple of Apollo at Bassae, oil on canvas, 1854

102. (inset) Detail of an Eastern Hermann's Tortoise (*Testudo hermanni boettgeri*) from Temple of Apollo

103a. Pencil study for The Pyramids Road, Gizah, Egypt, October 14, 1872

103b. The Pyramids Road, Gizah, oil on canvas, 1873

of supporting actors on a larger stage. His European, Mediterranean, Middle Eastern, and Indian landscape studies and finished works frequently include sheep, goats, and other domestic animals. Their picturesque clusters infuse his paintings with life and provide compositional details which help to differentiate his foregrounds from the middle-

grounds and distance. In a few paintings, such as *Nile with Water Buffalos* (fig.101), animals become the ostensible subjects of his work. In other paintings, such as *The Pyramids Road, Gizah*, they are essential components and narrative, providing motion and perspective to a painting that seems to celebrate travel. In at least one of his large oils, *The Temple of*

104. Abu Simbel, watercolor over graphite, February 9, 1867, 10:30 AM

105. Abu Simbel, watercolor over graphite, February 9 1867, 1 PM

Apollo of 1854 (fig.102), he inserts a detailed study of a tortoise in the foreground as an interesting counterpoint to the grandeur of the scene at large. Perhaps it is to reinforce the slow movement of time at this historic site. Perhaps it is a subtle reference to Lear's earlier life as a natural history painter. The Eastern Hermann's Tortoise (*Testudo hermanni boettgeri*) scrambling among the rocks at the very bottom of the painting could easily have crawled from a plate in Thomas Bell's monograph on turtles for which Lear had made the lithographs two decades before.[218] Perhaps it was intended to serve as a symbolic proxy for Lear himself as he slowly made his way from one historic site to another in pursuit of his life-long quest for interesting landscapes and the study of ancient civilizations.

As with his natural history paintings, it is the specificity of Lear's details that give his landscape paintings such immediacy. Despite his wish (and need) to earn an income by catering to travelers on the Grand Tour, Lear tried to avoid generic overviews of frequently depicted destinations. Instead, he chose less predictable subjects through which he could convey his own sense of discovery. He was a travel painter in the literal sense, capturing the excitement and mystery of the journey rather than his destinations. The feeling of motion conveyed by the forced perspective of a painting like *The Pyramids Road, Gizah* (figs.103a, b) gives that painting an evocative power that a traditional view of the pyramids

themselves could never achieve. Though they are visible at the right of the painting, it is the road, and the exotic travelers on it, that are the real subject of Lear's attention. "Nothing in all life is so amazingly interesting as this new road & avenue," he wrote in his diary on seeing the acacia-lined road, which had been built "literally all the way to the Pyramids" to commemorate the opening of the Suez Canal in 1869. "The effect of this causeway in the middle of wide waters is singular...there is much poetry in the scene, but it wants thought and arrangement."[219]

A series of watercolor studies made during his earlier, 1867 trip up the Nile record his travels to the historic site of Abu Simbel, but do not focus on the monument itself. Instead, employing an almost cinematographic approach to the subject, Lear sketched the giant carved figures and surrounding landscape from changing perspectives as he moved past it by boat on the adjacent river. He noted the exact time of each sketch, as if to reinforce that it was the experience of seeing the monument, more than its physical features, that interested him the most (figs.104,105). Begun by Rameses II in the thirteenth century B.C., Abu Simbel had been an appealing subject for Western artists since its first excavation in 1817. The acclaimed British landscape painter David Roberts (1796-1854) visited it in November, 1838 and spent three days there drawing at least four detailed views, including two interiors. While impressed by Abu Simbel itself ("The monument ... alone makes the trip to Nubia worthwhile," Roberts noted in his diary),[220] the well-travelled artist found the rest of Nubia dark and depressing.[221] "Thank God," he wrote on leaving the area, "our vessel's prow now faces north and civilization."[222] Lear, visiting the same area twenty-nine years later, was entranced by the "stern, uncompromising landscape" with its "dark ashy purple lines of hills, piles of granite rocks, fringes of palm, and ever and anon astonishing ruins of oldest temples: above all wonderful Abou Simbel, which took my breath away."[223] The differing reactions of the two artists is revealing. While Roberts saw Abu Simbel as an archaeological artifact to be recorded as part of his inventory of ancient sites, Lear saw it as a place to be experienced in the present, and enjoyed in the context of constantly changing perspectives, weather conditions, and light. For Roberts it was a picturesque subject 530 miles from Cairo that he needed to record as part of a publishing venture; for Lear it was a welcome example of historic continuity and the inseparable unity of culture and place.

Lear began his career as a landscape painter during walking and sketching trips through the English Lake District and to Ireland in 1835 and 1836, but he codified it with his move to Italy in 1837. In *Views in Rome and Its Environs*, published in 1841, the first of six travel books he would write and illustrate, Lear offered twenty-five lithographic plates of quiet, unexpected Italian landscapes. The lithographic plates were produced by Lear based on field studies he recorded over a period of several years as he immersed himself in the visual delights, sounds, smells and tastes of Rome. The book contains none of the traditional tourist views one might expect from a collection bearing such a title. Although he drew and painted St. Peter's Basilica many times while he was in Rome, it does not appear in this published work. The Roman Forum is not depicted either, though he wrote about his frequent visits to the site.[224] The Colosseum can be seen in one print, but it takes some searching to find it, for it is shrouded in shadows and seen from an unusual perspective

106. View of the Colosseum, lithograph from Lear's book *Views in Rome and its Environs* (1841)

107. "Chianina" oxen from Tuscany, lithograph from Lear's book *Views in Rome and its Environs* (1841)

from the grounds of a Jesuit monastery and associated convent (fig.106).[225] Instead of the well-known clichés of Roman scenery, Lear decided to offer unexpected glimpses of city landscapes. To these he added views of "the most amazing wildness & beauty" of the Roman Campagna."[226] He also traveled into the rich agricultural region of Tuscany, where he

108. Saint Peter's Basilica, Rome, graphite, 1842

admired the great white cattle working in the fields (fig.107), and to the nearby hill town of Tivoli, whose dramatic views and cascading waterfalls he found "the height of landscape perfection."[227] Lear considered the gardens of the Villa d'Este, visible in one of two views of Tivoli in his book, "a scene worth walking to Italy from England, if one could see nothing else."[228]

It is not that he didn't admire the more famous sites, it is just that he felt others could and had painted them better than he. His contribution, he believed, would come from his role as an outsider recording views of the less frequently explored parts of the city. When he chose to paint the Vatican, for example, he did so from a distance, from the gardens of the Villa Doria Pamphili on the Janiculum, from Monte Pincio (fig.108), or from the Campagna, not from St. Peter's Square.

When Lear wrote about Rome to his sister, he acknowledged disliking the tourists he encountered there ("I hate crowds and bustle").[229] Instead, he seemed to thrive on

his quieter, more solitary experiences, and on finding unexpected sights in the well-documented city. His delightfully excited description of a nighttime illumination of St. Peter's Basilica during Holy Week shows his fascination with light and his love of finding novelty in a time-worn place:

About dusk, men (400) are slung by ropes (!!!) all over the dome & colonnades of St. Peter's – where they put little paper lamps in regular places – till the evening grows darker- every line, column & window becomes gradually marked by dots of light! It has the exact appearance of a transparent church – with light seen through pricked holes. Imagine a dark sky & my ink dots [a reference to a small sketch in the letter] all light! – about 9 o'clock, by an astonishing series of signals, a whole fabric blazes with hundreds of torches; immense iron basins full of oil and shavings are suspended between the little lamps, & these all at once burst into light!

I can only compare it to a stupendous diamond crown in the dark night. It is the most beautiful thing in the world of its sort.[230]

When he could avoid the seasonal crush of foreign visitors, Lear responded to the beauty of Rome, describing it in a letter to his sister as "this most delectable of all delightful places."[231] Liberated from the constraints of Victorian England, he reveled in the sensual pleasures of the climate (he confessed "lizardish enjoyment" in basking in the sun near the Colosseum)[232] and in the freedom of being a bohemian artist:

At 8 I go to the café, where all the artists breakfast, and have 2 cups of coffee and 2 toasted rolls – for $6^1/^2$d. – and then I either see sights – make calls – draw out of doors – or, if wet, have models indoors till 4. Then most of the artists walk on the Pincian Mount (a beautiful garden overlooking all Rome, and from which such sunsets are seen!) and at 5 we dine very capitally at a Trattoria or eating house, immediately after which Sir W. Knighton and I walk to the Academy – whence after 2 hours we return home. This is my present routine, but there are such multitudes of things to see in Rome that one does not get settled in a hurry, and bye and bye I shall get more into the way of painting more at home, for I have 2 or 3 water coloured drawings ordered already, so I shall not starve.[233]

What a delightful contrast it must have been to the restrictive atmosphere of London, where he worked under the harsh and humorless control of the demanding John Gould. Even at Knowsley, he must always have been aware of the employer-employee relationship with his patron. That was a place where he sometimes longed to be among people from his own station in life. "I have no creature of my own grade of society to speak to," he confided to George Coombe two years before leaving for Italy.[234] In Rome, he was an equal among like-minded artists with whom he could share the pleasures of self-directed discovery.

During his first stay in the city, beginning in December 1837, Lear rented rooms in the well-established artists' colony near the Spanish Steps.[235] Monaldini's library, a combined lending library, publishing house, and bookstore located in the same part of the city, served as a gathering place and sort of social club for Lear and his fellow ex-patriots. It was there that he could receive parcels from England and catch up on the news from home. The nearby French Academy (founded in 1666 and headquartered in the Villa Medici since 1803) offered models and working space during inclement weather, while an informal British Academy provided a less structured atmosphere for exchanging ideas. The latter had been established in 1821 "for the purpose of studying from the living model, defraying the expenses by occasional subscriptions" among the participating artists. Additional support from the Royal Academy, the British Institution, and "several distinguished individuals" including George IV and later Queen Victoria, enabled the British Academy's managing committee to purchase "a few casts from the Antique" and "various works on art for the library," according to a contemporary account.[236] Interestingly, although Lear enjoyed seeing the great works of art of ancient Rome and the Renaissance, he made very few copies of these earlier creations, preferring instead to record the living

city with its intriguing narrow streets, atmospheric ruins, and colorfully costumed inhabitants. Unlike many of his fellow artists, who saw the city as a giant museum to be studied and recorded, Lear celebrated Rome and its surrounding countryside as he experienced it, always preferring to paint the present rather than the past. To his sister Ann he wrote glowingly of his walks in the Campagna where he sometimes encountered "foxes & hawks, tortoises & porcupines."[237]

Throughout Lear's stay in Rome, a steady stream of English visitors arrived in the city as part of the Grand Tour. Their presence was made known through correspondence and word of mouth, and later (after 1846) through a small publication called *The Roman Advertiser,* which was published "every Saturday evening by L Piale, Monaldini's Library, 79 Piazza di Spagna." It recorded which British citizens were in town and where they were staying. These wealthy travelers, some of whom Lear had met previously through Lord Derby and his circle, became Lear's patrons. They purchased his paintings to remind them of their trip, and sometimes hired him to provide artistic instruction for themselves and their children. Lear depended on this patronage, reporting it proudly to his sister, but after a while, he grew weary of the repetitive nature of their comments and queries, and even of their commissions, even though he knew these were necessary to support his life abroad.

He reveled in the warmer climate of Rome, especially in mid-winter when he would have been most uncomfortable at home. "My health… is better than I ever remember it," he wrote his sister in January 1838.[238] A pencil portrait of Lear in Rome by his Danish friend Wilhelm Marstrand (1810–1873) shows him as a pensive and serious person still absorbing the novelty of his new life abroad (fig.109). Over time, as his Italian improved and he grew more confident in his ability to navigate the poorly marked country roads on foot, he ventured farther and farther from the city, visiting the surprisingly little-explored Italian states and recording their appealing topography as few, if any, British artists had done before.

When he published his next book, *Illustrated Excursions in Italy* (1846), he included excerpts from his diary to provide his readers with the sort of running narrative he had previously shared only with his family and close friends through his letters. In his preface, Lear explained that his object was "the illustration of a part of Italy which, though nowise inferior in interest to those portions of that country so commonly visited, has hitherto attracted but little attention."[239] The approach was typical of Lear. Acutely aware of the long tradition of Italian landscape painting that preceded him, and believing himself incapable of competing with it, Lear positioned himself outside of the mainstream. He wanted to offer a book that would push the boundaries of tradition and celebrate the journey more than the destination. "The drawings with which the following pages [of travel narrative] are illustrated," he wrote, "are, I believe, the first hitherto given of a part of Central Italy as romantic as it is unfrequented."[240]

The two-volume work was well received. It stood out from the plethora of travel books then being published because of Lear's skill as an artist and his unusual perspective on what he considered worth noticing. A reviewer for *The Art Union Monthly Journal* enthused about Lear's "really poetical sketches" and noted that the book explored regions "very-rarely seen by tourists."[241] "This is a part of Italy that so few travellers visit, and of which

there are so few accessible accounts," commented the reviewer, "that those interested in this *terra incognita* cannot do better than consult Mr. Lear's book, who, in addition to his able lithographs of the *physique* of the country, dwells agreeably upon its *morale*, and also upon its *cuisine* – an important chapter in all histories."[242]

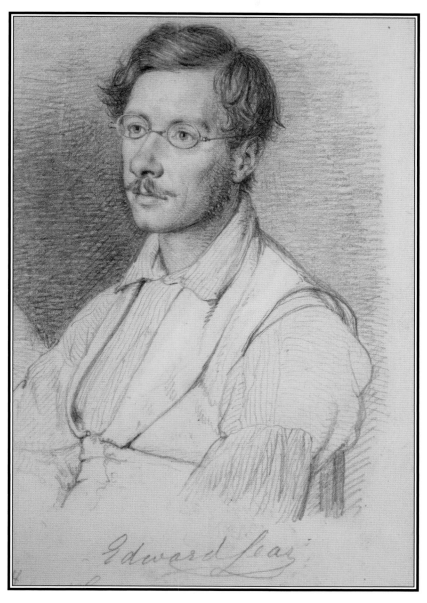

109. Edward Lear by Wilhelm Marstrand, graphite, 1840

INSTRUCTOR TO THE QUEEN

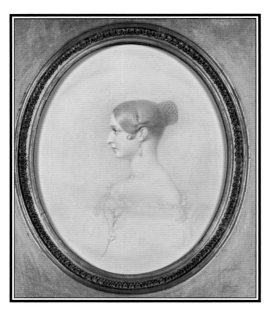

110. Queen Victoria by Richard James Lane (1800 -1872), graphite and watercolour, 1837

AMONG the many readers to respond favorably to Lear's book was the young Queen Victoria. (1819-1901). She was then twenty-seven years old, seven years younger than Lear (fig.110). In the summer of 1846, after just three years on the throne, and recently married to Prince Albert, the Queen invited Lear to visit the Royal family at Osborne House, her summer residence on the Isle of Wight. There she hoped Lear would be able to help her improve her skills in landscape painting. Lear gave her ten drawing lessons at Osborne House in July, and two more at Buckingham Palace in early August. On July 15th, 1846, she noted in her diary that "Mr. Lear ... sketched before me and teaches remarkably well, in landscape painting in water colours."[243] The next day she noted that she had "copied one of Mr. Lear's drawings and had my lesson downstairs with him."[244] On their third day together, the Queen recorded having had "another lesson with Mr. Lear, who much praised my 2nd copy. Later in the afternoon I went out and saw a beautiful sketch he has done of the new house."[245] On two of her watercolors she noted in pencil that they had been copied or partly copied from Lear. All of this suggests that, rather than having his students draw scenes for themselves, Lear demonstrated how to draw, and then had them copy from his finished work.[246] A comparison of paintings Lear made during the lessons with those made by the Queen (figs.111,112) shows that she possessed considerable talent as a draftsman, but not the

111. Osborne House by Edward Lear, watercolor over graphite, July 1846

112. Osborne House by Queen Victoria (after Lear), watercolor over graphite, July 1846

confidence or experience of her tutor.[247] The compositions she made under Lear's tutelage are generally stronger and more pleasingly balanced than those she created on her own. They convincingly demonstrate Lear's talent as an instructor.

Many artists would have exploited such royal attention, but Lear modestly downplayed it. When he received an engraving of one of his pictures as a gift from the Queen the following winter, he wrote excitedly to tell Ann about the gift, but cautioned her not to tell anyone else. "I am really quite pleased with my little engraving," he wrote, "and shall have it placed in a good frame as soon as I can get one made; – you need not, however, tell the incident to everybody; – for it would look like boasting upon my part, who have done little enough to deserve so gratifying a notice."[248]

TRAVELING FARTHER AFIELD

113. Richard Burton, ink and watercolor over graphite, December 1853

INSTEAD OF SETTLING BACK in England to capitalize on his new relationship with the Queen and growing reputation, enhanced by the publication of three books in 1846,[249] Lear returned to Italy in the fall and began to travel farther and farther afield from Rome. An increasingly turbulent political atmosphere in Italy encouraged him to move on to other areas, ultimately visiting – and painting in – Sicily, southern Calabria, the Kingdom of Naples, Malta, Corfu, the Ionian Islands, Greece, Thebes, Constantinople,

Albania, Egypt, Palestine, Sinai, and Mount Olympus, before returning to England in 1849.

Although Lear was an adventurous traveler, sometimes enduring both hardship and danger, he cannot be described as an explorer. The areas he visited, while often off the beaten path, had already been visited by others. Nor did he ever "go native," as some of his fellow countrymen did. Richard Burton (1821-1890), whose total immersion in and explicit writings about local customs in

the Middle East and India so scandalized his fellow Victorians, intrigued Lear, but it is unclear just what he thought of him. Lear made both a drawing and a watercolor portrait of Burton in 1853 (fig.113), based on a portrait by the Pre-Raphaelite artist Thomas Seddon (1821-1856), whom Lear met in Cairo while Seddon was working on the portrait. Lear also noted reading Burton's ground-breaking book *Personal Narrative of a Pilgrimage to El-Medinah and Meccah* (1855-1856), but there is no evidence that he ever met the mystic-traveler in person.[250] Nor did he emulate his controversial, experiential lifestyle, at least as far as he was willing to admit.

Lear was never an active member of the circle of British artists whose works focused on the Middle East, but he was familiar with many of its members. David Roberts, whose beautiful paintings and prints of Egypt and the Holy Land earned him the critical, pop-ular, and financial success that Lear could only dream about, was someone whom Lear almost certainly met, at least casually, while in London, for both artists knew and worked closely with the lithographer Charles Hull-mandel. Lear owned Roberts's six-volume work on Palestine and Egypt, ultimately sending it as a gift to his friend Arnold Congreve.[251] Through Holman Hunt, Lear also came to know and admire John Frederick Lewis (1804-1876).[252] "There never have been, & there never will be, any works depicting Oriental life — more truly beautiful & excellent," he wrote Lewis's wife when learning of the artist's final illness. "For beside the exquisite & conscientious workmanship, the subjects painted by J.F. Lewis were perfect as representations of real scenes & people," wrote Lear. "In my later visits to England ... I cared to go to the R[oyal] A[cademy] chiefly on account of his pictures."[253]

EXOTIC DRESS

There was an old man of Dee-side
Whose hat was exceedingly wide,
But he said, " Do not fail, if it happen to hail,
To come under my hat at Dee-side!"

114. Man from Dee-side with wide-brimmed hat, wood engraving from Lear's
More Nonsense, Pictures, Rhymes, Botany, Etc. (1872)

LTHOUGH HE LOVED TO COLLECT and paint the exotic clothes of local people wherever he traveled, and sometimes used them to conceal his lack of proficiency at painting the human form, Lear appears rarely to have adopted such clothing for his own use, and then only when he could not obtain clothing more to his custom and taste. He also did so when it was necessary for his own protection, as in parts of Albania, where he "was obliged to take to wearing the Fez or red cap – by means of which one may pass along the streets unnoticed; while a [Western-style] hat is a signal for stones & sticks."[254] Otherwise, he generally adhered to British taste and style when traveling. In his *Journal of a Landscape Painter in Albania* (1851), he advised fellow travelers to carry "as little dress as possible, though you must have two sets of outer clothing – one for visiting consuls, pashas and dignitaries, the other for rough, everyday work."[255] He occasionally bought local garments when his own wore out or became unusable, but never adopted them for the sake of appearing to be part of the indigenous culture.[256] Sometimes his unusual combination of British styles and local supplies created a look all his own. When the artist Thomas Seddon met Lear in Cairo in 1853, he noted Lear's distinctive appearance:

> He wears a straw hat, with a brim as large as a cart-wheel, with a white calico cover. He was called up the Nile *Abou lel enema el abiad seidy soufra*, which being interpreted means, the father with the white turban like a table.[257]

Seddon's description sounds very much like Lear's comical drawings of the Quangle Wangle hat which he first drew in 1865 and published in an illustration for his "History of the Lake Pipple-Popple" in *Nonsense, Songs, Stories, Botany, and Alphabets* in 1870. Lear drew a man with a similar wide-brimmed hat in *More Nonsense, Pictures, Rhymes, Botany, Etc.* in 1872 (fig.114).

THE DANGERS OF TRAVEL

LTHOUGH LEAR TRIED to assure his sister that he was never in serious danger when traveling in out-of-the-way places, this was not always the case. One day when sketching in Albania "hundreds" of angry residents surrounded him shouting "*shaitan! shaitan!* [devil! devil!]."[258] He later recounted the incident in gripping detail in his *Journals of a Landscape Painter in Albania*:

No sooner had I settled to draw than forth came the population of Elbassan, one by one, and two by two, to a mighty host they grew, and there were soon from eighty to a hundred spectators collected, with earnest curiosity in every look; and when I had sketched such of the principal buildings as they could recognize, a universal shout of "Shaitan!" burst from the crowd; and strange to relate, the greater part of the mob put their fingers into their mouths and whistled furiously, after the manner of butcher-boys in England. Whether this was a sort of spell against my magic I do not know... [Later] one of those tiresome Dervishes – in whom, with their green turbans, Elbassan is rich – soon came up, and yelled 'Shaitan scroo! Shaitan!' ('The Devil draws! The Devil!') in my ears with all his force; seizing my [sketch] book also, with an awful frown, shutting it, and pointing to the sky, as intimating that heaven would not allow such impiety. It was in vain after this to attempt more; the 'Shaitan' cry was raised in one wild

chorus – and I took the consequences of having laid by my fez, for comfort's sake, in the shape of a horrible shower of stones, which pursued me to the covered streets...[259]

Such local hostility toward foreigners of an artistic bent forced Lear to hire a policeman with a whip to provide him protection and allow him to continue his work. "It is not possible in the towns to draw without him," he observed.[260]

In Petra, Lear's difficulties derived from issues more mercenary than religious. There he was held captive by bandits. "Above 200 of them came down on me, & everything wh[ich] could be divided they took," he

115. Camel study, ink and watercolor over graphite, Suez, January 17, 1849

116a. Camel study, graphite and ink, January 20, 1849, 7 AM

116b. Camel study, graphite and ink, January 20, 1849, 8 AM

wrote one of his English patrons. "My watch they returned to me – but all money, handkerchiefs, knives, &c &c were confiscated."[261] Under the circumstances, Lear was fortunate to have escaped with his life.

Elsewhere he describes flea- and bedbug-infested hotels, poor food, exhausting traveling conditions, and other hardships and difficulties, including concern for his safety that he was rarely willing to admit to his sister. "Many places can only be visited at risk of robbery," he acknowledged to a friend when in Syria in 1858.[262] For the most part, however, he enjoyed traveling. "The walking – sketching – exploring – novelty perceiving & beauty appreciating part of the Landscape painter's life is undoubtedly to be envied," he wrote Emily Tennyson in 1865.[263] His goal, he confided in the wife of Britain's Poet Laureate and his close friend of many years, was "to leave behind me correct representations of many scenes little cared for or studied by most painters."[264]

Although Lear had long since moved away from his work with natural history by the time he started traveling the world to record such scenes, all of his paintings are informed and enriched by his deep sensitivity to the natural environment. The particulars of vegetation and habitat are evident in the thousands of field studies he made during his far-flung travels. Occasionally he drew upon his past experience as a wildlife painter to capture the details of the animals that enlivened his landscapes. Camels, for example, seemed to capture Lear's fancy when traveling in the Middle East (1853-1854 and 1866-1867). He made numerous studies of their ungainly postures and curious, human-like facial expressions (figs.115,116 a,b). In his view of Mount Sinai (begun in 1849 and finished in 1869) it is his composition of camels and their riders that gives the painting its interest and strength (fig.117).

Late in his life when he was traveling in India (1873-1875) elephants caught Lear's attention in a similar way. Although there was a living example of the species at Cross's Me-

117. Mount Sinai, watercolor, 1849 (completed in 1869)

nagerie until 1826 and at the London Zoo beginning in 1831, neither attracted his brush.[265] At the time, his sympathies and commercial interests were directed to smaller subjects. When he first saw an elephant working with its human handlers in Jubbulpore, he mistook it as part of the local geography, later describing its granite-gray body as looking like "a live Boulder."[266] His perceptions of these massive animals soon changed, however. Witnessing them in action, Lear came to appreciate their agility, intelligence, and strength over their size. In his many on-site studies of the animals, he emphasized their lightness and grace (fig.118).[267] As with his studies of camels, Lear celebrated working elephants as part of the living environment, not static specimens removed from their daily context. In this respect, they relate more closely to the imaginary birds that perched in the wholly invented landscapes of his youth than to the more accurate but decontextualized portraits of birds and mammals he made in the London Zoo and at Knowsley Hall in the 1830s.

118. Elephants bathing, Lucknow, India, watercolor and sepia ink over graphite, December 8, 1873

[130]

SPOOFING SCIENCE FROM THE SIDELINES: LEAR'S NONSENSE BOTANY

119. Landscape study, Reggio, July 26, 1847, ink over graphite

ALTHOUGH HE WOULD never return to the life of a scientific illustrator, Edward Lear's early focus on natural history and the rigorous observation of scientific subjects that his professional commissions required left a lasting influence on the way he viewed the world. In the same way he featured domestic animals in his later landscapes, he often used botanically recognizable plants to embellish and give specificity to works that were primarily topographical in nature (fig.119).

In his nonsense verse and alphabets he took delight in spoofing the seriousness with which his scientific colleagues categorized organisms. This often involved providing pun-filled, pseudoscientific names for the creatures that he invented to populate his imaginary world. [268]

The subset of Lear's nonsense that applies to botany provides the best example of his fondness of blurring the line between the real world of botanical taxonomy and his own fictional world of visual and verbal fun. Along with some other nonsense songs, stories, and alphabets, in 1871 Lear published twenty ink drawings in a work he called *Flora Nonsensica*.[269] Each drawing in the group shows a cluster of everyday objects — books, brushes, tea kettles, guitars, watches, etc. — creatively transformed into flowers and given mock serious names that Lear

Cockatooka Superba

120. Cockatooka Superba, ink

121. Manypeeplia Upsidownia, ink

The Biscuit Tree.

This remarkable vegetable production has never yet been described or delineated. As it never grows near rivers, nor near the sea, nor near mountains or vallies, or houses, — its native place is wholly uncertain. When the flowers fall off, and the tree breaks out in biscuits, and the effect is by no means disagreeable, especially to the hungry. — If the Biscuits grow in pairs, they do not grow single, and if they ever fall off, they cannot be said to remain on. —

122. Biscuit Tree, ink

hoped would amuse his readers. Among these, the *Cockatooka superba* (fig.120), a crested cockatoo emerging as a flower between two narcissus-like leaves, seems to grow right from plate 4 in Lear's parrot monograph, while his often-reproduced *Manypeeplia Upsidownia* illustration looks as though he has hung on a clothesline some of the people who either amused him or tried his patience through the years (fig.121). All of the whimsical botanical specimens in this set of drawings bear the same sorts of genus and species names that real plants have been

given since the system of binomial nomenclature was established by Carl Linnaeus (1707–1778) in the 1730s. As an associate member of the Linnean Society of London from 1831 to 1862, Lear knew full well the importance that was attached to the scientific names of plants and seemed to enjoy poking fun at it.

An undated, illustrated manuscript in the Houghton Library contains another of Lear's satirical jabs at the seriousness with which scientists take their subjects (fig.122). Beneath a quick sketch of an imaginary "Bis-

123. Caucasian Comfrey, or Beinwell (*Symphytum caucasicum*), ink and watercolor over graphite, circa 1829

cuit Tree," Lear has written: "This remarkable vegetable production has never yet been described or delineated." The humor was, at least in part, self-targeted, for Lear himself had once trumpeted his own illustrations of parrots as having been "hitherto unfigured" and therefore worthy of note. As he continued his description of the "Biscuit Tree," he may have been thinking of John Gould or one of his other humorless colleagues who reveled in the rarity of the newly discovered plants, birds and animals they described in their scientific publications:

As it never grows near rivers, nor near the sea, nor near mountains or vallies, or houses, – its native place is wholly uncertain. When the flowers fall off, and the tree breaks out in biscuits, the effect is by no means disagreeable, especially to the hungry. – If the Biscuits grow in pairs, they do not grow single, and if they ever fall off, they cannot be said to remain on.[270]

And yet, for all of his humor, Lear was also capable of taking his botanical studies as seriously as he had his ornithological ones.

[135]

LEAR'S BOTANY:
THE SERIOUS SIDE

124. Study of oranges, ink and watercolor over graphite, April 3, 1863

HIS EARLIEST BOTANICAL paintings, which date from the late 1820s, are as good as any botanical illustration of the era (fig.123 and see also figs.16, 17).[271] But while he was able to observe wild and domesticated plants growing in England, he was sometimes frustrated by his limited access to more exotic botanical subjects with which to embellish his non-native bird and mammal paintings. For these, he sometimes requested the help of others. In acknowledging the receipt of some flowers from Charles Empson in 1831 (whether pressed specimens or drawings we do not know), he went on to solicit additional botanical material from his correspondent: "If you have any more sketches of S[outh] American trees – (correct,) they would be invaluable for me– for I often want them to put birds on when I draw for Lord Stanley – which is very frequently."[272] This letter suggests that the lack of detailed backgrounds in many of his natural history paintings can be attributed to Lear's lack of adequate reference material and reliable information about the native habitats of his subjects, rather than a lack of interest in botany.

If anything, his fondness for botanical subjects seems to have grown over time. "When I go to heaven 'if indeed I go' – and am surrounded by thousands of polite angels," he wrote in 1862, "I shall say courteously – 'please leave me alone! … Let me have a park and a beautiful view of sea and hill, mountain and river, valley and plain, – with no end of tropical foliage.'"[273]

While some beautiful botanical studies survive from his time in Italy and his trav-

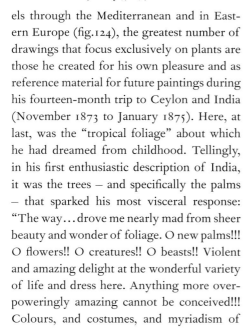

125. Study of Arcea palms, ink and watercolor, Calcutta, India, January 7, 1874

126. Study of palms, ink and watercolor, India, February 3, 1874

els through the Mediterranean and in Eastern Europe (fig.124), the greatest number of drawings that focus exclusively on plants are those he created for his own pleasure and as reference material for future paintings during his fourteen-month trip to Ceylon and India (November 1873 to January 1875). Here, at last, was the "tropical foliage" about which he had dreamed from childhood. Tellingly, in his first enthusiastic description of India, it was the trees – and specifically the palms – that sparked his most visceral response: "The way…drove me nearly mad from sheer beauty and wonder of foliage. O new palms!!! O flowers!! O creatures!! O beasts!! Violent and amazing delight at the wonderful variety of life and dress here. Anything more overpoweringly amazing cannot be conceived!!! Colours, and costumes, and myriadism of

impossible picturesqueness!!! These hours are worth what you will."[274]

A series of palm studies made in Calcutta a few months later (figs.125, 126) shows how Lear could blend his scientifically accurate approach to the subject with a loose handling of color and form. His palm paintings are at once precise and evocative; analytical and expressive. Even in their unfinished form, one senses that these watercolors are as much about light and air and movement as they are about the structural forms of the palm species recorded. While very different in style from his childhood flower studies or his parrot paintings of the 1830s, they capture much of the same feeling of individuality and personality as those early watercolors. This is the work of an artist with forty years of experience behind him, and working for himself

and not for a scientifically exacting patron, but they still convey the love of nature and attention to the essential elements of form.

In June 1878 Lear wrote to Sir Joseph Hooker (1817–1911), director of the Royal Botanic Gardens at Kew, to ask for his help in identifying ten Indian trees that he was drawing for one of his British patrons.[275] Six months later Lear made a similar request of Hooker in conjunction with a second set of tree drawings he was then making for his friend Lord Northbrook. While Lear's decision to use proper botanical names to identify these tree studies may reflect a request from his patrons, his many years of correspondence with Hooker demonstrate the value he placed in using proper scientific language when conversing on horticultural matters. Whether describing the subjects on his easel or the blooms in his flower beds at his home at the Villa Emily in Italy, Lear discussed plants with England's leading botanist toward the end of his life with the same ease that he had shown discussing birds with England's leading ornithologists at its beginning.[276] From the start to the close of his artistic career, Lear's paintings became looser, but no less rigorous in their accuracy.

Cabbidge Palm.
IE. June 19. 1876

CONCLUSION

PART I

MUCH OF THE appeal of Lear's watercolors – from the detailed paintings he made of parrots while in his late teens to the more impressionistic renderings of plants and landscapes he made later in life – lies in the sure and seemingly effortless way in which he applied pigment to paper. Despite the appearance of ease conveyed in his paintings, the process of painting was always a struggle for him. It was also an all-consuming passion. At the time of his death in San Remo, Italy, in 1888, Lear left behind more than 7,000 watercolors of his travels in Europe, the Greek isles, the Middle East, and India; about 2,000 studio watercolors; more than 300 oil paintings; almost 400 natural history paintings, five illustrated travel books, two books of natural history illustration, and more than 100 other published lithographs documenting birds, mammals, and reptiles from various parts of the world.[277] "Strange," he mused, "that what to me is always painful and disagreeable work, painting, should in a couple of months, create a work which not only gives pleasure to its possessor at present, but may continue to do so to hundreds of others for a century or more."[278] With his popularity only growing over time, it is clear that Edward Lear's "disagreeable work" will continue to give pleasure and inspiration well beyond the time he imagined.

PART II

TIMELESS STORIES FOR ALL AGES: LEAR'S IMPACT ON CHILDREN'S BOOKS

Lear showing a doubting stranger his name in his hat to prove that Edward Lear was a man and not merely a name.

Drawn by Himself.

1. Edward Lear's self portrait with his self-identifying hat, wood engraving from Lear's *More Nonsense, Pictures, Rhymes, Botany, Etc.* (1872)

ALTHOUGH Edward Lear initially deflected his responsibility for creating his famous nonsense poems and stories by using the pseudonym "old Derry-down-Derry," one of the fools in a traditional mummer's play, by the time the third edition of his *Book of Nonsense* was published in 1861, he was willing to acknowledge its authorship. As the book gained wider and wider attention (and as his reputation as a painter declined), he grew prouder of its success and resentful of the erroneous attribution of its creation to others. In the introduction to *More Nonsense, Pictures, Rhymes, Botany, Etc.* in 1872, he explicitly refuted the rumors that the book had been written by Lord Derby or Lord Brougham or written and illustrated by anyone other than himself. "Every one of the Rhymes was composed by myself and every one of the Illustrations drawn by my own hand at the time the verses were made," he assured his readers in an introduction.[1]

The most revealing anecdote about Lear's willingness to claim credit for the nonsense he wrote and illustrated is one that Lear himself told in a letter to his longtime friend and patron Lady Waldegrave. Illustrating the event with a self-portrait (fig.1), Lear described the incident as follows:

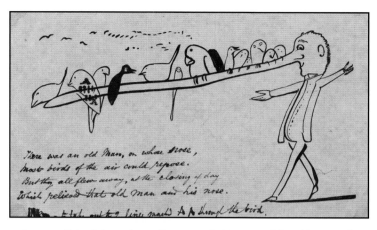

There was an old Man, on whose nose,
most birds of the air could repose.
But they all flew away, at the closing of day
Which pelieved that old Man and his nose.

2. Cartoon with Lear's instructions to his engraver for his picture of "an Old Man on whose nose, most birds of the air could repose," ink. The illustration, incorporating Lear's changes, was published in *A Book of Nonsense* in 1846, and in many later collections of nonsense

A few days ago in a railway as I went to my sister's a gentleman explained to two ladies (whose children had my "Book of Nonsense,") that thousands of families were grateful to the author (which in silence I agreed to) who was not generally known – but was really Lord Derby: and now came a showing forth, which cleared up at once to my mind why that statement has already appeared in several papers. Edward Earl of Derby (said the Gentleman) did not choose to publish the book openly, but dedicated it as you see to his relations, and now if you will transpose the letters LEAR you will read simply EDWARD EARL. – Says I, joining spontaneous in the conversations – "That is quite a mistake: I have reason to know that Edward Lear the painter and author wrote and illustrated the whole book." "And I," says the Gentleman, says he – "have good reason to know Sir, that you are wholly mistaken. *There is no such a person as Edward Lear*." "But," says I, there is – and I am the man – and I wrote the book!" Whereon all the party burst out laughing and evidently thought me mad or telling fibs. So I took off my hat and showed it all around, with Edward Lear and the address in large letters – also one of my cards, and a marked handkerchief: on which amazement devoured those benighted individuals and I left them to gnash their teeth in trouble and tumult."[2]

All of Lear's nonsense drawings are loose and childlike in style and appear to have been dashed off spontaneously, but this was not the case. They were, in fact, prepared by Lear with exacting care. Many were copied by him multiple times with only very slight variations, confirming his certainty over how he wanted them to appear in print. The plates for some of the early editions of his nonsense books were created as lithographs, but when he added more limericks, songs, and verses to his offerings, he had his illustrations "carefully reproduced in woodcuts by Messrs. Dalzell."[3] Lear's attention to detail in instructing the wood engravers he employed can be seen in his annotations on his original drawings (fig.2).

3. "And hand in hand, on the edge of the sand, they danced by the light of the moon…" from *The Owl and Pussy Cat* illustrated by Leonard Leslie Brooke, 1910

Because he saw his nonsense writing and illustration as inseparably interwoven, Lear would have been surprised, and undoubtedly distressed, that his publisher, Frederick Warne & Co. (formerly Rutledge and Warne), decided to hire another artist, Leonard Leslie Brooke (1862-1940), to re-illustrate some of them in 1910 (fig.3).[4] This new visualization was necessary, the publisher explained, "to create a further interest in verses, which for so many years have given unwonted pleasure to thousands of readers."[5] Frederick Warne was not the first publisher – or the last – to issue Lear's nonsense writing without his own illustrations. Even while Lear was alive, such books appeared on the market. In 1872, Cundall and Company (London) offered *The Owl and the Pussycat and Other Nonsense Songs* with illustrations by Lord Ralph Kerr (1837–1916).[6] There is no record of Lear's reaction to this publication, or whether he was even aware of it.

In the ensuing years, a wide range of artists, from Beatrix Potter to Edward Gorey to Jan Brett, have reinterpreted Edward Lear's verse with their own interpretations of his characters. In 1968 the well-known children's book writer, illustrator, and Caldecott Medal winner Maurice Sendak (1928–2012) paid tribute to Lear by placing a copy of A Book of Nonsense in the hands of one of the characters from his own iconic creation, *Where the Wild Things Are*.[7]

BEATRIX POTTER (1866-1943) was four-and-a-half years old when she was given a copy of Lear's *Nonsense Songs* as a Christmas present by her father. She fell in love with both the stories and their illustrations. She particularly enjoyed "The Owl and the Pussycat," as evidenced by the number of times she referenced it in her later correspondence with family friends. She sent a transcription of the poem to Eric Moore, along with her own illustrative drawing of the story, on March 28, 1894.[8] Eric was the younger brother of Noel Moore, the son of her former governess, to whom Potter had written

a letter just six months before in which she had created her immortal character, Peter Rabbit. Three years later, in her continuing correspondence with Noel, she again focused on "The Owl and the Pussycat," this time repeating some of the poem and offering her imagined sequel to the story. In two letters, less than a week apart, Potter provided her own drawings of the unlikely avian and feline couple "sailing away for a year and a day to the land where the bong tree grows" and then enjoying time together fishing and eating honey in their "beautiful pea green boat." "It is funny to see a bird with hands,"

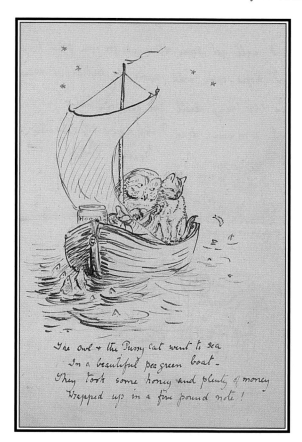

4. "The Owl and the Pussy Cat went to Sea" as portrayed by Beatrix Potter in a letter to
Noel Moore, ink, June 14, 1897

They sailed away
for a year and a day,
To the Land where the
Bong Tree grows

5. "They sailed away for a year and a day." The Owl and Pussy Cat as portrayed by Beatrix Potter in a letter to Noel Moore, ink, February 27, 1897

she wrote, "but how could he play the guitar without them?"[9] In all, Potter created at least seven different drawings of the owl and the pussycat, showing her fascination with the poem and its characters (figs.4,5).[10] At one point she tried her hand at limerick writing, but decided it was not her forte.[11] When Frederick Warne invited her to create illustrations for other writers' work, possibly thinking of Edward Lear, Potter declined for reasons of time, not because she couldn't imagine doing it. In fact she already had.[12] "With regard to illustrating other people's books," she wrote, "I have a strong feeling that every outside book which I did, would prevent me from finishing one of my own. . . . [Instead,] I will stick to doing as many as I can of my own books."[13] In one of the last of those books, *The Tale of Little Pig Robinson* (1930), she appropriated Edward Lear's pig with the ring at the end of its nose from "The Owl and the Pussycat" and inserted it into her own story.[14] Thus two of the great children's writers and illustrators of all time are inseparably linked.

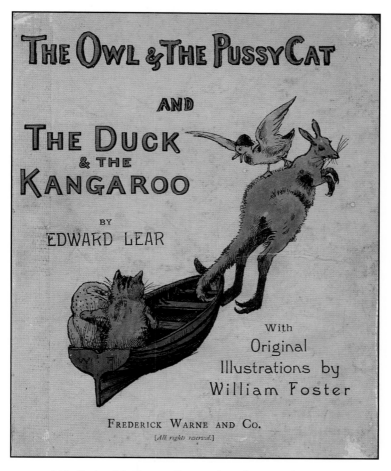

6. The Duck and the Kangaroo illustration by William Foster for *Nonsense Drolleries* based on Edward Lear's nonsense poems, 1889

Other artists were not so reluctant to apply their own interpretations of Lear's poetry. In the many years since his first book of nonsense was published in 1846, scores of editions of his collected works, as well as some of his individual poems, have been published with other artists' illustrations. An exhibition organized in Britain in 1988 to commemorate the 100th anniversary of Lear's death included more than twenty books written by Edward Lear but illustrated by other artists, including Paul Galdone, Janina Domanska, Owen Wood, Margaret Lock, Helen Oxenbury, Jenny Thorne, Lorinda Bryan Cauley, Joseph Low, John Vernon Lord, Dale Maxley, and a number of anonymous hands.[15] Although not represented in the exhibition, illustrators Judith Gwyn Brown, Nancy Ekholm Burkert, William Foster, Hilary Knight, Michele Lemieux, Barry Moser, Tomi Ungerer, and two-time Caldecott medalist Barbara Cooney have also created their own visual interpretations of Lear's nonsense stories and poetry (figs.6, 7, 8).[16]

7. "They sailed away for a year and a day" from *The Owl and the Pussy Cat* by Barbara Cooney, 1969

8. The Owl and the Pussy Cat by Barry Moser, wood engraving, 1985

EDWARD GOREY (1925–2000), featured in the 1988 exhibition, was among the best-known twentieth-century artists to pay homage to Lear with illustrations of his own. Gorey illustrated both *The Jumblies* (1968), and *The Dong with the Luminous Nose* (1969) (figs.9,10).[17] Gorey's thin line drawing style, while similar to Lear's in some ways, is more tightly strung. His famously dark humor suggests a slightly sinister interpretation of Lear's ambiguous stories. Gorey shared certain characteristics with Lear. An only child (Lear was raised as one), Gorey lived alone for much of his life. He loved cats and had a quick wit, a superb sense of design, and an irrepressible sense of humor. He dedicated one of his books to Lear's cat Foss, and even tried his hand at Lear's favorite literary form, the limerick:

There was a young lady named Mae
Who smoked without stopping all day;
 As pack followed pack,
 Her lungs first turned black,
And eventually rotted away.[18]

Gorey frequently mentioned Lewis Carroll and Edward Lear as two of the figures who had had the greatest influence on his work. "I'm an extravagant admirer of both of them and I'd love to be able to do things like they do, but I don't think I have," he said in a 1974 interview.[19] When illustrating Lear's work, he tried to strike a balance between following the author's text and inventing a visual narrative of his own. "Nonsense really demands precision," he explained. "Like in the *Jumblies*: 'Their heads are green, and their hands are blue. And they went to sea in

9. The Jumblies by Edward Gorey, wood engraving, 1968

[149]

a sieve,' which is all quite concrete, goofy as it is."[20] On the other hand, he was happy to invent his own meticulously rendered charts of Lear's imagined topography and add extra characters and scenes that never appeared in Lear's original poems. "Just because things aren't specifically mentioned in a text does not mean they are not there just the same," explained Gorey, with defiant certainty.[21]

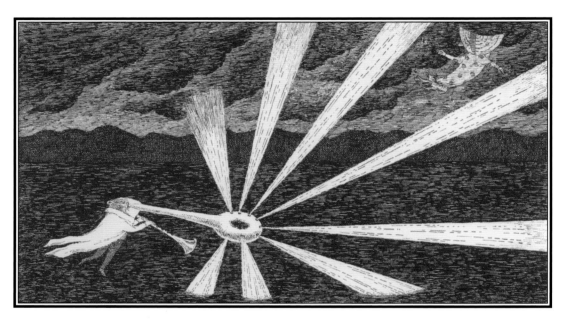

10. *The Dong with the Luminous Nose* by Edward Gorey, wood engraving, 1969

JAN BRETT, in her 1991 interpretation of *The Owl and the Pussycat*,[22] has created a series of images that lie at the other end of the emotional spectrum from Gorey's sometimes dark interpretations of Lear's nonsense. In her book, the artist transports Lear's famous characters to a sun-drenched Caribbean setting, dresses them in suitably tropical clothes, and surrounds them with scientifically accurate shells, corals, turtles, and fish (fig.11).[23] Their colorful sailboat, the *Promise*, is laden with enough tropical fruit to see them safely into their future life. The turkey that marries them is dressed in colonial garb and a white pith helmet, and the flirtatious bride holds a lavish bouquet of orchids. In the final scene, a yellow angelfish, contained in a glass aquarium throughout the book, jumps to freedom (and a waiting mate) as the newly married couple dances by the light of the moon (fig. 12). Brett's delightful illustrations, set in a wildlife-filled paradise, are both joyful and emotionally satisfying, rich in new detail unimagined by Lear, but still true to the spirit of his original poem.

[150]

11. "They dined on mince and slices of quince, Which they ate with a runcible spoon" from
The Owl and the Pussycat, illustrated by Jan Brett, 1991

12. "And hand in hand, on the edge of the sand, They danced by the light of the moon" from
The Owl and the Pussycat, illustrated by Jan Brett, 1991

THE LEGACY CONTINUES:
TWO CONTEMPORARY PAINTERS OF
NATURAL HISTORY WORKING IN THE
LEAR TRADITION

IN THE FIELD OF NATURAL HISTORY painting there are several notable artists who have carried Lear's legacy into the twenty-first century. Among those working as scientific illustrators are the British artist Elizabeth Butterworth, who has created her own spectacular monographs on parrots and their relatives, and the Australian artist William Cooper (1934–2015), who is famous for his large-format paintings of a wide variety of birds and mammals.

WILLIAM COOPER achieved his worldwide acclaim by creating a series of scientific monographs on parrots, toucans, and kingfishers during the final decades of the twentieth century. These lavishly produced, large format books have been fairly compared with those created by Edward Lear and John Gould in the nineteenth century. Enriched by comprehensive scientific texts by the Australian ornithologist Joseph M. Forshaw, Cooper's astonishingly beautiful paintings give each of his co-produced monographs an aesthetic quality rarely seen in scientific publications of their era (fig. 13). The artist's paintings, while contemporary in their applications, are, at least in part, an homage to the great eighteenth- and nineteenth-century artists whose work he admired from an early age. "I can clearly remember as a boy how Lear's birds stirred wonder and excitement in me and drove me to try and emulate his style," recalled Cooper. "Particularly impressing me was his Red & Yellow Macaw and the Baudin's Cockatoo, probably because of the feather detail. . . . At that time I wasn't aware of the artist, in fact, I thought, as many did, that these pictures were the work of [John] Gould. . . . Late in life I discovered his wonderful [bird] portraits in [Gould's] *The Birds of Europe* and *A Monograph of the Ramphastidae* [Toucans]."[24]

The lifelike quality of Edward Lear's bird pictures that so appealed to Cooper and set them apart from other nineteenth-century illustrations was due not only to Lear's talent as a draftsman, but to his practice of painting directly from living subjects. Cooper also preferred to work from live birds whenever possible. After observing aviary specimens or wild subjects in the field and examining museum study skins to note the details of their plumage, he carefully composed his birds, usually at least one male and one female, in a natural setting, paying equal attention to the vegetation with which they are associated (fig.14), something Lear

13. Ringed Kingfisher (*Megaceryle torquata*) by William Cooper, watercolor, 1981

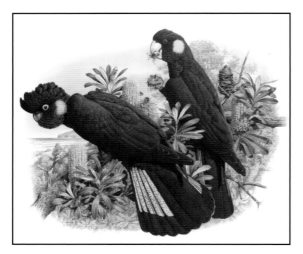

14. Yellow-tailed Black Cockatoo (*Calyptorhynchus funereus*) by William Cooper, watercolor, 2000

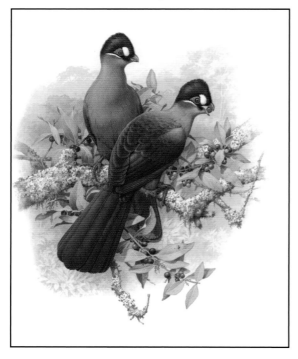

15. Hartlaub's Turacos (*Tauraco hartlaubi*) by William Cooper, watercolor, 1995

was often unable to do. In each picture he tried to show his subjects from several different angles. The finished paintings highlighted not only the distinctive appearance of the birds depicted, but also important details about their behavior, their preferred habitat, and even their favorite food (fig.15). At the time Lear was working, none of this information was known, nor did Lear have the capability of traveling to the places his subjects lived, as Cooper did.

Over time, like Lear, Bill Cooper grew increasingly interested in landscape painting. During the last decade of his life, while still actively creating evocative avian portraits, his focus shifted to entire ecosystems, of which he saw birds as one important element.[25] The subject he was working on at the time of his death – his last painting – was of a group of Lear's Macaws in their native dry habitat in Brazil.[26]

ELIZABETH BUTTERWORTH (born 1949) considers herself a natural history illustrator, although she was formally trained for a ca- reer in fine art, first at Maidstone College of Art in Kent and then at the Royal College of Art in London. In 1983, she collaborated with

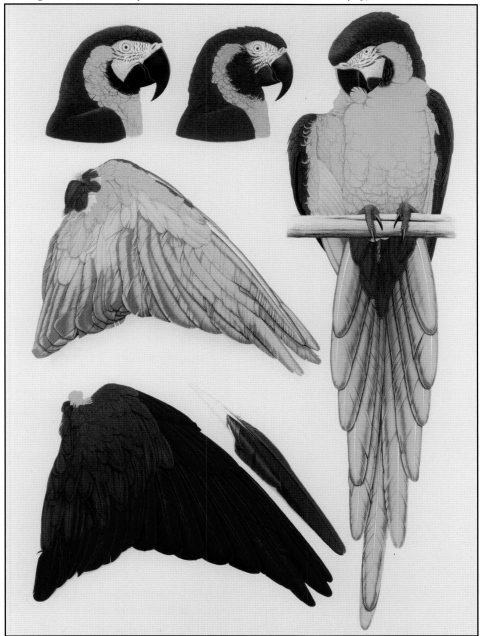

16. Blue and Yellow Macaw (*Ara ararauna*) by Elizabeth Butterworth, line etching and gouache 1984

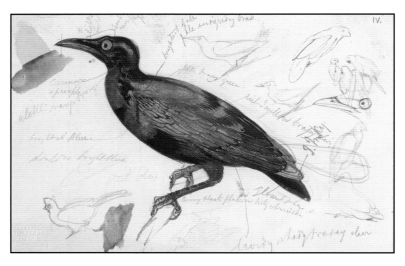

17. Lear's study of a Purple Glossy Starling (*Lamprotornis purpureus*) with notes, probably from a living bird at the London Zoo, ink and watercolor over graphite, date unknown

ornithologist Rosemary Low on a scientific publication, *Amazon Parrots: A Monograph*, but she has also explored the purely artistic possibilities of the parrot family in two print portfolios created for the fine art market: *Parrots and Cockatoos* (1978) and *Macaws* (1993). In these, and in related work, she, like Lear, often depicts her colorful subjects against white backgrounds, without any attempt to provide them with an environmental context (fig.16). To add to the artistic effect, as the art historian Richard Verdi has noted, Butterworth often combines "images of an entire bird with details of its anatomy, whether an extended wing, a head, or even a solitary feather. These are arranged on the page to stunning effect and recall the collaging techniques of the Cubist painters, in which fragments of reality are juxtaposed and the viewer invited to 'complete' them in the mind's eye."[27] Edward Lear included similar details, but for a different reason. He often covered the margins of his working drawings with miscellaneous anatomical details, notes, and color swatches as part of his investigatory process (fig.17). Paper was expensive and he didn't want to waste it. He never intended the unselfconscious studies that enliven his working drawings to be seen by anyone other than himself. Butterworth recognizes the appeal of such details and consciously works them into her final compositions (figs.18a, b).

Although interested in birds and fine art from an early age, Butterworth did not discover Lear until studying at the Royal College of Art. "I remember arranging to see the [parrot] lithographs at the British Museum of Natural History," she recalls. "I particularly liked his wonderful drawing and his ability to make the birds appear full of life."[28] Butterworth parallels both Lear and Cooper in working from live subjects whenever possible. But while Lear drew on stone to create his lithographic prints, Butterworth often uses the older technique of etching metal plates for limited edition printing. Like Cooper, she is "inspired by the 18th [and 19th] century idea of making a beautiful book."[29]

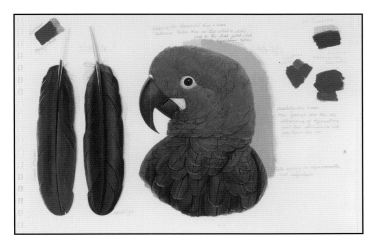

18a. Study of a Lear's Macaw (*Anodorhynchus leari*) by Elizabeth Butterworth, ink and gouache, 2005

18b. Study of a Palm Cockatoo (*Probosciger aterrimus*) by Elizabeth Butterworth, pencil, ink and gouache, 2005

TAKING LEAR IN A NEW DIRECTION

19. "Morire de Cara al Sol" Cuban Red Macaw (*Ara tricolor*) at fig trap by Walton Ford, watercolor, gouache, pencil and ink, 2004

WALTON FORD (born 1960), is an American painter who has taken Edward Lear's tradition of natural history painting and moved it more firmly into the realm of fine art, providing his own, considerably darker, perspective by creating works of art that con-tain complex subtexts about human excess and environmental degradation. Here the superficial beauty of the birds seduce us into admiring a scene that, on closer inspection, is filled with details that portend their ulti-mate destruction (fig. 19). Ford's paintings

often reveal a rapacious abuse of the natural world and make subtle (and not-so-subtle) references to human savagery and decadence. Sex, violence, cruelty, and man-made environmental disasters are sub-themes that run through almost every one of Ford's large, beautifully rendered paintings (figs.20, 21). Unlike Edward Lear's natural history paintings that start with a desire to capture the physical features of a living subject, Ford's paintings begin with an idea, often based on historic anecdote, and then move to an imagined portrayal of it. "Almost all of [his] paintings owe their conception to a piece of text," observes the American journalist Bill Buford.[30] "You can't ignore that the paintings want you to think of them in the context of a specific history, almost as if they were not paintings, but documents or literary works," says Buford.[31] Like Lear, Ford's paintings often have marginal notes, but while Lear's messages were written for the artist himself

20. "Au Revoir Zaire" African Gray Parrots (*Psittacus erithacus*) by Walton Ford, watercolor, gouache, pencil and ink, 1998

21. "Sensations of an Infant Heart" Military Macaw (*Ara militaris*) and Red Howler Monkey (*Alouatta seniculus*) by Walton Ford, watercolor, gouache, pencil and ink, 1999

There was an old man of El Hums,
Who lived upon nothing but crumbs,
Which he picked off the ground, with the other birds round,
In the roads and the lanes of El Hums.

22a. "There was an old man of El Hums" from
More Nonsense, Pictures, Rhymes, Botany &c., 1872

There was an old person of Shields,
Who frequented the valley and fields;
All the mice and the cats, And the snakes and the rats,
Followed after that person of Shields.

22b. "There was an old person of Shields" from
More Nonsense, Pictures, Rhymes, Botany &c., 1872

to help him refine the visual accuracy of his work, Ford's are aimed at his general audience, often adding a literary or historical component to an imagined scene. In Lear's case, the birds and animals were sufficiently novel to capture and sustain the interest of his patrons. For Ford, the wildlife serves as a vehicle through which to convey a number of complex, often socially charged messages. He consciously gives them a historical look, mimicking earlier styles of painting to evoke a feeling of age. Ford often works on a monumental scale with his animals rendered life-size, ensuring that anyone viewing his paintings is immersed in the scene and its complex narrative. Ford is a storyteller who uses nature as a doorway to history and a window into the human psyche.

Despite the somber, sometimes cataclysmic themes addressed in many of Ford's paintings, it was the animated, humorous quality of Lear's nonsense drawings that first attracted his attention to Lear and turned Ford into a Lear enthusiast. "I was shown Lear's limericks as a child and I loved them

at first sight," he explains. "His line drawings of the eccentric people he described in them are incredibly well observed. They convey equal parts humor and emotion. You can't help identifying with the humor in them, and recognizing in every one the raw elements of humanity. Some of his jumping, running, flying figures seem to anticipate animation with their energized antics. I love the way he distills everything to its most basic elements (figs.22a, b)."[32]

Ford sees the same life-like qualities in Lear's natural history paintings. "Unlike Audubon's paintings, which I admire, but which can sometimes be stiff and contrived, Lear's birds radiate life and personality," he observes. "When you are with one of Lear's birds, you feel as though you are in the presence of an animate being. You can practically tell the temperature of the room they were painted in!" "There have been many good painters of natural history over the centuries, and a few great ones, like Barraband and Audubon," says Ford, "but Lear is one of those very rare artists you can truly call a genius."[33]

JAMES PROSEK (born 1975), another contemporary American painter with a reverence for historical precedent, shares Ford's admiration for Lear's talents as both a naturalist-artist and an observer of the human condition. "These two sides of Lear's life are usually cited as conflicting and at odds with one another," says Prosek, "but they are really just two parts of a whole. Both have to do with observation. One side treats the surface. The other explores what lies beneath it. Lear was amazingly gifted at both."[34]

Like Lear, Prosek's reputation was established at a very young age by his ability to paint natural history subjects — in his case trout and other sporting fish — with stunning fidelity, personality, and grace. Before he had graduated from college, Prosek had published a best-selling book on the trout of North America.[35] A few years later, after traveling the world in pursuit of his favorite fish, he published a much larger work documenting all of the salmonid species and subspecies he could locate and identify (figs.23a, b).[36] Although his scientific work continues — he published a book on marine fishes in 2012 — he is now almost as well known for his playful, slightly surrealistic interpretations of wildlife as for his more traditional ones.

His 2008 watercolor of an imaginary bird called a "cockatool" provides a good example of his ability to move from the serious to the

23a. Brown Trout (*Salmo trutta*) by James Prosek, watercolor, graphite and colored pencil on paper, January 29, 2002; 23b. Miyabe Iwana, a Japanese char (Salvelinus malma miyabei), by James Prosek, watercolor, graphite and colored pencil on paper, October 29, 2001

absurd without a loss of artistic fidelity and flair (fig.24).[37] While it may not be obvious at first sight, the bird in Prosek's painting has a variety of Swiss army knife-like tools emerging from the feathers in its crest. In a faux-serious homage to the tradition of scientific illustration, the artist has scrawled notations at the bottom of his painting in which he offers an alternate name for the bird ("can-do-ca-too"), behavioral notes ("efficient at most simple carpentry jobs"), and authenticating field observations ("bird sighted on Kosrae Island; only known specimen; painted from life"). The painting, while intended to be humorous, also hints at the philosophical issue of how or whether evolving organisms can adapt to an increasingly human-centric world. One could well imagine Lear himself creating drawings like this in one of his pun-filled letters. Although Prosek's paintings are not directly derived from Lear, when they are compared with Lear's work, the parallels are striking (figs.24, 25, 26).

Just as Lear sought new subjects for his pencil and brush through travel, Prosek has accompanied scientific research expeditions to remote areas to record and document the specimens collected. In a series of paintings he made of specimens from a Yale-Peabody Museum expedition to Suriname in 2010, Prosek intentionally distorted the perspective of some of his subjects by painting them from a strongly oblique angle.[38] The resulting pictures, which he paired with more conventional views of the same subjects, suggest the arbitrary nature of traditional scientific illustration.

Like Lear, Prosek loves to play with puns as he explores the meaning of taxonomic classification. "Prosek relishes the slippage in language," observes art historian John Ravenal, "the ambiguities, misnomers, and contradictions that reveal it as an artificial system mapped onto a world it seeks to render comprehensible."[39] Thus, the popular identifications of certain creatures (turtle doves, rooster fish, parrot fish, etc.) inspire Prosek to create his own menagerie of imaginary hybrids based on the literal interpretations of their names (fig.27).

Prosek has a Lear-like propensity both to celebrate nature and simultaneously spoof the rules of scientific classification used to organize it. On one hand, his meticulously studied and scrupulously rendered watercolors of fish, organized through a rigid classification system that dates back to the eighteenth century, have been published as scientific works. On the other, some of his more purely imaginary paintings, while equally detailed in their renderings, intentionally subvert this same system. His imaginary hybrids, like his "parrotfishe" (2009), "question what his naturalistic works affirm," observes Ravenal, "presenting a vision of nature that defies our categories and exceeds language's ability to contain it."[40]

One can only imagine how pleased Edward Lear would be to see artists like James Prosek and Walton Ford giving new interpretations to some of the very same subjects that he so enjoyed during the early decades of his life.

Lear's extraordinary paintings and those of others who continue to probe the boundaries between science, art, and imagination enrich our lives and make the world a more interesting place. This is the kind of continuing legacy which Lear would have enjoyed and encouraged. Who knows what kinds of paintings he himself might be creating were he alive today!

24. Cockatool by James Prosek, watercolor, gouache, graphite and colored pencil on paper, 2008

25. Edward Lear's study of a Lesser Sulphur-crested Cockatoo (*Plyctolophus sulphureus*), now Yellow-crested Cockatoo (*Cacatua sulphurea*), ink and watercolor and graphite, September 1830

26. Cockatooka Superba by Edward Lear, pen and ink

27. "Parrotfishe" by James Prosek, watercolor, gouache, graphite and colored pencil on paper, 2009

POETICAL TOPOGRAPHERS: THREE CONTEMPORARY TRAVEL AND LANDSCAPE PAINTERS WORKING IN THE LEAR TRADITION

WHILE EDWARD LEAR did not spend a lot of time studying art, he was a natural teacher of others. Queen Victoria was his best-known pupil, but there were many others whose names and subsequent achievements we know little or nothing about. Although they had no direct contact with him, except through his paintings, a number of contemporary painters still embrace Lear's way of recording landscapes. Tony Foster, John Doyle, and Philip Hughes are three English artists whose philosophy of painting and insightful landscape views suggest a continuation of a nineteenth-century painting tradition that was personified by Edward Lear.

28. Silver Maple by Tony Foster, watercolor over graphite, Concord River, July 5, 1984

TONY FOSTER (born 1946) likes to paraphrase Henry David Thoreau when explaining his philosophy of travel painting,: "The two best organs for experiencing the landscape are the soles of the feet."[41] In a contemporary world of speed and modern technology, Foster consciously travels at a Lear-like pace – on foot (or in a raft, kayak, or canoe) – making paintings as he goes (fig.28)."It is my contention," he writes, "that the slower I travel and the longer I spend studying and experiencing my subject, the better the paintings."[42] Foster's large watercolors (his largest so far is an eight by four foot one of the Grand Canyon described by the art historian Richard West as "heroic") often incorporate found objects and the kind of written annotations and marginal vignettes that Lear used as instructive reminders to himself (fig.30).[43] For Foster, these become integral parts of his compositions and tools with which he hopes to further engage his viewers. Foster's collected talismans – feathers, stones, pieces of bark – conceptually integral to, and matted with, his paintings, are reminiscent of Lear's early trompe l'oeil painting of feathers from the London Zoo (see figs.24 and 25 in part 1 of this book).

Lear may have consciously chosen out-of-the-way places to travel and paint, but he rarely went where there were no people. It was the overlay of human activity, both historical and contemporary, that partly attracted him to a place and gave him his artistic focus. By contrast, Foster has chosen as the subjects for his paintings places devoid of humans. "My work is about wilderness," he says, "a celebration of the fact that even on our overcrowded and increasingly polluted planet there exist places of intense beauty without any mark of human interference. I see it as my role as an artist to spend time in these places, to distill my experiences, and to bring back to civilization my evidence." Foster describes his paintings as "not simply landscapes – they are ways of describing what happens when I make my journeys."[44] Edward Lear may have felt the same way. "My life's occupation is travelling," he wrote in his *Journal of a Landscape Painter in Corsica* (1870), "adding fresh ideas to both mind and portfolio."[45] Lear recorded his lifelong travels with annotated sketches and journals. Foster creates large finished paintings and what he calls "watercolor diaries" of the wild places he finds of interest.

29. Study of trees, Barrackpore by Edward Lear, ink and watercolor, December 29, 1873
30. Pinchot Pass by Tony Foster, watercolor over graphite, 23-24 August, 1986

31. "Mar de Cortes #4" by Tony Foster, watercolor over graphite, January 1994

Lear traveled slowly and on foot by necessity; Tony Foster does so by choice, leaving plenty of time to see, think about, and record the world around him. "Even my hiking pace – I insist on stopping every two hours to brew tea and contemplate [my] surroundings – can be upsetting to fellow hikers who are more used to climbing a mountain or descending a canyon as rapidly as their physical condition allows," he explains. "I proudly boast that I hold the world record for the slowest traverse of many wilderness routes."[46] His painting trips have taken him around the world, from deserts and rain forests to mountains, canyons, and ocean coasts (fig.31), sometimes alone, but more often accompanied by traveling companions willing to tolerate the artist's slow pace and geographical focus. "They are all lovers of wilderness and creative adventure and seemingly content to fit their itinerary to my idiosyncratic requirements," Foster notes appreciatively.[47]

"Any artist would agree that making art is a lonely business," observes Foster. "My way of working could be more lonely than most, cut off from loved ones, from home, and from the society of my beloved Cornish village for months at a time. . . . I sometimes spend days or weeks alone in the wilderness. It is at these times that I realize that without my friends it would be quite impossible for me to continue my work."[48] Lear too relied on the companionship of friends to sustain his spirits when traveling. "I never go out [into the Campagna] without one or more companions," he wrote his sister from Rome in 1838.[49] The most important of his fellow travelers were Chichester Fortescue and Franklin Lushington, but there were many others as well. Some were fellow artists, some family friends.[50] In addition, for almost thirty years, he was accompanied by his servant, Giorgio Kokali, who carried his supplies, offered a certain degree of protection, and provided companionship to the often lonely Lear. Together, they traveled at a walking pace through Italy, France, Crete, Egypt, Corsica, Malta, and India, pausing whenever and wherever Lear wished to capture the scenery on paper (fig.32).

[166]

32. Finale, Italian Riviera by Edward Lear, ink and watercolor over graphite, December 16, 1864

JOHN DOYLE, another present-day landscape painter who prides himself on working at a civilized, nineteenth-century pace, would have felt quite comfortable traveling with Edward Lear. Like Lear, but unlike Foster, he is more often drawn to landscapes steeped in human history than to those without it. He is particularly interested in the religious and cultural sites of England and the continent. In 1992 the Dean of Canterbury invited Doyle to create a series of paintings to celebrate the 1,400th anniversary of St. Augustine's mission to Kent in 597. In response, the artist suggested making a pilgrimage to Rome, walking the entire distance from Canterbury, painting as he went (fig.33). "I

33. Saint Peter's Basilica and Castel Saint Angelo on the Tiber, Rome by John Doyle, watercolor

34. Dows on the Nile by John Doyle, watercolor, 2002

must be among the very few painters left who are truly peripatetic topographical recorders of the picturesque view," he observes.[51] The resulting works of art – more than one hundred watercolors in all – were exhibited in the Chapter House of Canterbury Cathedral in May and June 1997. Doyle loves the slow and steady pace of his ambulatory painting trips. Whether these are short or long, he seeks "the thrill of turning a corner and being stunned by what one sees. It is the thrill of the unexpected that is gripping," he explains, "and being once gripped, one paints" (fig.34).[52]

Doyle has always been as interested in the history and local traditions of a place as in its natural and man-made environments. Each of his watercolors is a celebration of a particular place and time. They are often made from the same kinds of unusual vantage points that attracted Lear (fig.35).

35. Sunrise at Cuceron, Provence, France by John Doyle, watercolor, 1995

PHILIP HUGHES (born 1936) is equally fascinated by human impact on the landscape, although he tends to look even further back in time. He has walked the length and breadth of Britain following the routes of ancient people to create drawings and paintings of the places that resonate with interesting natural and human history (fig.36). "The tracks that engage me," he says, "either have an archaeological interest or a special geological aspect. The two are often connected."[53]

Thus his pictures explore prehistoric forts, footpaths, settlements, and landscape marked by monolithic stones (fig.37). In describing his approach to painting, Hughes might easily be describing Edward Lear's (fig.38): "When I walk a track I often write down personal notes, which form a sort of diary, marking the stages of my progress; sometimes these notes appear as a part of the drawing. This way the track becomes my own, my walking along it, my unique experience."[54]

36. South-west Coastal Path by Philip Hughes, watercolor over graphite, September 23, 1999

37. Brookan, the stones, the Ring of Brookan by Philip Hughes, watercolor and graphite, January 17, 2010

38. Malabar Hill, Bombay by Edward Lear, watercolor over graphite, January 7, 1875

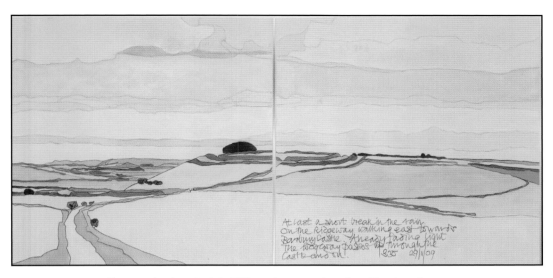

At last a short break in the rain. On the Ridgeway walking east towards Barbury Castle. Already fading light. The Ridgeway passes up through the Castle and on. 8:35 29/11/09

39. Ridgeway and Barbury Castle by Philip Hughes, watercolor and graphite, November 29, 2009

Like Lear, Foster, and Doyle, Hughes has traveled widely. He has painted from Mexico and Peru to Australia and Antarctica, where, from 2001 to 2002, he was artist-in-residence with the British Antarctic Survey. But there are certain parts of Britain that seem to speak to him most deeply: Orkney, Islay, Assynt, and Rannoch Moor in North Scotland; the far west of Cornwall; Stonehenge, Avebury, and Silbury; Ridgeway and the South Downs.[55] His painting style, while more abstract than Lear's, does show the same confident handling of line. "I think [my works] are . . . a slightly uneasy mixture between realism and abstraction," he says. "In terms of line, it's like a religious belief – I will never alter a landscape, I'll never say 'Oh, it would look nicer if that mountain was a bit to the left' – that is sacrosanct, so they're almost photographic in that sense, but within that I feel I can do whatever I want with colour"(fig. 39).[56]

Edward Lear, who also experimented with color in his painting, often left written rather than painted references to the shades he wished to remember (fig.40). He did not describe his working methods, but Hubert Congreve, who first met Lear when the artist arrived at San Remo, Italy, in 1870, did. Lear gave Congreve drawing lessons when the latter was a young man. Years later, Congreve described what it was like to be a student studying drawing with Edward Lear:

These lessons were some of the most delightful experiences of my young days as they were accompanied with running comments on art, drawing, nature, scenery, and his travels mixed up with directions for our work. . . . I was frequently with him in his studio, and we also went [on] sketching expeditions together, Lear plodding slowly along, old George [Kokali] following behind, laden with lunch and drawing materials. When we came to a good subject, Lear would sit down, and taking his block from George, would lift his spectacles, and gaze

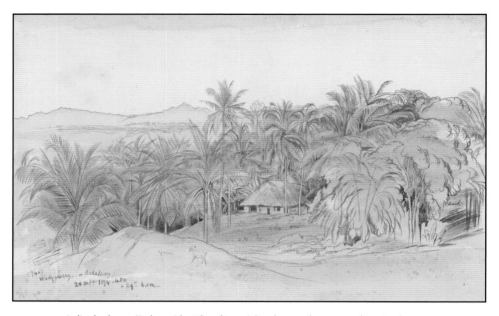

40. Indian landscape (Badagora) by Edward Lear, ink and watercolor over graphite, October 28, 1874

for several minutes at the scene through a monocular glass he always carried: then, laying down the glass, and adjusting his spectacles, he would put on paper the view before us, mountain range, villages and foreground, with a rapidity and accuracy that inspired me with awestruck admiration. . . . The drawings were always done in pencil on the ground, and then inked in in sepia and brush washed with colour in the winter evenings.[57]

While each of the contemporary painters profiled here has his own artistic style and method of painting, all share a sensibility that Lear would have appreciated. What interesting traveling companions they would have made!

A POLITICAL CARTOONIST
INFLUENCED BY LEAR

ALTHOUGH EDWARD LEAR is known for his uninhibited sense of humor and his strongly held opinions on everything from dogs to clergy (he disliked both), he generally avoided inserting political commentary into his art.[58] Historians and biographers have long attempted to read political messages into his limericks and nonsense verse, but Lear was generally successful at keeping an enigmatic distance between his drawings and his political views. It would have been surprising to Lear, therefore, that several modern-day cartoonists have turned to his drawings for inspiration.[59]

NICHOLAS GARLAND (born 1935) is one such person. A contemporary artist who was the first editorial cartoonist at England's *Daily Telegraph* and *Independent* newspapers and has been a regular contributor to the *New Statesman*, the *Spectator*, and *Private Eye* over a period of almost fifty years, Garland has frequently called upon Lear's drawings to serve as image sources when lampooning politicians and their behavior.[60] Turning to other artists for this sort of inspiration is not unusual in the field of cartooning. "Many cartoonists base political cartoons on the work of Old Masters and other comic artists," Garland explains, citing the English caricaturist and illustrator John Leech (1817–1854) as an example. Leech "based a political cartoon on Oliver Twist saying, 'Please sir, I want some more,' immediately after Dickens published that famous episode, and cartoonists have been using [that quote] ever since," says Garland. "During my career I [have] probably used it four or five times."[61]

Garland recounts how he often turned to Lear during his five decades of almost daily cartooning: "Sitting at my desk, trawling through the news for that day's subject, I would be considering how, if I chose this or that theme, I would illustrate it. On such a day, when Prime Minister Thatcher was rampaging about, I thought of the

'. . . *Old Person of Stroud,*
who was horribly jammed in a crowd.
Some she slew with a kick,
some she scrunched with a stick,
That impulsive old person of Stroud'

And I had my cartoon for the day" (figs. 41, 42).

"I am familiar enough with Lear's work to, at times, be able to reach immediately for such happy conjunctions of news and limerick," he writes.[62] There are many examples in Garland's career, which the artist is happy to acknowledge: "For instance, a politician, chided for being slow about something, might find me half-remembering a [Lear] limerick about a person riding on a tortoise, and, indeed there is one: He came from Ickley, and '*could not abide to ride quickly.*'" Garland continues: "It might occur to me that a party leader, attempting to take his colleagues in an unpopular direction, was like the Old

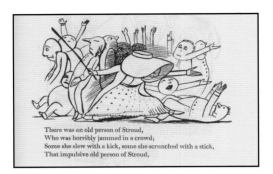

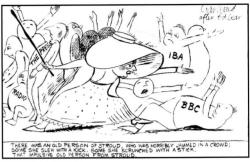

41. "There was an old person of Stroud" by Edward Lear, wood engraving as published in *More Nonsense, Pictures, Rhymes, Botany, Etc.*, 1872.

42. "There was an old person of Stroud" (Margaret Thatcher attacking the press) by Nick Garland, ink, published in *The Independent*, May 6, 1988

Person of Dundalk, *'who tried to teach fishes to walk.'* And so on . . ."[63] At the start of the second Gulf War in 2003, Garland turned to Lear's famous poem "The Jumblies" (fig.43) to show a group of US and British leaders sailing in a sieve as a metaphor for what he believed was a misguided invasion of Iraq.[64] In his drawing, US President George W. Bush, Vice President Dick Cheney, Secretary of State Condoleezza Rice, and a scowling Secretary of Defense Donald Rumsfeld are joined by their British counterparts, Prime Minister Tony Blair, Foreign Secretary Jack Straw, Secretary of State for Defense Geoff Hoon, and a number of gloomy-looking GIs (fig.44). Their circular sieve is being tossed and turned by a stormy sea. The caption reads: "Though the sky be dark and the voyage long, yet we never can think we were rash or wrong, while round in our sieve we spin!"[65]

In an earlier cartoon (2000), Garland suggests the futility of President Bill Clinton's efforts to have the Irish Republican Army decommission their arms as part of a peace deal with England. His source for the image was a limerick in Lear's *Complete Nonsense* (fig. 45). He found both the rhyme and the drawing that accompanied it perfect metaphors for what many believed to be the hopelessness of

Clinton's well-intentioned intervention (fig. 46). Garland had used the walking fish metaphor on at least two other occasions.[66]

It is a testament to the timelessness and adaptability of Lear's limericks that they could be so easily applied to twentieth- and twenty-first-century politics. For Garland they sometimes shaped the way he came to view a politician or enabled him to find humor in even the most serious national and international events. "I must confess that on those terrible days when I could not think of anything to do a cartoon about," he writes, "I would take down the *Book of Nonsense* and leaf through it, trying to fit a Lear to a political situation instead of the other way around."[67]

Like so many of his generation, Garland grew up in a household where Lear's books were close at hand. These, combined with a strong family involvement in the arts, provided the ideal climate for him to develop a lifelong appreciation of Lear's work. "My mother, her father, and one of my aunts, were all artists and my childhood home was full of paintings, sculptures, drawings and illustrated books," he recalls, adding:

I can't remember a time when I did not

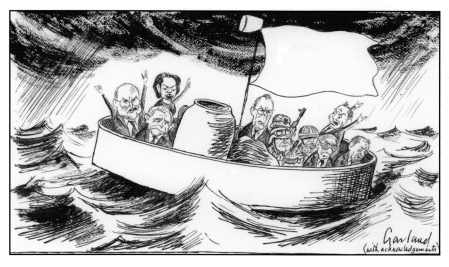

44. The Jumblies by Nick Garland, ink, published in the *Daily Telegraph*, October 8, 2004

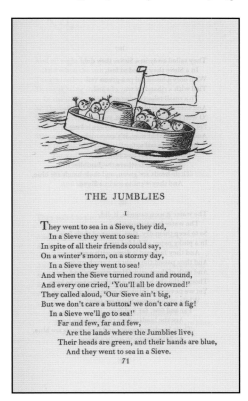

THE JUMBLIES

I

They went to sea in a Sieve, they did,
 In a Sieve they went to sea:
In spite of all their friends could say,
On a winter's morn, on a stormy day,
 In a Sieve they went to sea!
And when the Sieve turned round and round,
And every one cried, 'You'll all be drowned!'
They called aloud, 'Our Sieve ain't big,
But we don't care a button! we don't care a fig!
 In a Sieve we'll go to sea!'
 Far and few, far and few,
 Are the lands where the Jumblies live;
 Their heads are green, and their hands are blue,
 And they went to sea in a Sieve.
71

THE COMPLETE NONSENSE BOOK

There was an old person of Dundalk,
Who tried to teach fishes to walk;
When they tumbled down dead, he grew weary, and said,
" I had better go back to Dundalk!"

[340]

43. The Jumblies by Edward Lear, wood engraving from Lear's *Nonsense Songs, Stories, Botany and Alphabets*, 1871

45. "There was an old person of Dundalk," wood engraving from *The Complete Nonsense Book*

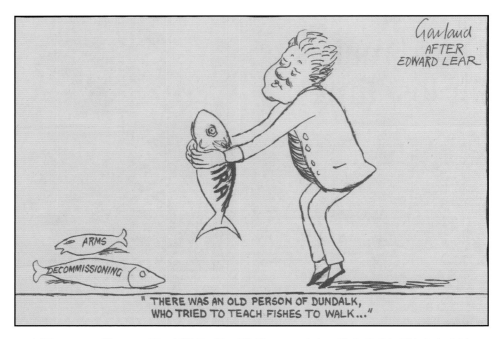

46. "There was an old person of Dundalk" (President Bill Clinton negotiating with the IRA) by Nick Garland, ink, published in the Daily Telegraph, December 13, 2000

know the Nonsense Verses and Drawings of Edward Lear. I have a dreamy, half-memory of being read Lear and Lewis Carroll when I was very small and being puzzled by the fact that the adult reading [them] was so amused. Alice's adventures frightened me; they were like a nightmare in which nothing made sense. Lear's verses, on the other hand, were harmless, if a bit silly. I liked them well enough. It wasn't until I was much older that I began to read Alice with pleasure and saw that Lear's work was not nonsense. For a start, it was beautiful – both the verses and the drawings. It was while one day saying to myself the line, "On the coast of Coro mandel, Where the early pumpkins blow . . ."that I understood for the first time that the sound of a line of poetry

matters as well as the sense.

"Calico jam
The little fish swam
Over the syllabub sea . . ."

There was a strength in the rhythm and jolts of pleasure in sudden unexpected words: *syllabub sea? early pumpkins blow?* And in the mad, comic little pictures I found unmistakable signs of powerful representational drawing.[68]

What Garland especially admires about Lear's work is that the freely executed drawings are "so firmly rooted in diligent study of the appearance of things." And where others have seen dark and negative content in Lear's cartoons, Garland finds them "good-

[176]

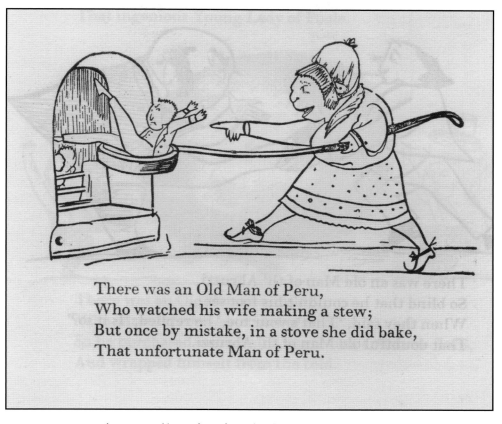

There was an Old Man of Peru,
Who watched his wife making a stew;
But once by mistake, in a stove she did bake,
That unfortunate Man of Peru.

47. There was an Old Man of Peru from Edward Lear's *A Book of Nonsense*, 1846

natured, benign, lively and funny."[69] "No one ever gets hurt in his drawings," he explains. "Even the old man who screamed out whenever they knocked him about – he appears to be laughing in the illustration. Or the Old Man of Peru, accidently baked in a stove by his wife (fig.47). Everyone survives. As in the famous cartoon by [James] Thurber of a duel in which one of the men has swiped off the head of his opponent and cried out, 'Touché!' As has been written elsewhere, clearly the fellow is going to apologize, replace his friend's head, and the fencing match will continue. Great artists have a way of communi-

cating with you as you look at, listen to, or read their work," observes Garland. "Lear is a charming, intelligent companion."[70]

When Garland adopts a Lear drawing to make a political point, it is his goal to capture a familiar image and infuse it with contemporary meaning, not to insert Lear himself into the debate. "I don't think his humour, or his political outlook, about which I am ignorant, has affected mine at all," he explains. "I do not have anything like such a free-ranging mind as he had; I am nothing like so inventive. I can walk, I can even climb. But I cannot fly."[71]

CONCLUSION

PART II

FOR ALMOST TWO hundred years, Edward Lear has had a subtle, but significant influence on Western culture. As a natural history illustrator, travel writer, landscape painter and humorist he and his work quietly shaped public opinion and taste. Although reclusive and modest in person, Lear was ultimately beloved by millions, and respected by all those who came in contact with him and his paintings. "Lear was a man both for manners in Society, & skill in his profession not easily found or replaced," observed one of his professional colleagues, already speaking of him in near reverential tones when Lear was still just thirty-two years old.[72]

Although they never met, the widely read British art historian and essayist John Ruskin (1819–1900) ranked Lear first among his favorite authors,[73] and Britain's beloved poet-laureate, Alfred, Lord Tennyson (1809–1892), extolled Lear's virtues as a literary explorer with a poem about his travels in Greece. One stanza in that poem contained Tennyson's timeless homage to the power of Lear's writing and art:

> . . .With such a pencil, such a pen
> You shadow forth to distant men,
> I read and felt that I was there[74]

As much as he enjoyed these accolades, Lear judged the success of his life by the sale of his books and paintings. Fortunately, in both of these he was just successful enough to sustain his peripatetic life while creating a remarkable body of work.

Despite his public visibility, Lear was a very private person. Nevertheless, he kept in close touch with a small network of family, patrons, and friends with frequent letters in which he reported on his daily activities and asked about theirs. In some of his chatty, pun-filled, and sometimes illustrated correspondence, we get rare glimpses of his insecurities, ambitions, and concern for posterity. Emily Tennyson, wife of the poet laureate, was one of the few people with whom Lear felt comfortable shedding his protective facade of light-hearted frivolity to discuss his disappointments and self-perceived failures. In an 1856 letter to her, he expressed his modest wish to "leave behind me correct representations of many scenes little cared for or studied by most painters." In the same letter he noted with humble satisfaction that his work was appreciated by more people than he had ever imagined: "I certainly give great pleasure to numbers of people through my work," he wrote with apparent surprise.[75]

Although he was referencing his landscape painting and nonsense, which were both then much on his mind, his comments would also apply to his paintings of wildlife and other aspects of the natural world (fig. 48). Although little-known today, these paintings, made during the earliest years of his career, rank among the greatest natural history paintings of all time. Their fresh, intimate quality still possess the same eloquent if understated power that so impressed his contemporaries. That they continue to inspire succeeding generations of artists and art connoisseurs is testament to Lear's remarkable skill and originality of vision. Though his focus on wildlife lasted for less than a decade, it helped establish a closeness to nature that remained with Lear throughout his life and created a body of paintings that has been rarely equaled in the history of art.

48. Mandarin Duck (*Aix galericulata*), ink and watercolor over graphite, date unknown

1. The only other book devoted exclusively to members of the parrot family at the time of Lear's publication was François Levaillant's *Histoire Naturelle des Perroquets* (1801-1805), a two-volume work published in Paris containing 145 color-printed engravings by Jacques Barraband (1768-1809). See p. 64 for a discussion of this book and others that feature members of the parrot family.

2. Lear first published his nonsense verse, anonymously, in England in 1846. His iconic poem "The Owl and the Pussycat" was first published by the American publisher James Fields of Boston in a children's magazine entitled *Our Young Folks* in 1870.

3. This was first published in 1872 in Lear's *More Nonsense, Pictures, Rhymes, Botany, Etc*

4. Hove is a coastal town just to the west of Brighton. Might Lear have visited it on holiday?

5. Of the many biographies of Lear, the most complete and accurate is that written by Vivien Noakes. See Vivien Noakes, *Edward Lear: The Life of a Wanderer,* first published in 1968. There were several subsequent editions. The final, revised and enlarged edition was published in 2004 (Stroud, Gloucestershire: Sutton Publishing). It is the pagination from this last edition that is cited in these notes. Two other Noakes volumes that will be cited throughout these notes are (1) the exhibition catalog she produced for the Royal Academy of Arts in 1985: *Edward Lear 1812-1888* (London: Royal Academy of Arts in association with Weidenfeld and Nicolson, 1985), and (2) her edited volume of his selected letters: *Edward Lear: Selected Letters* (Oxford: Oxford University Press, 1990).

6. Letter to Chischester Fortescue, 2 September, 1859, in *The Letters of Edward Lear*, ed. Lady Strachey, (London: T. Fisher Unwin, 1907), p. 148 quoted in Noakes, *Life of a Wanderer*, 10.

7. Lear, preface to *Nonsense Songs and Stories*, 6th edition (London: Frederick Warne, 1888).

8. I wish to thank Jonathan Evans at the Royal London Hospital Museum, William Schupbach at the Wellcome Library, Sam Alberti at the Royal College of Surgeons of England, and Christine Ruggere at the Institute for the History of Medicine, Johns Hopkins University, for their help in determining the nature of Lear's medical illustrations. According to William Schupbach, making such morbid anatomy drawings of the sort Lear described remained a fairly obscure sub-culture in Great Britain until the formation of the Medical Artists' Association in the mid-twentiethth century.

9. Lear later acknowledged studying "bones & muscles" with William Yarrell (1784-1856). Yarrell was an early member of the Zoological Society, treasurer of the Linnean Society, and, the author of *History of British Fishes* (1836) and *History of British Birds* (1843). See letter from Lear to Charles Empson, 1 October 1831, in Vivien Noakes, ed., *Selected Letters*, 15.

10. These albums are now at Harvard University's Houghton Library, MS Typ 55.4 and MS Typ 55.27. There is a third, closely related album at the National Library of Scotland in the Hugh Sharp collection, shelf mark H.S.954. (Note: This volume is also catalogued as part of the manuscript collections and appears in the MSS catalogue as MS.3321).

11. One of the "fancy bird" landscapes is clearly signed by Ann. There are also a number of very similar paintings in private collections in England that are signed by Edward.

12. The description comes from Lear's friend Daniel Fowler, who recalled Lear telling him this and recounted it in his autobiography. He is quoted in Noakes, *Life of a Wanderer*, 15.

13. The manufacture and decoration of such wares, featuring birds, shells, seaweed, moss and feathers, took place in London, Worcester, Staffordshire, and Wales. The companies whose productions most closely resembled the Lear studies were Spode, Bar, Flight, and Barr, and Chamberlain & Co. For illustrations and descriptions, see John Sandon, The *Ewers-Tyne Collection of Worcester Porcelain at Cheekwood* (Suffolk: Antique Collector's Club, 2008). See also: David Drakard and Paul Holdway, *Spode Printed Ware* (London: Longman, 1983), and Leonard Whiter, *Spode*, (London: Barrie & Jenkins, 1970).

14. A family history does make mention of inherited china, but does not describe it in enough detail to shed further light on this speculation.

15. Lear may have had a family connection to Lewis Weston Dillwyn, a member of the Linnean Society and a principal in the Welsh pottery firm of Glamorgan in Swansea. While I have not yet been able to find any direct links between Lear and Dillwyn, there are paintings of shells in the Lear albums at Houghton Library and others in private hands that are attributed to Lear that closely resemble the shell decorations on some Glamorgan Pottery. I am grateful to Charles Lewsen, Stephen Duckworth, and Andrew Renton, Head of Applied Art, National Museum of Wales in Cardiff, for helping me to pursue this avenue of research, which, while not yet fully developed, I believe will eventually bear fruit.

16. While one applied lithograph of a feather is the same on the two leaves, they differ in color: the feather in album MS Typ 55.4 is painted blue and the one in MS Typ 55.27 is brown. In album MS Typ 55.4, the second application is a single feather tinted pink; in album MS Typ 55.27, the second lithographic addition shows the tips of four overlapping tail feathers. Of the two head studies, one is colored blue, while the other is colored green. The blue painted head is in album MS Typ 55.4, while the green-painted head is in album MS Typ 55.27 (Note: all of these

are in the Lear collection at Houghton Library, Harvard University, Cambridge, MA.)

17. There are two hand-colored prints of this apparently unpublished lithograph in Houghton Library. See MS Typ 55.9(2) and MS Typ 55.9(26). The watercolor "original" is in MS Typ 55.4.

18. The feathers represented appear to be from one or more Amazon parrots, while the painted feather is probably from a European Jay *(Garrulus glandarius.)*

19. In MS Typ 55.4, the seventy leaves of paper watermarked "J. Whatman 1827" are bound in marbled boards, with a red leather spine. MS Typ 55.27 is of identical construction and appearance. It contains sixty-two pages.

20. The uncolored, trimmed lithograph in MS Typ 55.4 is of an undulated parakeet (plate 13 in *Lear's Illustrations of the Family of … Parrots*). It was issued in October 1831. Lear's watercolor of a peacock on a separate sheet formerly laid into the album is signed and dated 1831. The album also includes a sketch of grasses signed and dated September 9, 1834, by Lear, but this is so unlike anything else in the album that it may have been added at a later date. The two ornithological watercolors in album MS Typ 55.27 that are dated are of an Angola Vulture (fol. 32r) and a Brazilian Caracara (incorrectly called an eagle by Lear) (fol. 38r). Both birds were at the London Zoo. Both watercolors are signed "E. Lear" and dated October 7 and October 4, 1831, respectively.

21. Some of the paintings from this collection are reproduced in *One Hundred Drawings and Watercolours* (London: Guy Peppiatt Fine Art Winter Catalogue, 2012–2013), 50–51. Others are reproduced in *Happy Birthday Edward Lear: 200 Years of Nature and Nonsense* (Oxford: Ashmolean Museum, 2012), 3 and 32. I am grateful to Charles Lewsen for bringing these paintings to my attention and to Guy Peppiatt for making digital images of them accessible for study and reproduction.

22. On rare occasions, this species strays into Great Britain, but the likelihood of Lear finding a single throat feather from one in pristine condition in the wild is infinitesimally small.

23. It is possibly a feather from the very same European Jay whose painted feather accompanies the four parrot feathers in one of the youthful albums at Houghton Library (MS Typ 55.4). Sarah married Charles Street in Sussex on July 25, 1822. In 1858 they moved to New Zealand, where their descendants still live. I am indebted to Harlon V. Wells for his exhaustive genealogical research on the very complex Lear family.

24. See Houghton Library MS Typ 55.27 (21 and 47).

25. Small watercolors of the Stanley Parakeet and Pigeon Parakeet, in similar poses to the ones illustrated in Lear's parrot monograph, can be found on page 4 of album MS Typ 55.27, Houghton Library.

26. See a summary of the 1825 prospectus in Wilfrid Blunt, *The Ark in the Park: The Zoo in the Nineteenth Century* (London: Hamish Hamilton, in association with the Tryon Gallery, 1976), 25. See also John Bastin, "The First Prospectus of the Zoological Society of London, New Light on the Society's Origins," *Journal of the Society for the Bibliography of Natural History*, 5 (1970): 369-388 and 6 (1970): 236-241.

27. Edward Stanley (1775-1851), the thirteenth Earl of Derby (after 1834), who served as president of the Zoological Society from 1831 to 1851, has been described as "the father of the acclimatization movement in Britain." See Christopher Lever, *They Dined on Eland: The Story of the Acclimatization Societies* (London: Quiller Press, 1992), 19.

28. Alwyne Wheeler, "Zoological Collections in the Early British Museum: The Zoological Society's Museum," *Archives of Natural History*, 24, NO. 1 (1997): 89–126.

29. For a detailed discussion of Gould's activities at the zoo, see Ann Datta, *John Gould in Australia* (Melbourne: The Miegunyah Press and Melbourne University Press, 1997). See also Isabella Tree, *The Ruling Passion of John Gould* (London: Barrie & Jenkins, 1991).

30. Daniel Hahn, *The Tower Menagerie* (New York: Jeremy P. Tarcher/Penguin, 2003) and Geoffrey Parnell, *The Royal Menagerie at the Tower of London* (London: Royal Armouries, 1999). The collections were given to the Zoological Society by King William IV. The minutes of the Zoological Society Council for December 21, 1831, refer to the Council's acceptance "of His Majesty's most generous offer … of the Collection of Wild Animals … now in the Tower." The Royal Menagerie was officially closed on August 27, 1835.

31. Hahn, 208.

32. Edward T. Bennett, *The Tower Menagerie: Comprising the Natural History of the Animals Contained in That Establishment, with Anecdotes of Their Characters and Histories,* (London: Robert Jennings, 1829).

33. John Bayley, *History and Antiquities of the Tower of London,* quoted in Hahn, 208.

34. Edward Cross was the son-in-law of Mr. Polito. He was also a "dealer in foreign birds and beasts"; see Richard D. Altick, *The Shows of London* (Cambridge: The Belknap Press of Harvard University Press, 1978), 308. For a comprehensive history of menageries in Great Britain, see Christine E. Jackson, *Menageries in Britain: 1100-2000,* (London: The Ray Society and Scion Publishing, 2014).

35. Exeter Change Handbill, British Library, described in Altick, 308.

36. "Miss Frasier's album" is in a private collection. The leopard watercolor is reproduced in Vivien Noakes, *The Painter Edward Lear* (London: David & Charles, 1991), 34. The handbill is reproduced in Altick, 308.

37. Incidents of captive male elephants going berserk due to hormonal changes during "musk," are relatively common. For accounts of Chunee's execution, see Altick, 311-316; and Hahn, 199-206. For an account of the ways in which the event was recorded visually, see Diana Donald, *Picturing Animals in Britain* (New Haven: Yale University Press, 2007), 171-2.

38. Charles Dickens, *Sketches by Boz*, quoted in John Butt and Kathleen Tilotson, *Dickens at Work* (London, 1957), 55.

39. Altick, *The Shows of London*, 316.

40. Before moving the animals from Exeter 'Change, the menagerie's proprietor, Edward 'Cross, offered to sell any or all of them to the Zoological Society. He also applied to become the manager of the Society's living collections, but both of his offers were declined. Subsequently Cross moved the collection across the Thames to establish the Surry Zoological Gardens on the thirteen-acre grounds of the former manor house of Walworth, near Kennington Park. See Altick, 317 and 323.

41. Prospectus for the Zoological Society, 1825, in Gwynne Vevers, *London's Zoo: An Anthology* (London: The Bodley Head, 1976), 14.

42. Harriet Ritvo, *The Animal Estate: The English and Other Creatures in the Victorian Age* (Cambridge: Harvard University Press, 1987), 205-6.

43. Joshua Brookes, *An address delivered at the anniversary meeting of the Zoological Club... 1828* (London, 1828), 27, quoted in Desmond, 232 and in P. C. Mitchell, *Centenary History of the Zoological Society of London* (London: Zoological Society of London, 1929), 97.

44. The friend is usually identified as Mrs. Godfrey Wentworth, the daughter of Turner's patron Walter Ramsden Fawkes. See Lear's essay "By Way of Preface," in *Nonsense Songs and Stories*, 6th edition (London: Frederick Warne, 1888).

45. The Council minutes of June 16, 1830, grant Lear permission "to make drawings of the Parrots belonging to the Society." I wish to thank Ann Sylph, librarian of the society, for providing details of the council minutes.

46. At least nine of the bird studies in the Lear collection in Harvard's Houghton Library are noted as having been made at Bruton Street (see MS Typ 55.9 [3, 8, 9, 10, 15, 17, 17, 30, 69] while another [36] has a note, probably to his sister, saying "I am going to Bruton Street"). Two studies are noted as having been made at "the Gardens" (MS Typ 55.9 [13 and 57]); and two at the "Zool. Soc." (MS Typ 55.9 [8 and 35]).

47. The project Swainson was working on was John Richardson's multi-volume *Fauna Boreali-Americana* (1831), which described the findings of Sir John Franklin's expeditions to the Arctic (1820-22 and 1826-27). Adrian Desmond, "The Making of Institutional Zoology in London 1822-1836," *Centaurus* 27, no. 3-4 (1984): 172.

48. Ibid., 172.

49. Ibid., 173.

50. N. A. Vigors, "A reply to some observations in the *Dictionnaire des Sciences Naturelles*' upon the newly characterized groups of the Psittacidae," *Zoological Journal* 3 (1827-28): 91-123.

51. Vigors would also become one of Lear's sponsors at the Linnean Society of London, nominating him for Associate Member status as soon as he published the first parts of his parrot monograph in November 1830. Lear's affection for his mentor is reflected in references to him in correspondence long after he had moved away from London and given up an active role in scientific affairs.

52. Letter to John Gould, 14 October 1863, Houghton Library, bMS Eng 797.

53. Lear, preface to *Nonsense Songs and Stories*, 6th edition.

54. Five plates by Edward Lear, all engraved by J. C. Zeitter, appear in volume 1 of the *Transactions of the Zoological Society of London* (1833–1836): plates 3, 4, 21, 24, and 37. Three plates appear in volume 2 (1836–1841): plates 6, 16, and 17. In all but two cases, the illustrations accompany papers by Edward T. Bennett. The original paintings for six of these illustrations are still in the possession of the Society. Missing from its collection and not accounted for elsewhere are illustrations of a kangaroo (*Macropus parryle*): Vol. 1, plate 37; and a bat (*Pteropus whitei*): Vol. 2, plate 6.

55. Edward T. Bennett, *The Tower Menagerie*, (London: Robert Jennings, Poultry, 1829).

56. In a practice that was typical of the period, Harvey, himself, appears to have adapted his leaping cat image from an earlier design of a leaping dog by Samuel Howitt that was created about 1807 to serve as a decorative vignette on sets of Spode porcelain. For reproductions of Howitt's leaping dog design, see David Drakard and Paul Holdway, *Spode Printed Ware* (London: Longman, 1983), 85.

57. The lemur illustration is on p. 299 of Vol. 1 (mammals), and the macaw illustration is on p. 125 of Vol. 2 (birds). Other illustrations which may be by Lear (with the vaguest hint of *EL* monograms) are the Red Lemurs in Vol. 1, p. 145, and the Galleated Curassow in Vol. 2, p. 65. It should be noted that the *EL* monogram is more clearly visible in some copies of the book than in others, depending on the inking of the wood blocks.

58. The wood-engravers were Branston and Wright, the same men who had worked with Harvey on the illustrations for Bennett's *Tower Menagerie*.

59. The others who supported Lear's nomination to the Linnean Society were the Zoological Society's secretary Nicholas A. Vigors, and Thomas Bell, for whom Lear would also provide illustrations.

60. The plates are all in "folio" format (15 x 10½ inches

or 38 x 27 cm).

61. For more on Ackerman and the company he created, see Ian Maxted, *London Book Trades 1775–1800* (London: Dawsons of Pall Mall, 1977) and John Ford, *Ackerman 1783-1983* (London: Ackerman, 1983).

62. To confuse matters, the name "Ackerman & Co" was used concurrently with "R. Ackerman" between 1829 and 1832. Had Lear begun the project between 1827 and 1829, the name "R. Ackerman" would have been the one used. Had the project been started after 1829, "Ackerman & Co." would have been the more likely imprint. "R. Ackerman" was continued for ongoing projects between 1829 and 1832. The use of the name was discontinued on October 16, 1832. See Ford, pp. 89-97. Although it is possible the plates were created between 1830 and 1832 (exactly the same years as Lear's parrot monograph), the most likely dates for Lear's zoo *Sketches* are 1828-29.

63. The pencil study of the Polar Bear, drawn on the same scale as the surviving (sample?) print for Lear's *Sketches*, is at Houghton Library, MS Typ 55.9 (9). It is drawn on the back of a sheet that shows a blue parrot with its wings raised. That study is labeled "1830 August *Pittacus Obscurus* from a living bird at Bruton Street." Lithographic prints of this same species, in a different pose, can be found at Houghton Library, MS Typ 55.9(4) and MS Typ 55.9(8). A preliminary pencil sketch of the 1830 study survives in the Lear collection at Blaker-Wood Library at McGill University in Montreal, Canada. It is reproduced in Brian Reade, *An Essay on Edward Lear's Illustrations* (New York: Johnson Reprint Co., 1978), fig. 1. A final version of the parrot painting is in Lord Derby's collection at Knowsley Hall (#26).

64. The Polar Bear sketch is in album MS Typ 55.27 at Houghton Library. A drawing of a wolf or other unidentified canine (MS Typ 55.9 [59]), also at Harvard, may or may not be related to the zoo project.

65. National Library of Scotland, H.S.954, leaf 7.

66. Although Lear was always hard up for money, the period from 1827 to 1832 was a particularly stressful time, for Lear was not only helping his sister with the expenses of maintaining their new, shared flat at 38 Upper North Place, Gray's Inn Road, but he was also bearing the considerable cost of creating the lithographic plates for his self-published parrot monograph.

67. In later life Lear described being carried out of his childhood house (Bowman's Lodge) to watch the fireworks celebrating the defeat of Napoleon at the Battle of Waterloo. Letter to Chichester Fortescue, 27 September 1884, published in *Later Letters of Edward Lear*, ed. Lady Strachey (London: T. Fisher Unwin, 1911), 311. This event is cited in Angus Davidson, *Edward Lear, Landscape Painter and Nonsense Poet* (London: John Murray, 1933), 2; and Noakes, *Life of a Wanderer*, 5.

68. At least one of the watercolor studies in the

Houghton Library collection is noted by Lear as having been based on Vigors's collection (MS Typ 55.9 [31]). It is a study of a Rose-ringed Parakeet (*Paleornis Torquatus*), inscribed: "Leila: living at Mr. Vigors, Chester Terrace drawn February 1831." This image was not used in Lear's monograph, but may have served as the basis for a later illustration of a closely related species in Jardine and Selby's volume on parrots in *The Naturalist's Library* (1836). For another Vigors specimen, see fig. 33.

69. It seems likely that Beechey or his publisher would have commissioned the illustrations concurrent with or soon after inviting the various authors to participate (1829). Since the introduction to the section on mammals by John Richardson (who had accompanied John Franklin on a previous Arctic expedition, 1819–1822) is dated March 1, 1831, presumably most of the rest of the book and all of its illustrations were ready at that time. Since Lear's paintings had to go through the lengthy process of engraving (by John Christian Zeitter and Thomas Landseer, older brother of the well known animal painter Edwin H. Landseer) and hand-coloring by a team of unidentified colorists, he must have had them finished long before.

70. The original manuscript and proof plates for the book at the Natural History Museum in London suggest that two of Lear's illustrations for *The Zoology of Captain Beechey's Voyage*, engraved by Zeitter, were considered for publication in Jardine and Selby's *Illustrations of Ornithology* (1826–1835) before they appeared in Beechey's book. The plates selected by Jardine and Selby were *Colaptes collaris* (a flicker), plate 9 (p. 25) in Beechey; and *Troglodytes spilurus* and *Litta pygmaea* (two wrens), plate 4 (p. 19) in Beechey.

71. Beechey curbed none of his frustration in identifying Edward Gray (1800–1875), keeper of zoology at the British Museum, as the delinquent contributor to the long-delayed publication. See Beechey's Introduction in *The Zoology of Captain Beechey's Voyage*. For a portrait of Gray, see figure 100.

72. I am indebted to Sir David Attenborough for first drawing the chronology of Beechey's publication to my attention during an exchange of letters in 1995.

73. When the book was finally published, two additional plates were needed. These were created by Thomas Landseer (1795–1880), the brother of the famous animal painter Sir Edwin Henry Landseer (1802–1873) and a highly accomplished animal painter in his own right. The high quality of Landseer's plates only served to highlight the relatively amateurish character of Lear's youthful illustrations.

74. For more on traditional ways of preserving specimens, see Robert McCracken Peck, "Preserving Nature for Study and Display" and "Alcohol and Arsenic, Pepper and Pitch: Brief Histories of Preservation

Techniques," *Stuffing Birds, Pressing Plants, Shaping Knowledge: Natural History in North America, 1730-1860,* ed. Sue Ann Prince (Philadelphia: American Philosophical Society, 2003), 11-53.

75. Lear to Charles Empson, 1 October 1831, Morgan Library, published in Noakes, *Edward Lear, Selected Letters,* 14. In a letter to William Lizars, 17 June 1834, Lear repeated this sentiment: "I do not feel competent to undertake quadrupeds – unless I draw them from life – which takes more time of course than when, as with the birds, I have numerous sketches by me." (This letter, in the Royal Scottish Museum, was transcribed by Christine Jackson, to whom I am most grateful.)

76. All of Lear's plates in the Beechey book were engraved on metal by John C. Zeitter (1796–1862). Lear's plates in E. T. Bennett's book on the London Zoo were engraved on wood by Branston and White.

77. For a description of the lithographic process and its popularity in England, see Michael Twyman, "Lear and Lithography,"in *Edward Lear The Landscape Artist: Tours of Ireland and the English Lakes, 1835 & 1836,* ed. Charles Nugent, (Grasmere: The Wordsworth Trust, 2009), 11-29. See also Michael Twyman, "Charles Joseph Hullmandel: Lithographic Printer Extraordinary," in *Lasting Impressions,* ed P. Gilmour (London: Alexandria Press, 1988), 42-90.

78. Letters to Fanny Coombe, 19 June 1835 and 3 January 1837. The original letters, in the collection of Frederick Warne & Co., are published in Nugent, Appendix A, 206 and 220.

79. Houghton Library collection, MS Typ 55.9 (16).

80. Compare the images on this trial plate with the original drawings in Houghton Library albums MS Typ 55.4 and MS Typ 55.27. The original sketch for the Temple of Jupiter is in a friendship album presented to a friend sometime in 1829 or 1830. It is reproduced in Noakes, *The Painter Edward Lear,* 35.

81. Philip Hofer, *Edward Lear as a Landscape Draughtsman* (Cambridge, MA: Belknap Press of Harvard University Press, 1967), 16 and plate 1A.

82. Houghton Library collection, MS Typ 55.9 (3). For an original watercolor of this bird in a slightly different pose, see MS Typ 55.9 (55). For another, partly colored print of this bird, see MS Typ 55.9 (45). A completely different lithograph of the same Black-capped Lory was used as plate 37 in Lear's *Illustrations of the Family of ... Parrots.* A slightly fanciful watercolor of the same species – possibly the same bird – entitled *Black cap Lory Zoological Society* can be found in one of his youthful albums (MS Typ 55.4, fol. 8r).

83. We know that Bayfield was Lear's colorist for the parrot monograph from the prospectus of Thomas Bell's *A Monograph of the Testudinata* (1836–1842) which refers to it; see Nugent, 22-23, n. 52. For more on Bayfield, see

Christine E. Jackson and Maureen Lambourne, "Bayfield – John Gould's Unknown Colourer," *Archives of Natural History* 17, no. 2 (1990): 189-200. Houghton Library owns the printer's and/or colorist's pattern plates (colored and annotated by Lear) for five of the plates in *Illustrations of the Family of ... Parrots*: They are: plate 8 – MS Typ 55.9 (78); plate 14 – MS Typ 55.9 (71); plate 16 – MS Typ 55.9 (1); plate 40 – MS Typ 55.9 (73); and plate 42 – MS Typ 55.9 (49). The Yale Center for British Art owns the color pattern sheet for plate 4 (B1997.7.369).

84. The Society for the Encouragement of Arts, Manufactures & Commerce was established in 1754. It received its royal charter in 1847 and was given permission to add "Royal" to its title by King Edward VII in 1908.

85. According to the minutes of the society for February 9, 1831, Lear had just presented it with "Nos I–IV of his work on the Psittacidae." The minutes of November 2, 1832, report that Nos. 5 & 6 had been presented by the artist. The word "presented" suggests that they were a gift from the artist and not a purchase by the society. I wish to thank Susan Bennett, Library Administrator at the RSA, for supplying this information.

86. Unpublished letter from Edward Lear to Arthur Aikin, Society of Arts, no date, from the archive of the society.

87. Letter to Charles Empson, 1 October 1831, Pierpont Morgan Library, published in Noakes, *Selected Letters,* 12-17.

88. Ibid.

89. Ibid.

90. Ibid.

91. In October 1831, in addition to producing his own monograph on parrots, Lear was simultaneously fulfilling painting commissions from John Gould (for *The Birds of Europe*), Lord Derby (a commission for individual paintings of his birds and animals ultimately leading to *Gleanings from the Menagerie and Aviary at Knowsley Hall*), Thomas Bell (*A Monograph of the Testudinata*), and Edward T. Bennett (*The Gardens and Menagerie of the Zoological Society Deliniated*). The Red and Yellow Macaw (*Macrocercus aracanga*) – now Scarlet Macaw (*Ara macao*), plate 7 in *Illustrations of the Family of ... Parrots,* was issued on November 1, 1831.

92. William Swainson to Lear, 26 November 1831, in Noakes, *The Life of a Wanderer,* 19. The original letter is tipped into Ann Lear's copy of Lear's *Illustrations of the Family of ... Parrots,* which is owned by Houghton Library (MS Typ 805L .32[A].

93. Prideaux John Selby to Sir William Jardine, 10 January 1831, Cambridge University Library.

94. So little was known about some of the parrots that Lear drew, that geographical organization would have been a challenge

95. See, for example, Joseph M. Forshaw and Sir

William T. Cooper, *Parrots of the World*, (Melbourne: Lansdowne, 1973), or Joseph M. Forshaw and Albert Earl Gilbert, *Trogons: A Natural History of the Trogonidae*, (Princeton: University Press, 2009).

96. George Edwards, *Gleanings of Natural History* (London: Royal College of Physicians, 1758), vol. 5:45.

97. Eleazar Albin, preface to *A Natural History of Birds*, vol. 3 (London: William Innys and R. Manby, 1738).

98. Albin based most of his illustrations on bird skins from private "cabinets," many of whose owners he identifies in the accompanying text.

99. Albin, preface to *A Natural History of Birds*, vol. 1.

100. Albin, vol. 3, 26.

101. *The Ash-colour'd Parrot* (vol. 1, no. XII), shown picking up a connected pair of cherries, and the *Laurey From the Brasils* (vol. 1, no. XIII), shown peering curiously at a grasshopper, were both painted by Albin's daughter, Elizabeth (1708-1741). They are clearly both drawn from living birds and represent the most life-like illustrations in Albin's book.

102. It is estimated that there were never more than 100 copies of volume I or more than 150 copies of either volumes II or III of Albin's book. See Roger F. Pasquier and John Farrand, Jr., *Masterpieces of Bird Art* (New York: Abbeville Press, 1991), 57.

103. The engravings were color-printed ("a la poupee"), then hand-finished by Louis Bouquet (engraver) and Francois Langlois (printer).

104. Although Vivien Noakes speculates that Lear lived alone here (see *Edward Lear: The Life of a Wanderer*, 22), a letter from Lear to Ann dated 27 January 1838 suggests otherwise. Also, in a letter to John Gould of 17 October 1839, Lear states unambiguously that his sister Ann "always lived with me in England." See Gordon Sauer, *John Gould the Bird Man, Correspondence*, vol. 2 (Mansfield Centre, CT: Maurizio Martino, 1998), 116.

105. Letter to Fanny Jane Dolly Coombe, 15 July 1832, in Noakes, *Selected Letters*, 17-18. Lear was then working on the illustrations for Thomas Bell's *A History of British Quadrupeds* (1837), a circumstance that accounts for the presence of some of these animals in his living quarters.

106. For an example of the second wrapper design and the title page together in the Houghton collection, see MS Typ 55.9 (end-5). Houghton also has a wrapper of the first design, designated in print and manuscript "January 1st, 1831" and "No. 3" (Typ 805L.32 [D]).

107. The two different wrapper designs for the twelve parts of *Illustrations of the Family of ... Parrots* (that for part 1 is in a private collection, and for part 12 is at Houghton, which also has a wrapper for part 3) are illustrated in the Royal Academy catalog, p. 83. Judging from two almost complete sets at the Linnean Society of London and in the Balfour/Newton Library, Downing College, Cambridge (ref L ff.KP[2]), the change

occurred in part 6, issued at an unknown date between June and October, 1831. Art historian Christine Jackson has discovered a third variant of the wrapper design associated with part 5 (May 1831). In this, Lear has added the designation "A.L.S." to the first wrapper design to reflect his election as an Associate of the Linnean Society of London. This election occurred within days of his publishing the first part of his book (he was nominated in November 1830 and elected in January 1831), but evidently he had already printed an adequate supply of wrappers and decided to use these up before printing new ones to reflect his new academic credential. The patronage of HRH Queen Adelaide, however, was sufficiently important to prompt Lear to redesign the wrappers for the subsequent part of his book.

108. Letter to Sir William Jardine, 23 January 1834, published in Noakes, *Selected Letters*, 19.

109. Letter to Charles Empson, 1 October 1831, ibid., 14.

110. Letter to George Coombe, 19 April 1833, Frederick Warne Archive, published in Nugent, 202-4.

111. The unsold inventory of lithographs that Gould acquired from Lear may have contained mostly uncolored (i.e., black and white) prints. These would have been hand-colored by Bayfield (and/or others) as needed when they were sold.

112. See notes 110 and 113

113. Lear describes the details of his planned trip to Europe, and Gould's reason for postponing it, in a letter to George Coombe, 19 April, 1833, Frederick Warne Archives, published in Nugent, 202-4.

114. See notes 110 and 113..

115. John Gould to Sir William Jardine, 16 January 1834, in *John Gould the Bird Man: Correspondence*, vol. 1, ed. Gordon Sauer (Kansas City: Privately printed, 1998), 58.

116. Lear's plates in *The Birds of Europe* were so outstanding that they caused a contemporary reviewer to declare the young artist who made them "one of the best Ornithological Draftsmen the world has yet seen." This review, published in the *Encyclopedia Britannica*, was relayed to John Gould during his stay in Australia by his secretary Edwin C. Prince in a letter dated 2 March 1839. See Gordon C. Sauer, editor, *John Gould the Bird Man: Correspondence*, vol. 2, 38.

117. Letter to George Coombe, 19 April, 1833 Frederick Warne Archive, published in Nugent, 202-4.

118. Lear Diary, March 1 1861, quoted in Nugent, 8.

119. Lear Diary, April 26, 1861, ibid., 8.

120. Lear Diary, February 7, 1881, as quoted in Noakes, *Life of a Wanderer*, 23.

121. Ibid.

122. The album is at Houghton Library (MS Typ 55.27, fol. 12r). The animal depicted appears to be a

Short-tailed Field Vole (*Microtus agrestis*). Thanks are due to Dr. Clemency Fisher and Dr. Tony Parker at the World Museum, National Museums Liverpool, for their identification of the species.

123. For more on Gould, see Gordon C. Sauer, *John Gould the Bird Man: A Chronology and Bibliography* (Lawrence: University Press of Kansas, 1982); and Isabella Tree, *The Ruling Passion of John Gould: A Biography of the Bird Man* (London: Barrie & Jenkins, 1991).

124. Also, the scientific consensus on the birds' identities was in a constant state of flux. In the case of the Patagonia Parakeet Maccaw (plate 10 in *Illustrations of the Family of … Parrots*), between the time Lear created the plate (in February 1831) and the time he issued his contents list (in March 1832), the scientific name had been changed from *Psittacara patagonica* (which he put on the plate) to *Psittacara patachonica* (which he put in the index). The bird is now known as the Burrowing Parakeet (*Cyanoliseus patagonus*).

125. For more information on the status of this species, see André Julião's article "Sertão Azul" in *National Geographic (Brazil)*, December 2013, 84-97, available through the following link: http://viajeaqui.abril.com.br/materias/arara-azul-de-lear-animal-ameacado-de-extincao-conservacao

126. For an account of which of Lear's plates were credited to the Goulds, see Noakes, *Edward Lear*, 208.

127. John Gould, *The Birds of Europe*, (London, [1832]-1837), viii.

128. When John Gould published a second edition of *A Monograph of the Ramphastidae, or Family of Toucans* in 1854, the plates were all newly created by Gould and H. C. Richter (1821-1902) for the purpose. One of the plates in the second edition (the Culminated Toucan) was copied directly from Lear's plate from the first edition (which is signed and dated 1833), but without attribution.

129. Victoria and Albert Museum, Department of Prints and Drawings, #29557-96/PO26. For a description of this sheet as a lithographic experiment made by Lear as part of his parrot monograph, see Susan Hyman, *Edward Lear's Birds* (Stamford, Ct: Longmeadow Press, 1989), 24-26; and Nugent, 20-21, and note 39. See also Brian Reade, *Edward Lear's Parrots*, London, 1949 (republished as *An Essay on Edward Lear's Illustrations of the Family of Psittacidae or Parrots*, 1978), 22 or 11 in reprint.

130. The three heads on the Victoria and Albert Museum sheet that are copied from Lear's *Illustrations of the Family of…Parrots* are: (plate 5) the Leadbeater's cockatoo (*Plyctolophus leadbeateri*), now known as the Pink Cockatoo (*Cacatua leadbeateri*); (plate 16) the Tabuan Parakeet (*Platycercus tabuensis*), now known as the Shining-Parrot (*Prosopeia tabuensis*); and (plate 30) the Barraband's Parakeet (*Polytelis Barrabandi*) – called the Roseate Parakeet (*Paleornis rosaceus*) by Lear and

now known as the Superb Parakeet (*Polytelis swainsonii*)). A head study at Knowsley Hall, also cut from Gould's Synopsis, is of the Greater Sulphur-crested Cockatoo (*Plyctolophus sulphurens*), now known as the Yellow-crested Cockatoo (*Cacatua sulphurea*). It is copied from the third plate in Lear's *Illustrations of the Family of…Parrots*. For a discussion of the cutting book at Knowsley Hall in which this head vignette was found, see Robert McCracken Peck, "Cutting up Audubon for Science and Art," *The Magazine Antiques* 164, no. 4 (October 2003): 104-113.

131. For more on this practice and on cutting collections made by John Gould and Thomas Eyton in particular, see ibid.

132. Lear's illustrations for Jardine and Selby's book appear in volume 3, part 10, plates 147, 149, 151; volume 4, second series, plates 2, 4, 5, 6, 8, 12, 13, 16, 17, 24, 29, 32, 33, 34, 37, 38, 40. He also produced illustrations for their popular *Naturalist's Library* (various dates). I am indebted to Christine Jackson for her insights on the relationship between Lear, Selby, and Jardine (personal correspondence, various dates beginning in 1994). See also her books *Prideaux John Selby: A Gentleman Naturalist* (Stocksfield, Northumberland: The Spredden Press, 1992), and *Sir William Jardine: A Life in Natural History* (London: Leicester University Press, 2001).

133. In a letter to Sir Joseph Hooker in 1878, Lear wrote "I find a notice of the death of Sir W. Jardine [who was] for many years a very kind friend to me. I made some of my earliest drawings for him – as far back as 40 years ago! [Lear underestimated the time]. I was introduced to him as a young artist by N.A Vigors, then Secy. Z.S." Letter to Sir Joseph Hooker, 3 June 1878, in Noakes, ed. *Selected Letters*, 252.

134. The Great Auk specimen Lear painted in 1831 was the one owned by the British Museum. It was originally collected in the Orkney Islands in the summer of 1813 by William Bullock who sold it to the museum in 1819. See Errol Fuller, *The Great Auk* (New York: Harry N. Abrams, Inc., 1999), 141-145. Selby wrote to John Gould on April 27, 1831 asking for a painting of this specimen. Gould apparently asked Lear to make it for him. See Sauer, *John Gould the Bird Man: Correspondence*, vol. 1, 27. Lear's finished painting of the Great Auk is in a private collection. His study is at the Blacker-Wood Library collection at McGill University, Montreal.

135. A preliminary study for one of Lear's illustrations for Jardine's book on ducks is in the Houghton Library (MS Typ 55.21).

136. Thomas Eyton, *A Monograph of the Anatidae, or Duck Tribe* (London: Longman, Orme, Brown, Green, & Longman, 1838). While most of Lear's original watercolors for this work are at the Ruskin Gallery in Sheffield, England, a preliminary study for one of the Eyton plates is owned by Houghton Library (MS Typ.

55.9 [8]).

137. William Lizars to P. J. Selby, 6 November 1834, quoted in Christine Jackson and Peter Davis, *Sir William Jardine: A Life in Natural History* (London: Leicester University Press, 2001), 74.

138. Jardine wrote Selby in January 1834 that he had already received "some beautiful drawings of Cats by Lear (the parrot man) which are nearly engraved for the forthcoming vol." See Jackson and Davies, 79.

139. Letter to Sir William Jardine, 23 January 1834, in Noakes, *Selected Letters*, 19-20. Jardine confirmed that "Lear used to charge a pound when he did only one or two [illustrations] but somewhat less when he did 20 or 30 at a time." Letter from Jardine to Gould, 30 November 1827, in Sauer, *John Gould the Bird Man: Correspondence*, vol. 1, 204.

140. Noakes, *Selected Letters*, 20.

141. Ibid.

142. Unpublished letter from Sir William Jardine to Prideaux John Selby, 1 August 1834, Royal Scottish Museum, transcribed by Christine Jackson.

143. Unpublished letter to Sir William Jardine, 5 September 1834, Royal Scottish Museum, transcribed by Christine Jackson.

144. In the introduction to his book, Bennett writes, "He [the author] also feels bound to acknowledge how much the work is indebted to the artists Mr. Dickes and Mr. Vasey, by whom the whole of the illustrations have been drawn and engraved." p. xii.

145. Lear's copy of the book is now owned by Houghton Library, Harvard University, Typ 805L.37c.

146. The page numbers for these illustrations are as follows: the Greater Horseshoe Bat (pp. 68 and 72), the Hedgehog (p. 76), the Common Shrew (p. 109), the Water Shrew (p. 115), the Ferret Weasel (p. 161), and the Brown Rat (p. 315).

147. One of these – the Hedgehog – is in the Houghton Library collection (MS Typ 55.12 f.4r) (see fig. 78).

148. Eight parts of this important monograph were completed in the 1830s, but the book was not brought to completion until 1872 when it was published under the title *Tortoises, Terrapins, and Turtles* with a short text by John Edward Gray. For more on this important publication, for which Lear was creating lithographic plates as early as 1832, see Kraig Adler (introduction and commentary), *Thomas Bell: A Monograph of the Testudinata* (New York: Octavo Editions, 1999) and K. Adler, ed., *Contributions to the History of Herpetology*, vol. 2 (St, Louis, Society for the Study of Amphibians and Reptiles, 2007), 61–62. See also R.J. Cleevely, "The Sowerbys and Their Publications in Light of the Manuscript Material in the British Museum (Natural History)," *Journal of the Society for the Bibliography of Natural History* 7, no. 4 (1976): 343-68. I am grateful to R.J. Cleevely and Kraig Adler

for the information they have shared about Thomas Bell and his relationship with Edward Lear though personal correspondence.

149. Two watercolors of a water turtle (*Leopondus yagovarondi*) at Knowsley Hall reveal Lear's ability to paint turtles without reliance on Sowerby. One is reproduced as plate 4 in John Edward Gray, *Gleanings of the Menagerie and Aviary at Knowsley Hall*, (Knowsley: printed for private distribution, 1846), plate IV. A pencil sketch of the lower carapace of a tortoise in the Houghton Library (MS Typ 55.9 [34]) and a watercolor study in a private collection may relate to Bell's publication (see figure 81).

150. Thomas Bell to James De Carle Sowerby, 2 March 1832, Natural History Museum (London), quoted in Adler, p. 3.

151. The publisher of the 1872 edition was Henry Sotheran and Joseph Baer & Co. of London.

152. This preliminary study is in the Houghton Library (MS Typ 55.12, 1-4:2)

153. Hofer, 11.

154. Hyman, 15. In his biography of Lear, Peter Levi also describes this study as Lear's "first datable animal sketch." See Peter Levi, *Edward Lear: A Biography* (London: MacMillan and New York: Scribner, 1995), 26

155. S. S. Flower et al., *List of the Vertebrated Animals Exhibited in the Gardens of the Zoological Society of London, 1828–1927* (London: Zoological Society of London, 1929), 247. For the location of the hyrax at the time of its death, see the reference in note 81 in Flower.

156. For a reproduction of this finished painting, see item 71 in the catalog for Agnew's 120th Annual Watercolour Exhibition, London, 8 March – 2 April, 1993, exhibition catalog (London: Agnew & Sons, 1993). See also Peter Levi, *Edward Lear: A Biography* (London: Macmillan, 1995), illustrative portfolio following p. 74.

157. See *Proceedings of the Committee of Science and Correspondence of the Zoological Society of London*, Part II (1832): 202-207.

158. Letter to Sir William Jardine, 17 June 1834, National Museums of Scotland Library, quoted in Christine Jackson and Peter Davies, *Sir William Jardine: A Life in Natural History* (London: Leicester University Press, 2001), 134.

159. Among the most beautiful of the little known and "previously unfigured" avian novelties featured in his monograph was a bird leant to him by Lord Stanley. On the advice of Nicholas Vigors, who served as secretary of the Zoological Society from its founding in 1826 until 1833, Lear identified the bird as a Stanley Parakeet (*Platycercus stanleyii*) using the name Vigors provided to honor its owner. Unfortunately, because the species had already been named the Western Rosella (*Platycercus icterotis*) by someone else in 1820, this honorific appellation was declared invalid. Despite the rules of ornithological

nomenclature that favor publishing precedent, the vernacular name of Stanley's Rosella or just "Stanley" remains in fairly widespread use in the avicultural community. I am grateful to Drs. Leo Joseph and Nate Rice for assistance with this taxonomic question.

160. Robert McCracken Peck, "Edward Lear Down Under," *Explore*, Australian Museum, Vol. 34, No. 3, Nov. 2012, 12-16; and "A Passion for Parrots," *Landscope*, Vol. 28, No. 2, Summer 2012, 11-17.

161. For a discussion of earlier and contemporary illustrations of Australian wildlife by European artists, see Penny Olsen, *Upside Down World: Early European Impressions of Australia's Curious Animals*, (Canberra: National Library of Australia, 2010).

162. Lear to William Lizars, 17 June 1834, (letter at Royal Scottish Museum, transcribed by Christine Jackson).

163. The picture is on the same gray paper that Lear used to draw another sketch at Knowsley in which several kangaroos are seen grazing at a distance. Since that drawing is dated 1834, it is most likely that Lear's close-up study of the kangaroo dates from the same period. Lear's view of the Knowsley estate with Lord Derby's kangaroo herd is owned by the Yale Center for British Art. For a reproduction, see Clemency Fisher, ed., *A Passion for Natural History: The Life and Legacy of the 13th Earl of Derby* (Liverpool: National Museums and Galleries on Merseyside, 2002), 93. The Kangaroo study is at Houghton Library (MS Typ 55.12[17]) (see fig. 87).

164. For more on this, see Fisher, 108. There are at least three Lear watercolors of this animal. One is at Knowsley Hall, one at Houghton Library (MS Typ 55.12[8]), and one is in a private collection in the US.

165. Lear painted at least two different Tasmanian Devils, one of which was almost certainly painted from life. These are now in a private collection. His Thylocene, although lifelike in appearance, was more likely painted from a skin. That painting is now owned by the Tasmanian Museum of Natural History and Art in Hobart, Tasmania.

166. John Gould published a book on the mammals of Australia, but that was later (1845-1863), after the time Lear had given up natural history painting. Since all of Lear's Australian mammal paintings were made between 1831 and 1837, before Gould had conceived of that book, it is unlikely that any of Lear's paintings were made with that project in mind.

167. See Gordon C. Sauer, editor, *John Gould the Bird Man: Correspondence*, vol. 2.

168. This letter is at the Morgan Library, New York.

169. There are at least two other paintings of this species by Lear. One is at the Houghton Library, and the other in a private collection in the US.

170. For a comprehensive account of Gould's work in Australia, see Anne Datta, *John Gould in Australia* (Melbourne: The Miegunyah Press and Melbourne University Press, 1997). See also Sean Dawes, *John Gould and the Fauna of Southern Australia*, (Adelaide: Crawford House, 2004).

171. Lear to John Gould, 17 October 1839, quoted in Gordon C. Sauer, ed., *John Gould the Bird Man: Correspondence*, vol. 2, 115. The original letter is in the Morgan Library, New York.

172. Lear's cockatiel (*Nymphicus novae-hollandie*) plate first appeared as plate 27 in Lear's *Illustrations of the Family of Psittacidae or Parrots*. It was copied and reused as plate 45 in volume 5 of Gould's *The Birds of Australia*. The Spotted Cormorant (*Phalacrocorax punctatus*) originally appeared in Gould's suppressed book, *The Synopsis of Birds of Australia and the Adjacent Islands* (1837-1838). It was used again as plate 71 in volume 7 of *The Birds of Australia*. Since Gould had already paid for these two pictures (the cormorant by commission, and the cockatiels by buying the rights to Lear's parrot monograph), he saw no reason not to use them again. When his Australia book was published, he asked Charles Lucien Bonaparte, Napoleon's nephew, to show it to Lear, their mutual friend, then living in Italy.

173. Letter to George Coombe, 19 April 1833, Frederick Warne Archives, published in Nugent, 202-204.

174. *Illustrated London News*, October 11, 1851, quoted in Clemency Fisher, "The Knowsley Aviary & Menagerie," in *A Passion for Natural History: The Life and Legacy of the Thirteenth Earl of Derby*, ed. Clemency Fisher (Liverpool: National Museums and Galleries of Merseyside, 2002), 85.

175. Lord Stanley's name appears eighteenth on Lear's list of 110 subscribers.

176. Several of the people listed as subscribers may have provided services rather than cash for their copies of the book. Charles Hullmandel, for example, was Lear's lithographer, and John Gould, as keeper of collections at the Zoological Society, provided many of the birds depicted in *Illustrations of the Family of... Parrots*. As sources for the birds he painted, Lear acknowledged Lord Stanley, the Zoological Society, Mr. Gould, Mr. Vigors, Mr. Leadbeater, Sir Henry Halford, and the Countess of Mountcharles.

177. In Lord Stanley's diary (Tin Box, Knowsley Hall), he records Lear's personal delivery of part 4 of his *Illustrations of the Family of... Parrots*. He notes that he has now paid him for parts 3 and 4. Although the entry is undated, we can assume that Lear would have delivered the parts as they were issued. According to the records of the Linnean Society, part 3 (consisting of plates 26, 9, and 30) was issued sometime between December 30, 1830, and January 20, 1831. Part 4 (consisting of plates 20, 10, 2, and 25) was issued February 1, 1831. While this would establish the date of their meeting as February 1831, it does not establish when the two men may have first met. Did Lear

deliver parts 1 and 2 of his monograph to Lord Stanley in December 1830? Did Lord Stanley agree to subscribe to Lear's book even earlier, and, if so, was his decision based on a personal solicitation by the artist? Did Lear and Lord Stanley first cross paths at the Zoological Society? Unfortunately, Lear's diaries from this period have been destroyed, and some of Lord Stanley's diaries have been lost. Also none of the existing letters from either man makes mention of their first contact, so we may never know for sure. (For a discussion of the dating of Lear's *Illustrations of the Family of...Parrots*, see Brian Reade, *An Essay on Edward Lear's Illustrations of the Family of Psittacidae, or Parrots*, (London: Prion Ltd., 1978). This was first published by Gerald Duckworth, London, under the title *Edward Lear's Parrots*.

178. In a letter to Chichester Fortescue, 31 July 1870, Lear refers to beginning his life at San Remo "with the same Knowsley patronage I began life with at 18 years of age (i.e., 1830)," published in Noakes, *Selected Letters*, 224. In another letter, written at the time of Lord Derby's death in 1851, he states that he first went to Knowsley twenty-two years before (i.e., 1829), published in Strachey, *Letters of Edward Lear*,.

179. A painting of a Vasa Parrot (*Psittacus vasa*) by Lear in the Blaker-Wood Library at McGill University (Montreal, Canada) is noted by Lear as having been painted at Knowsley on July 5, 1830. A second parrot painting (a Golden or Queen of Bavaria's Parrot – *Psittacus lutens*) bears what appears to be a similar date, but is difficult to read with certainty. I am indebted to Eleanor MacLean and Richard Virr for the assistance they have provided me with the Lear collection at McGill over a period of thirty years.

180. This, according to the ornithologist Louis Fraser, as quoted in Barbara and Richard Mearns, *The Bird Collectors* (San Diego, Academic Press, 1998), 290.

181. Ibid., 291.

182. I wish to thank Clemency Fisher for the help she has provided throughout my many years of researching Lear's natural history paintings, and Lord and Lady Derby for generously allowing me access to their important collection of Lear's watercolors at Knowsley Hall during repeated visits since 1985. For a comprehensive discussion of the Knowsley estate and Lord Derby's natural history interests, see Fisher, *A Passion for Natural History*.

183. The African species was named in honor of Lord Stanley because it was he who "discovered" it among the living birds kept in the aviary at the Tower of London. See Gray, *Gleanings from the Menagerie and Aviary at Knowsley Hall*.

184. MS Typ 55.12 (fol.. 6), Lear Collection, Houghton Library, Harvard University.

185. While many of the preliminary studies for Lear's parrot plates are in the Houghton Library collection,

others can be found at the Blacker-Wood Library of Biology, McGill University in Montreal, Canada.

186. As has been noted, the numerical sequence of plates in *Illustrations of the Family of...Parrots* was determined after all the plates had been issued. The order in which the plates are listed in the table of contents (which determined the sequence in which most owners had their plates bound) was intended to conform with the taxonomic classification of the species depicted and does not reflect the order in which the illustrations were painted or issued. See Appendix.

187. Letter to Charles Empson, 1 October 1831, Pierpont Morgan Library, published in Noakes, *Selected Letters*, 14-15. According to invoices in the Knowsley Hall archives, Lear was being paid between two guineas and three pounds for each painting delivered to Lord Derby. In addition, all of his living expenses were covered while he was at Knowsley Hall. For comparison, the Scottish artist James H. Stewart (1789–1856) was being paid one guinea for each of the watercolors he prepared for Jardine and Selby's *The Naturalist's Library*. See Christine Jackson, *Dictionary of Bird Artists of the World* (London: Antique Collectors' Club, 1999), 450.

188. From the Knowsley Hall account books, Knowsley Hall, Lancashire.

189. During Lear's Knowsley years, five shillings would buy five pounds of butter or ten pounds of meat, seven shillings would provide a family of five with good table beer for a month, and three pounds was the price of a fine frock coat. See Richard D. Altick, *The English Common Reader* (Chicago: The University of Chicago Press, 1957), 276. For typical budgets for early Victorian families belonging to various income groups, as well as prices of various commodities, see G. M. Young, ed., *Early Victorian England: 1830-1865* (London: Oxford University Press, 1934).

190. Letter to Mrs. George Coombe, 20 July 1835, Frederick Warne Collection, quoted in Nugent, p. 209.

191. Letter to George Coombe, 24 June 1835, Frederick Warne Collection, quoted in Nugent, p. 207-8.

192. Ibid.

193. Letter to Mrs. George Coombe, 24 August 1836, Frederick Warne Collection, quoted in Nugent, pp. 213-214.

194. Lear was particularly close to the landscape artist Daniel Fowler (1810–1894), to whom he refers as "my old friend" and whose paintings from the Middle East he described as "without exception the finest sketches I ever saw from any artist's portfolio; some are beyond wonderful." (Letter fragment, c. 1835, Frederick Warne Archives). Through Hullmandel, he also knew the travel artist David Roberts (1796–1864).

195. Lear was closer in age to Audubon's son Victor Gifford Audubon (1809–1860) and the two men became

life-long friends. See Lear-Audubon correspondence in the Morris-Tyler family collection, Beinecke Rare Book and Manuscript Library, Yale University, GEN MSS 85, Box 5.

196. Audubon bought an already made-up copy of the book, possibly from John Gould. On April 20, 1835, he wrote John Bachman in Charleston, South Carolina, from London as follows: "I have also purchased a monograph of Parrots from a Mr. Lear." See *Letters of John James Audubon 1826–1840*, ed. Howard Corning (Boston: Club of Odd Volumes, 1930), 69. Because of the late date of the purchase, Audubon is not listed as a subscriber to Lear's book.

197. Letter from J.J. Audubon to Lord Derby, 26 July 1835, Knowsley Hall Collection.

198. Unfortunately, neither the two letters written to Audubon about the trip, nor Audubon's reply to Lear, appear to have survived. Evidence of the proposal is found only in Audubon's letter to Lord Derby of July 26, 1835.

199. Letter from J. J. Audubon to Lord Derby, 26 July 1835, Knowsley Hall Collection.

200. Ibid. The young man to whom Audubon refers here was probably Henry Ward, a taxidermist whom the artist had brought from London to assist him in his work. Although a competent technician, Ward was not an easy traveling companion, for he was erratic in his behavior and created friction among members of Audubon's traveling party. He later stole specimens from the Charleston Museum and so was considered untrustworthy by Audubon.

201. Letter to Fanny Coombe, 11 February 1837, quoted in Noakes, *Life of a Wanderer*, 40.

202. Letter to Mrs. George Coombe, 3 March 1837, Frederick Warne Collection, quoted in Nugent, 221-22. Vivien Noakes has speculated that because Lear later spoke of having been sent to Rome by Lord Derby and Robert Hornby with no mention of anyone else being involved, it is possible that the thirty other supporters cited in this letter were invented by Lear to suggest a wider base of friendship and patronage than actually existed. See Noakes, *Life of a Wanderer*, 275, n. 43.

203. Letter to Mrs. George Coombe, 3 March 1837, Frederick Warne Collection, quoted in Nugent, 221-22.

204. Letter to Emily Tennyson, 14 January 1861, in Noakes, *Selected Letters*, 166.

205. For more information on Gray, see Albert E. Gunther, *The Founders of Science at the British Museum*, 1753–1900 (Halesworth, Suffolk, England: Halesworth Press, 1980) and *A Century of Zoology at the British Museum Through the Lives of Two Keepers, 1815-1914*, (London: Dawsons of Pall Mall, 1975).

206. For more on Hawkins and his work for Lord Derby, see Valerie Bramwell and Robert McCracken Peck, *All in the Bones: A Biography of Benjamin Waterhouse Hawkins*, (Philadelphia: The Academy of Natural Sciences

of Philadelphia, 2008).

207. Letter from J. Edward Gray to Lord Derby, 14 February 1844, Liverpool Archives Department, ref MM/8/K/3 173-5 (i.e., Letterbook 3, pp. 173-75).

208. Ibid.

209. In a letter to John Gould of October 19, 1846, Lord Derby confirmed that the books were "only printed privately and for presents." See Sauer, *John Gould the Bird Man: Correspondence*, vol. 4, 80. Harvard's Houghton Library may be the only library in the world to own three copies of this book. One of them, a gift from W. B. O. Field, was once owned by Queen Victoria and bears her Windsor Castle library bookplate (Typ 805L.46pf). Another copy of the book remains in the Royal Library.

210. John Gould to the thirteenth Earl of Derby, 25 September 1846, in Gordon Sauer, *John Gould the Bird Man: Correspondence*, Vol. 4, 74-75.

211. Thirteenth Earl of Derby to Edwin Prince, 19 October 1846, in Sauer, *John Gould the Bird Man: Correspondence*, vol. 4, 80.

212. Lear to John Gould, 31 October 1836, in Sauer, *John Gould the Bird Man: Correspondence*, vol. 1, 144.

213. Some of these letters have been published. Others I have accessed as typed transcripts through the kindness of David R. Michell.

214. For an analysis of the likely date of this trip, see Sauer, *John Gould the Bird Man: Correspondence*, vol. 1, appendix C, 309-13.

215. Lear to George Coombe, 19 April 1833, quoted in Sauer, *John Gould the Bird Man: Correspondence*, vol. 1, appendix C, 310.

216. Letter to George Coombe, 19 April 1833, Frederick Warne collection, published in Nugent, 203.

217. Lear diary entry (?), quoted in Sauer, *John Gould the Bird Man: Correspondence*, vol. 1, appendix C, 309.

218. I am indebted to Dr. Kraig Adler of Cornell University and Dr. Roger Bour of the Muséum National d'Histoire Naturelle in Paris for the identification of this tortoise.

219. Lear diary entry, October, 13, 1872, quoted in Noakes, *The Painter Edward Lear*, 91.

220. David Roberts, quoted in *Egypt Yesterday and Today*, ed. Fabio Bourbon, (Shrewsbury: Swan Hill Press/ Airlife Publishing, 1996), 67.

221. Katherine Sim, *David Roberts R.A. 1796-1864, A Biography*, (London: Quartet Books, 1984), 143.

222. Roberts, quoted in Sim, 142.

223. Lear to Lady Waldegrave, 9 March 1867, in Strachey, *Later Letters of Edward Lear*, 83.

224. "I sit and draw all day long in the sun – among the ruins..." Letter to Ann Lear, 14 December 1837, Morgan Library.

225. The Convent of SS Giovani Paolo still exists at the elevated site overlooking the Colosseum from which Lear

made this view. In a letter of March 1, 1838, Lear described it as an "enchanted spot," and indicated it was a place he visited often.

226. Lear to Ann Lear, 27 January, 1838, quoted in Michael Montgomery, *Lear's Italy: In the Footsteps of Edward Lear*, (London: Cadogan, 2005), 26.

227. Lear to Ann Lear, 11 May 1838, Morgan Library.

228. Lear to Ann Lear, 3 May 1838, Morgan Library.

229. Ibid.

230. Lear to Ann Lear, ibid, quoted in Michael Montgomery, *Lear's Italy*, 31-32.

231. Lear to Ann Lear, 14 December 1837.

232. Lear to Mrs. Roberts, 1 March 1838.

233. Lear to Ann Lear, 14 December 1837, quoted in Montgomery, *Lear's Italy*, 23-24.

234. Lear to George Coombe, 24 June 1835, quoted in Noakes, *Life of a Wanderer*, 30.

235. Lear rented a studio and a bedroom on the second floor of a grand house at 39 Via del Babuino for ten dollars a month. See letter to Ann Lear, 14 December 1837, Morgan Library, quoted in Noakes, *Selected letters*. Lear subsequently rented rooms at 107 Via Felice, and at No. 9 Via dei Condotti. See Maldwin Drummond, *After You, Mr. Lear: In the Wake of Edward Lear in Italy* (Rendelsham, Suffolk: Seafarer Books, 2007), 136. I am grateful to the American Academy in Rome for giving me the opportunity to visit these and other places in the city frequented by Lear during my residency at the Academy in 2013.

236. F.T.,"British Academy of the Arts in Rome," *The Roman Advertiser*, no. 11, (Jan. 2, 1847): 82.

237. Lear to Ann Lear, 27 January 1838.

238. Ibid.

239. Edward Lear, preface to *Illustrated Excursions in Italy* (London: Thomas M'Lean, 1846).

240. Ibid.

241. Review of *Illustrated Excursions in Italy*, vol II, in *The Art Union Monthly Journal of the Fine Arts and the Arts Decorative and Ornamental* 8 (December 1846): 322.

242. Ibid., 242.

243. HRH Queen Victoria, diary entry, July 15, 1846, quoted in Noakes, *Life of a Wanderer*, 61.

244. Ibid., July 16, 1846.

245. Ibid, July 17, 1846.

246. This may explain the existence of many contemporary copies of Lear's parrot plates. Though sometimes attributed to Lear, these paintings are almost certainly the works of his students. Examples can be seen in the Donald Gallup collection at the Yale Center for British Art. (See B1997.7.352 through 357.)

247. I wish to thank Her Majesty Queen Elizabeth II and her curator of prints and drawings, Martin Clayton, for allowing me to visit the Royal Collection at Windsor to inspect these materials firsthand, and to reproduce two of the paintings from her collection in this book.

248. Lear to Ann, 6 February, 1847 quoted in Noakes, *Life of a Wanderer*, 63. The engraving has since been lost.

249. *Illustrated Excursions in Italy* (2 volumes), *Gleanings from the Menagerie and Aviary of Knowsley Hall*, and *A Book of Nonsense* (under the pseudonym Derry-down-Derry).

250. Lear's portrait of Burton (Houghton Library) matches two painted by Thomas Seddon in 1854. Lear's portrait is dated Cairo, December 23, 1853, a year before Seddon finished his, and several years before a lithograph of one of the Seddon portraits appeared in Burton's *Personal Narrative of a Pilgrimage to El-Medinah and Meccah*. Did Lear copy a preliminary study by Seddon? Did he backdate his painting? Vivien Noakes notes that Lear never mentions the portrait or Burton in his diary. See Noakes, *Life of a Wanderer*, 280, n. 3. The Lear portrait of Burton, reproduced in the Royal Academy exhibition catalog (1985), 72, remains an unresolved mystery. For Seddon's description of Lear, see [John Pollard Seddon], *Memoir and Letters of the Late Thomas Seddon by his Brother* (London: Nisbet, 1858), 60. I am indebted to the art historian Briony Gimmson for her help in sorting out the confusing sequencing of the so-called Burton portraits by Seddon and Lear, and to Sarah Searight for first drawing my attention to the still-unresolved relationship between the two-artists.

251. Peter Levi, *Edward Lear: A Biography*, (New York: Scribner, 1995), 328.

252. In letters to Thomas Seddon about his pending trip to Egypt in 1853, Hunt mentions both Lewis and Lear. He was undoubtedly the one who introduced Lear to both artists.

253. Lear letter to Mrs. John Frederick Lewis, 22 June 1875, in Noakes, *Selected Letters*, 248.

254. Lear to Ann Lear, 21 October 1848, in Noakes, *Selected Letters*, 90.

255. Edward Lear, *Journal of a Landscape Painter in Albania*, quoted in Paul Theroux, *The Tao of Travel: Enlightenment from Lives on the Road*, (New York: Mariner Books/ Houghton Mifflin Harcourt, 2012), 79.

256. For an essay on how other British travelers adopted local dress, see: John Rodenbeck, "Dressing Native," in *Unfolding the Orient*, eds. J & P Starkey (Reading: Ithaca Press, 2001).

257. *Memoir and Letters of the Late Thomas Seddon, Artist, by His Brother* [John Pollard Seddon], London, 1858, p. 60, quoted in James Thompson, *The East Imagined, Experienced, Remembered: Orientallist Nineteenth Century Painting* (Dublin: The National Gallery of Ireland, 1988), 103.

258. Lear to Ann Lear, 21 October 1848, in Noakes, *Selected Letters*, 93.

259. Edward Lear, *Journals of a Landscape Painter in*

Albania, 92, quoted in Davidson, *Edward Lear, Landscape Painter and Nonsense Poet*, 59-60.

260. Lear to Ann Lear, 21 October 1848, in Noakes, *Selected Letters*, 93.

261. Lear to Lady Waldegrave, 27 May 1858, in Noakes, *Selected Letters*, 154. For a more detailed account of the attack, see Davidson, 116-18, and Noakes, 135-36.

262. Lear to Lady Waldegrave, 27 May 1858, in Noakes, S*elected Letters*, 153.

263. Lear to Emily Tennyson, May 10, 1865, in Noakes, *Selected Letters*, 204.

264. Lear to Emily Tennyson, 9 October 1856, in Noakes, *Selected Letters*, 140.

265. Similarly, the Indian Rhinoceros, on view at the London Zoo beginning May 1834, never attracted Lear's interest. I am grateful to Ann Sylph, librarian at the Zoological Society of London, for providing the resident animal records of the London Zoo.

266. Lear, Indian Journal, Nov. 26, 1873, quoted in Vidya Dehejia, *Impossible Picturesqueness: Edward Lear's Indian Watercolours, 1873-1875*, (Chidambaram, Ahmedabad: Mapin Publishing Pvt., Ltd., and Middleton, New Jersey: Grantha Corporation in conjunction with Columbia University, 1989), 6.

267. Although he came to them relatively late in life and long after he had stopped focusing exclusively on natural history topics, Lear painted elephants more than any other mammal except, perhaps, camels. There are thirty-one elephant studies in the Houghton Library collection alone.

268. For a further discussion of the ways in which Lear transformed his knowledge of natural history into irreverent "nonsense," see Ann C. Colley, *Wild Animal Skins in Victorian Britain: Zoos, Collections, Portraits, and Maps* (Farnham, Surrey: Ashgate Publishing Ltd., 2014).

269. The original ink drawings were given to Houghton Library by W. B. O. Field in 1942 (MS Eng 797.1). First published by Lear in 1871, they were republished by the Department of Printing and Graphic Arts of the Harvard College Library, with an introduction by Philip Hofer, in 1963.

270. Lear, *The Biscuit Tree*, ink on paper, undated. Houghton Library, MSTyp. 55.14(26), first published in *Teapots and Quails and Other New Nonsenses* (London: John Murray, 1953).

271. See his undated *Caucasian Comfrey*, or Beinwell (*Symphytum caucasicum*), at Houghton Library (MS Typ 55.4, folder 2 of 11), or his *Oak-leaved Geranium* (*Pelargonium quercifolium*), dated 1828, private collection, illustrated in Noakes, Edward Lear 1812–1888, 78. These two paintings are illustrated in this book as figures 123 and 17 respectively.

272. Letter to Charles Empson, 1 October 1831, published in Noakes, *Selected Letters*,12-17.

273. Lear, April 20, 1862, quoted in Dehejia, *Impossible Picturesqueness*, v.

274. Lear's Indian Journal, November 22, 1873, quoted in Dehejia, 6.

275. Alfred Seymour, brother of Lady Rawlison.

276. Ten letters from Lear to Sir Joseph Hooker, dating from 1872 to 1878, are owned by the Royal Botanical Garden at Kew. I wish to thank Christopher Mills and Charles Lewsen for bringing these letters to my attention.

277. Noakes, *Edward Lear 1812–1888*, 10.

278. Lear quoted in Susan Chitty, *That Singular Person Called Lear* (London: Weidenfield and Nicolson, 1988), 165.

NOTES FOR PART II

1. Edward Lear, introduction to *More Nonsense, Pictures, Rhymes, Botany, Etc.* (London: Robert John Bush, 1872), reprinted in *The Complete Nonsense Book*, ed. Lady Strachey (New York: Duffield & Co., 1912), 25–27.

2. Lear to Lady Waldegrave, 17 October 1866, in Strachey, *Later Letters of Edward Lear*, 78–79. An expanded version of this story was published in the introduction to *More Nonsense, Pictures, Rhymes, Botany, Etc.*, 1872, xiii–xiv, reprinted in Strachey, *The Complete Nonsense Book*, 26–27.

3. Lear, introduction to *More Nonsense, Pictures, Rhymes, Botany, Etc.*, 1872, reprinted in Strachey, *The Complete Nonsense Book*, 27.

4. Edward Lear, with drawings by L. Leslie Brooke, *The Jumblies and Other Nonsense Verses* (London: Frederick Warne & Co., 1910); and Edward Lear, with drawings by L. Leslie Brooke, *The Pelican Chorus and Other Nonsense Verses* (London: Frederick Warne & Co., 1910).

5. Lear, introduction to *The Pelican Chorus and Other Nonsense Verses*.

6. The book included three poems in all. Two, "The Owl and the Pussycat" and "The Duck and the Kangaroo," were by Lear. The publisher claimed they were "printed with permission from Mr. Lear's *Nonsense Songs and Stories* published by Robert John Bush, 32, Charing Cross, London." The third poem in the collection, "How the Beasts got into the Ark," was not by Lear.

7. Sendak made several spot drawings of his parrot figure from *Where The Wild Things Are* reading a copy of one of Lear's books of nonsense to serve as illustrations for a 1968 article by Brian Alderson for the *London Times Book Review*. Unfortunately, Maurice Sendak's estate refused permission to reproduce any of these or any of Sendak's other Lear-related illustrations in this book. For a reproduction of the artist's Lear-reading parrot, see Justin Schiller and Maurice Sendak, *Maurice Sendak: A Celebration of the Artist and His Work* (New York: Abrams and Society of Illustrators, 2013), 202. Lear's influence on Sendak is evident in a number of his works, especially in his early books such as *A Hole is to Dig* with text by Ruth Krauss (1952). He created his own interpretation of Lear's poem "The Jumblies." For more biographical information on Sendak and Lear's influence on him, see Selma Lanes, *The Art of Maurice Sendak* (New York: Abrams, 1980), and Tony Kushner, *The Art of Maurice Sendak, 1980–Present* (New York: Abrams, 2003).

8. Letter from Beatrix Potter to Eric Moore, 28 March 1894, Cotsen Children's Library, Princeton University, #21862.

9. Letter from Beatrix Potter to Noel Moore, 4 March 1897, Morgan Library, MA 2009.10. Her previous letter to Noel Moore, also containing illustrations of Lear's owl and pussycat, is dated February 27, 1897. It is at the Morgan Library, MA 2009.9. There is an even earlier letter from Potter to Moore dated February 13, 1897, at the Cotsen Children's Library at Princeton. It contains the first verse of the rhyme.

10. These letters are at the Cotsen Children's Library at Princeton University, the Morgan Library in New York, the Beinecke Library at Yale University, the Victoria and Albert Museum in London, and in a private collection in the UK. Some are reproduced in Judy Taylor, ed., *Letters to Children from Beatrix Potter* (London: Frederick Warne, 1992). I am indebted to Beatrix Potter's biographer, Linda Lear, for her help in tracking down Potter's various interpretations of Lear's poem and for her insights into the influence Lear had on Potter and her art.

11. Joyce Irene Whalley and Anne Stevenson Hobbs, "Fantasy, Rhymes, Fairy Tales and Fables," in *Beatrix Potter 1866–1943, The Artist and Her World* (London: Frederick Warne & Co. with the National Trust, 1987), 70.

12. According to Potter expert Derek Ross, Potter may have considered printing a small booklet containing her Lear-inspired drawings, for she borrowed them back from the Moore children in order to make copies of them, as she did others. The copies exist (at the Victoria and Albert Museum in London) but no booklets were ever printed.

13. Beatrix Potter quoted in Whalley and Hobbs, *Beatrix Potter 1866–1943*, 70.

14. Linda Lear has found evidence that Potter first illustrated a "pig with a ring in his nose" as early as 1883. Personal correspondence, August 21, 2014.

15. The "How Pleasant to Know Mr. Lear" exhibition was held at the Brighton Museum & Art Gallery from 29 November 1988 to 29 January 1989. The books exhibited are itemized in the exhibition catalog.

16. Judith G. Brown in Joanna Cole, ed., *A New Treasury of Children's Poetry* (New York: Doubleday, 1984); Nancy Ekholm Burkert, *The Scroobius Pip* (New York: Harper & Row, 1968); William Foster, *Nonsense Drolleries* (London: Frederick Warne, 1889); Hilary Knight, *The Owl and the Pussycat* (New York: Macmillan, 1983); Tomi Ungerer, *Lear's Nonsense Verses* (New York: Grosset & Dunlap, 1967).

17. Both books were published by Young Scott Books of New York.

18. Edward Gorey limerick in Peter F. Neumeyer, ed., *Floating Worlds: The Letters of Edward Gorey and Peter F. Neumeyer* (San Francisco: Pomegranate, 2011), 199.

19. Gorey in Tobi Tobias, "Battelgorey," *Dance Magazine*, 1974, quoted in Karen Wilkin, ed., *Ascending Peculiarity: Edward Gorey on Edward Gorey* (New York: Harcourt, Inc., 2001), 21.

20. Gorey, quoted in Stephen Schiff, "Edward Gorey and the Tao of Nonsense," *The New Yorker*, November 9, 1992, reprinted in Wilkin, *Ascending Peculiarity*, 147.

21. Gorey, letter to Peter Neumeyer, 11 April 1969, quoted in Neumeyer, *Floating Worlds*, 218.]

22. Edward Lear and Jan Brett, *The Owl and the Pussycat* (New York: G. P. Putnam's Sons, 1991).

23. According to the artist, the scenes are set on the island of Martinique.

24. William Cooper, personal correspondence, July 18, 2014.

25. For more on Cooper, see Penny Olson, *An Eye for Nature: The Life and Art of William Cooper* (Canberra: National Library of Australia, 2014).

26. Wendy Cooper, personal communication, May 17, 2015.

27. Richard Verdi, *The Parrot in Art from Durer to Elizabeth Butterworth* (Birmingham: Scala Publishers in Association with the Barber Institute of Fine Arts, the University of Birmingham, 2007), 47.

28. Elizabeth Butterworth, personal correspondence, July 28, 2014.

29. Elizabeth Butterworth, personal correspondence, July 28, 2014.

30. Bill Buford, "Field Studies: Walton Ford's Bestiary," in Walton Ford, *Pancha Tantra* (Hong Kong and London: Taschen, 2009), 8.

31. Ibid.

32. Walton Ford, personal communication, March 4, 2015.

33. Ibid.

34. James Prosek, personal communication, 2014.

35. James Prosek, *Trout, an Illustrated History* (New York: Knopf, 1996).

36. James Prosek, *Trout of the World* (New York: Tabori and Chang, 2003; revised edition, Abrams, 2013).

37. In another "cockatool" painting made three years after the first (2011), Prosek offered a different cockatoo with tools emerging from its wings, confirming that a tool-equipped bird was a subject of continuing interest to him.

38. James Prosek, *Suriname*, exhibition catalog (New Haven: The Gallery at the Whitney, Yale University, 2011).

39. John B. Ravenal, introduction to *James Prosek Real & Imagined*, exhibition catalog (Richmond: VA, Reynolds Gallery, 2009).

40. Ibid.

41. Quoted in *Worldviews: The Watercolor Diaries of Tony Foster* (Seattle: Frye Art Museum in association with the University of Washington Press, 2000),11.

42. Ibid., 11.

43. Ibid., foreword, 7.

44. Ibid., 9.

45. Lear, *Journal of a Landscape Painter in Corsica* (1870).

46. *Worldviews*, 11.

47. Ibid., 11.

48. Ibid., 11.

49. Lear to Ann Lear, January 27, 1838.

50. Among his fellow travelers were Charles Marcus Church, Daniel Fowler, John Gould, Robert Hornby, Bernard Husey Hunt (Bernard Senior), William Knighton, John Joshua Proby, Arthur Penrhyn Stanley, William Theed, and James and Thomas Uwins.

51. John Doyle, personal correspondence, June 3, 2014.

52. Ibid.

53. Toby, "Philip Hughes Walks the Ancient Landscapes of Britain," *Thames & Hudson* (blog), June 19, 2012, http://www.tandhblog.co.uk/2012/06/philip-hughes-on-walking-the-ancient-landscapes-of-britain/.

54. Ibid. For more on Hughes, see Philip Hughes, *Tracks: Walking the Ancient Landscapes of Britain* (London: Thames and Hudson, 2012).

55. Philip Hughes interview with Roger Cox, *The Scotsman*, May 28, 2012.

56. Ibid.

57. Hubert Congreve, preface to Strachey, *Later Letters of Edward Lear*, 22–23.

58. "Neither perpetual church services (high or low – candlestix or cursings) are to my taste; nor are balls & lawn tennis among my weaknesses," he wrote Wilkie Collins on March 7, 1886 (Morgan Library). The only people who would admire priests, he told Chichester Fortescue some years earlier, were "Fanatics, Farisees, Faymales and Fools" (letter to Fortescue, 3 November 1864, in Strachey, *Later Letters of Edward Lear*, 55). In a letter from Corfu a decade before that, he was even more outspoken in his criticism of the monks he encountered in a monastery on the Holy Mountain near Kariess. "I would not go again," he wrote, "for any money, so gloomy – so shockingly unnatural – so lonely – so lying – so unatonably odious seems to me all the atmosphere of such monkery. . ." He went on to decry the monks as "muttering, miserable, muttonhating, manavoiding, misogynic, morose, & merriment-marring, monotoning, many-Mulemaking, mocking, mournful, mincedfish and marmalade masticating Monx . . ." concluding that "it is not them – it is their system I rail at." Letter to Chichester Fortescue, 9 October 1856, in Strachey, *Letters of Edward Lear*, 412, quoted in Noakes, *Life of a Wanderer*, 123.

59. Some of the British cartoonists who have used Lear

images in their work are Steve Bell, Neil Bennett ("N.B."), Wally Fawkes ("Trog"), Stanly Franklin, John Jensen, and John Musgrave-Wood ("Emmwood").

60. The University of Kent's British Cartoon Archive cites at least thirty-four cartoons in which Garland acknowledges Lear as the source of his inspiration.

61. Nicholas Garland, personal correspondence, May 18, 2014.

62. Ibid.

63. Ibid.

64. Garland particularly liked the "Jumblies" metaphor for depicting government projects that he thought were doomed to fail. In the British Cartoon Archives at the University of Kent are five other "Jumblies"-inspired cartoons by him.

65. This cartoon was published in the *Daily Telegraph* on October 8, 2004.

66. See British Cartoon Archive website.

67. Nicholas Garland, personal correspondence, May 18, 2014.

68. Ibid.

69. Ibid.

70. Ibid.

71. Ibid.

72. Edward Gray to the thirteenth Earl of Derby, 27 January 1844 in Sauer, *John Gould the Bird Man: Correspondence*, vol. 3, 272.

73. John Ruskin, *Pall Mall Magazine*, February 15, 1886.

74. Tennyson's poem "To E.L. on His Travels in Greece" was written in 1851–1852 and published in 1853. See Ruth Pitman, *Edward Lear's Tennyson* (Manchester: Carcanet Press, Ltd., 1988), 140.

75. Lear to Emily Tennyson, 9 October 1856, in Noakes, *Selected Letters*, 140.

The Zigzag Zealous Zebra, who carried five Monkies on his back all the way to Jellibolee.

APPENDIX

Only two copies of Lear's parrot monograph appear to survive with either the original wrappers or a record of when each part was received. These are owned by Downing College, Cambridge, and the Linnean Society of London. A listing of the sequence in which the Linnean Society received its parts was compiled by Gavin Bridson, librarian of the society, and published by Brian Reade in *An Essay on Edward Lear's Illustrations of the Family of Psittacidae, or Parrots* (London: Pion, 1978).

The information provided in this appendix differs slightly from the Linnean Society sequence and so is being offered here for reference. This Balfour/Newton copy, which retains its original wrappers, was acquired by Downing College, Cambridge, early in the twentieth century. This transcription was made by the art historian Christine E. Jackson, to whom I am indebted.

Each of the first five covers (sometimes referred to as wrappers) has "——— 1st 183———" printed in the top left-hand corner, allowing the month and year to be added by hand in ink. In the upper right-hand corner are printed "No.——" (once again to be completed by hand) and the price "Ten Shillings." The part number and the date of issue are repositioned in the table below for the sake of readability. Nos. 1 through 5 have the same cover design with a

macaw on the left and a cockatoo and a parrot on the right-hand side of a wall of stones (a reproduction of which can be seen in figure 56 on page 66), except that in No. 5, after Lear's name, the designation "A.L.S." is added (following his election as an Associate of the Linnean Society). Covers for nos. 6 through 10 have a different design, this one with different writing and a parrot sitting on a single block of stone (see figure 57 on page 66). The alteration was made to accommodate the heading "Under the patronage of and Dedicated by Permission to The Queen's Most Excellent Majesty." Covers 6 through 10 omit the partially printed date and number that were included in the earlier covers. "To be published in 14 parts" persisted on the covers through part 12 (only nos. 1 through 10 are present in this copy, but the wrapper to part 12 at Houghton Library confirms this detail). The nomenclature below comes from the plates themselves, which are not numbered. The final plate numbers and nomenclature adjustments, given in brackets here, come from Lear's "List of Plates" leaf, and are included in this appendix for ease of reference. The "List of Plates" leaf is letterpress and was issued, along with the letterpress title leaf, dedication leaf, and subscribers' leaf. These were distributed to subscribers with the parrot plates in part No. 12.

No. 1. November 1st 1830 [Note: part numbers and dates were completed by hand for nos. 1–5. For image of the cover design that was used for these first five parts, see figure 56 on page 66]

Plates: *Platycercus Stanleyii* [23 or 24]
 Palaeornis torquatus [33]
 Palaeornis Columboïdes [31]

No. 2. December 1st 1830

Plates: *Psittacus badiceps* [1]
 Psittacula Swinderniana [42]
 Plyctolophus sulphuratus [4, *sulphureus* in Lear's List of Plates (1832)]
 Platycercus pileatus [21 or 22]

No. 3. January 1st 1831

Plates: *Platycercus Pacificus* [26]
 Macrocercus hyacinthinus [9]
 Palaeorinis rosaceus [30]

No. 4. February 1st 1831

Plates: *Platycercus Brownii* [20]
 Psittacara Patagonica [10, *Patachonica* in Lear's List of Plates (1832)]
 Plyctolophus rosaceus [2]
 Platycercus unicolor [25]

No. 5. ——— 1st 183——— [cover changed to read "By E Lear, A.L.S."]

Plates: *Platycercus Barnardi* [18]
 Platycercus erythropterus 1. Female 2. Young Male [15]

 Psittacara nana [12]

No. 6. [Note: Lear issued a new cover (wrapper) design from part 6 on, with no printed date or number and no price – see figure 57 on page 66]

Plates: *Platycercus Baueri* [17]
 Nanodes undulatus [13]
 Plyctolophus Leadbeateri [5]
 Psittacula Kuhlii [38]

No. 7 *Lorius Domicella* [37]
 Trichoglossus versicolor [36]
 Psittacara leptorhyncha [11]

No. 8 *Palaeornis Novae Hollandiae*
 1. Male 2. Female [27]
 Palaeornis anthopeplus [29]
 Trichoglossus rubritorquis [34]

No. 9 *Macrocercus Aracanga* [7]
 Psittacula torquata [40]
 Plyctolophus galeritus [3]
 Psittacula rubrifrons [41]

No. 10 *Trichoglossus Matoni* [35]
 Platycercus Tabuensis [16]
 Psittacula Taranta [39, *Tarantae* in Lear's List of Plates (1832)]
 Platycercus erythropterus [14]

Seven plates (6, 8, 19, 21 OR 22, 23 or 24, 28, and 32) are not included in this appendix because parts No. 11 and 12 are missing from the Downing College copy.

ACKNOWLEDGMENTS

The idea of writing a book on the natural history painting of Edward Lear was first suggested to me by Sir David Attenborough. Beginning in the early 1980s, we shared frequent conversations ranging from natural history and wildlife conservation, to travel and fine art. On this last subject, Sir David often focused my attention on the talents of Edward Lear, saying that more research was needed on the natural history paintings that dominated his early life. His friend Vivien Noakes, Edward Lear's biographer and the curator of a dazzling exhibition of Lear's paintings at the Royal Academy of Arts in London in 1985, agreed with Sir David that more research was needed on this little-studied aspect of Lear's career, and that it would be best carried out by someone steeped in the field of natural history.

Inspired by their encouragement and support, I decided to explore the possibility of such a project by introducing myself to the world's largest collection of Lear paintings at Harvard University's Houghton Library. I was able to begin this research in earnest when I was granted a research fellowship at the library in 1995. Two years later I received a similar fellowship at the Yale Center for British Art, where I was able to expand my understanding of Lear's place in the history of English painting, writing, and exploratory travel.

While working on several other writing projects, I had to interrupt my Lear research for a number of years, but I was able to return to it in 2010. That spring I met with William Stoneman, the Florence Fearrington Director of the Houghton Library, and Hope Mayo, the Philip Hofer Curator of Printing and Graphic Arts there, to ask whether the library would allow me to reproduce some of its collection in a book about Lear's natural history paintings. To my delight, they agreed. Soon our conversation expanded to a discussion of how the Houghton Library might celebrate the 200th anniversary of Edward Lear's birth. One thing led to another, and at the conclusion of our meeting, I was flattered to receive two invitations: the first to serve as the guest curator of a bicentennial exhibition of Lear's paintings at the library, and the second to write an essay about Lear's natural history interests for the *Harvard Library Bulletin* in a special Lear-focused issue which would be published in conjunction with the show. With the blessing of the Academy of Natural Sciences of Philadelphia (now part of Drexel University), where I serve as Curator of Art and Artifacts and Senior Fellow, I happily accepted Harvard's invitations. I was awarded a second fellowship at the library – and a short leave of absence from the Academy – in the spring of 2011 to work on both parts of the 2012 anniversary celebration.

The Lear book that David Attenborough had suggested I write so many years before took another critical step when David R. Godine expressed interest in publishing an illustrated account of Lear's natural history. Having enjoyed the Houghton exhibition featuring this subject, he asked if I would like to write a book about it. The answer, of course, was yes. I had admired his beautiful books for many years, and was thrilled by the opportunity to collaborate with such a respected publisher on a subject that had fascinated me for so long. We have been working closely together ever since.

In addition to Bill Stoneman and Hope Mayo, who did so much to support my research at the Houghton, I want to thank others who have helped me at Harvard over the years. They have included the late Eleanor Garvey, long a champion of Lear at the library, Anne Anninger, who was in charge of the Lear collection at the time of my first Houghton fellowship there, Dennis Marnon, coordinating editor of the *Harvard Library Bulletin*, and Caroline Duroselle-Melish, who helped me locate many of Lear's most beautiful but rarely seen paintings in the collection.

David R. Godine, Publisher is a privately owned publishing house that has earned a world-wide reputation for the beauty of its books and the quality of its scholarship. I have greatly enjoyed working with them over the past four years. I wish to thank David, first and foremost, for his invitation and his generous support. I also want to acknowledge Sara Eisenman, who did such a spectacular job designing this book, Chelsea Bingham, who has overseen its production, and Sue Ramin, who has worked closely with the Antique Collectors' Club on the book's publication in the U.K., have also been wonderful colleagues. To everyone at Godine, and to our indexer Helene Ferranti, I am extremely grateful. At the Antique Collectors' Club I would like to acknowledge the enthusiastic support of James Smith, the publisher of ACC Editions.

While I was at the Yale Center for British Art as a fellow in 1997, and in many research visits since, I have been given the warmest welcome and invaluable assistance. I would especially like to thank Amy Meyers, the center's director, Elisabeth Fairman, the Curator of Rare Books and Manuscripts, Sarah Welcome, also in the Rare Book and Manuscript Department, Cecie Clement, a long-time friend and Yale Center champion, and Scott Wilcox, the center's Curator of Paintings, all of whom have helped me with Lear and so much else. The late Donald Gallup, also affiliated with Yale, was a perceptive Lear collector who generously shared his knowledge with me before and after donating his paintings to the British Art Center. I am pleased that I could include a few of them in this book.

In England, in addition to the encouragement and support given by Sir David Attenborough and the late Vivien Noakes (whose husband, Michael, generously permitted my access to her Lear-related papers, now at Somerville College, Oxford), I have been helped by many others. At the World Museum (National Museums)

in Liverpool, Clemency Fisher has been an encouraging friend and an invaluable source of information throughout this project. At Knowsley Hall, Lord and Lady Derby have been extremely generous and supportive, as has Stephen Lloyd, Curator of the Derby Collection. At the Royal Collection at Windsor, I am grateful to the Senior Curator of Prints and Drawings, Martin Clayton, for making paintings by both Lear and Queen Victoria available for my inspection and for inclusion in this book. At the Ashmolean Museum in Oxford, the Senior Curator of European Art, Colin Harrison, a Lear expert in his own right, has provided both encouragement and assistance. At the Fitzwilliam Museum in Cambridge, I am grateful to Senior Curator Jane Munro. At the Royal Botanical Gardens at Kew, Curator Christopher Mills made an interesting collection of Lear letters to the garden's director, Sir Joseph Hooker, available for my use.

The Zoological Society of London, where Lear spent such critically important time in his early life, is an important source of original art work. There, Librarian Ann Sylph and her colleagues, Michael Palmer, Rowena Fisher, and James Godwin, have been extremely helpful over many years, and I am much in their debt. Ann Datta, formerly at the Natural History Museum in London, and periodically affiliated with the library at the London Zoo, has also been a long-time supporter of my research. Similarly, Gina Douglas, former librarian at the Linnean Society of London, and Paul Martyn Cooper, librarian at the Natural History Museum in London, have been extremely helpful and hospitable during my repeated visits to their respective institutions and in our correspondence. I am grateful to Janis Rodwell, a Trustee of the Spode Museum Trust, for her help in identifying links between Lear's artistry and the production of "fancy bird" ceramics in Great Britain. Jonathan Gray also added useful information to my research on this topic.

I wish to thank Edward Wakeling and Charles Lovett, two of the world's leading experts on Charles Dodgson (Lewis Carroll), for helping me to explore and confirm the surprising lack of communication between Dodgson and Lear, despite the two writers' common interest in children and nonsense poetry, and their mutual friendship with Emily Tennyson.

I am deeply indebted to Maureen Lambourne, an expert on the life and art of John Gould, and Christine Jackson, a well-known authority on many wildlife artists, as well as the history of British menageries. Their guidance and support over many years has been critically important to my work. They have also made my intellectual journey through the subjects they know so well a thoroughly enjoyable experience. I am also grateful to the many scholars who have written on Lear's important contributions to literature. I would especially like to thank James Williams and Mathew Bevis. James organized a stimulating conference on that subject at Oxford University in 2012, and Mathew gave the

British Academy's Chatterton Lecture on "Edward Lear's Lines of Flight" in that same year.

A number of art historians have been extremely generous with their advice on Lear during the course of my research. I would especially like to thank Derek Johns, a founder of the Edward Lear Society, the late Andrew Wyld, an authority of British watercolors, and Harriet Drummond, who for several decades has overseen the sale of Lear's paintings at Christie's. I would also like to thank Briony Gimmson and Sarah Searight, two experts on British artists who painted in the Middle East, for their help in sorting out Lear's portrait of Richard Burton in Cairo.

Roger Taylor, an authority on 19th century British photography, has provided invaluable advice on the photographs of Lear and his family. Pete Gillies, Susie Winter, and David Michell have each contributed significant content to this book, enabling me to form opinions and chronicle Lear's life in ways that I could not have without them. Also making a major contribution in this regard was Charles Lewsen, a long-time friend of Vivien Noakes, an authority on Lear's epilepsy, and a tireless champion of Lear's important place in the history of art and literature. I wish to thank him for his encouragement and support with this book. Without his many introductions to personal contacts relating to Lear, and his help following countless leads in the U.K and around the world, my research would have been less comprehensive and rewarding.

Four authoritative experts in differing aspects of British art, Rupert Maas, Guy Peppiatt, Lowell Libson, and W. Graham Arader, along with a number of private collectors in the U.S., Great Britain, Australia and New Zealand, who have requested anonymity, made available paintings for reproduction in the book. For this I am deeply grateful. It is a delight to make these beautiful watercolors available for public view, many for the first time.

Since starting this project, I have read and learned a great deal from not only Vivien Noakes' foundational books on Edward Lear, but also from publications by many others, including Peter Levi and Susan Chitty (through their respective biographies of Lear), Ruth Pitman, Seamus Perry, and Richard Cronin (all on Lear's relationship with Alfred Lord Tennyson), Susan Hyman (on Lear's birds), Ann C. Colley (on Lear's interest in animals), Allen Stanley and Vidya Dehejia (on Lear's travels in India), Bejtullah Destani and Robert Elsie (on Lear's travels in Albania), Stephen Duckworth, Rowena Fowler, and Elizabeth Wells (on Lear's travels in Greece and Crete), Michael Twyman (on Lear's lithography), John Varriano (on Lear's paintings in Malta), and Michael Montgomery and Maldwin Drummond (on Lear's travels in Italy). I am grateful to Charles Nugent for his important work on Lear's evolution as a landscape painter with a particular focus on his early travels in Ireland and the English Lake District. His beautifully illustrated book on this subject, published by

the Wordsworth Trust in 2009, is an invaluable resource in documenting Lear's youthful interests and his transition from the field of natural history to landscape painting.

Admiration and affection for Lear are, of course, world-wide in scope, as I am constantly reminded during my own travels in Lear's footsteps. In Italy his greatest champion is Marco Graziosi, who has shared his enthusiasm for all things Learian. His invaluable web site, "A Blog of Bosh," keeps its subscribers up to date on articles, books, exhibits, lectures, and anything else that is going on in the ever-growing field of Lear studies.

In 2013 I was fortunate to be able to spend time as a visiting scholar at the American Academy in Rome. While taking advantage of the Academy's intellectual stimulation and superb library, and my daily access to Lear's beloved city, I also spent time in the Vatican Library, where curator Barbara Jatta, graciously allowed me to examine all of the Lear paintings in care of the Holy See. The island of Corfu, where Lear found much happiness, has honoured him with conferences, an exhibition (in 2012), and a public bust by Margo Roulleau-Gallais (unveiled in 2014). The Italian coastal town of San Remo, where Lear spent the last seventeen years of his life and is buried, has commemorated his memory with concerts, symposia, and exhibitions, the most extensive of which was organized by Rodolfo Falchi and Valerie Wadsworth in 1998.

In Canada, Eleanor MacLean and her successor Richard Virr, Librarian at McGill University, Montreal, have been extremely helpful to me by providing access to the important Lear holdings in the Blaker-Wood collection. In Kansas City, Karen Severud Cook, librarian at the University of Kansas, provided access to the Spencer Library's collection of John Gould paintings and manuscripts, including a number by Edward Lear. At Princeton University Andrea Immel, Director of the Cotsen Children's Library, generously shared her knowledge of Lear and his contemporaries, and made the Lear materials in her care accessible. Similarly, John Bidwell, the Astor Curator of Printed Books and Bindings at the Morgan Library in New York, took time to discuss with me the relationship between Edward Lear and Beatrix Potter, an equally interesting artist-writer about whom Linda Lear, Potter's biographer, was also willing to provide much useful information. Justin G. Schiller, an expert on children's art and literature, and a long-time admirer of Edward Lear, very kindly put me in touch with private collectors in that field, and with both institutions and individuals who could provide appropriate images for inclusion in this book. Leslie Overstreet, Curator of Natural History Rare Books at the Smithsonian Institution, and Christopher Brown, Curator of Children's Literature at the Free Library of Philadelphia, have both been generous in making the resources in their respective libraries available.

The Academy of Natural Sciences of Drexel University, where I serve as Curator of Art and Senior Fellow, has been the base for much of my research throughout the preparation of this book. I am fortunate that among the 250,000 volumes in its comprehensive natural history library are all of the scientific illustrations that Lear published during his lifetime. This has allowed me a first-hand look at the productive side of his scientific career. I wish to thank my present and former colleagues in the library, Danial Elliott, Carol Spawn, Eileen Mathias, Clare Flemming, Cathy Buckwalter, Bridget Clancy, Jennifer Vess, Ria Capone, Evan Peugh, and David Campbell for their help in making these images and other resources available for use in this book. Dan Thomas, also at the Academy, was my technological coach, assistant, and mentor throughout. He patiently helped me gather all of the high resolution digital images that appear here, and that I have used in public presentations on Lear in recent years. Without his help, *The Natural History of Edward Lear* would not have been possible.

Other friends and colleagues throughout the Academy have also been extremely helpful. I especially want to thank George Gephart, the Academy's president and CEO, who supported my work on this book, and has done so much else to make the Academy an inspiring place to work. Among my scientific colleagues, Ted Daeschler, Nate Rice, Ernie Schuyler and Ned Gilmore were not only encouraging, but invaluable to sorting out Lear's many unlabelled and sometimes unfinished drawings of plants, birds, mammals, reptiles, and amphibians. Also extremely helpful in this process were colleagues from other institutions, including Kraig Adler, from Cornell University, and Roger Bour, from the Muséum National d'Histoire Naturelle in Paris (both on Lear's turtles), Leo Joseph, Director of the Australian National Wildlife Collection at Australia's Commonwealth Scientific and Industrial Research Organization (CSIRO) and Penny Olsen, at the Research School of Biological Sciences of the Australian National University (both on Lear's Australian birds and mammals), and Clemency Fisher and Tony Parker in Vertebrate Zoology at the World Museum, National Museums Liverpool, on a range of Lear's unidentified wildlife subjects. Others, too numerous to mention, have also assisted in this time-consuming and difficult task. To each and every one of them I am most grateful.

Although he was never as financially successful as he had hoped in his lifetime, Edward Lear created a lasting influence on the art world. I have included in this book four outstanding natural history artists, three contemporary landscape artists, and a political cartoonist, all of whose work reminds me of Lear at his very best. I want to thank the late William Cooper, Elizabeth Butterworth, Walton Ford, James Prosek, Tony Foster, John Doyle, Philip Hughes, and Nicholas Garland for providing examples of their paintings for use in Part 2 of *The Natural History of Edward Lear*.

It has been a great pleasure getting to know each of them though personal meetings and correspondence. I find their work every bit as inspiring as Edward Lear's. I wish them well as they continue to forge new ground in the Edward Lear tradition. Other contemporary artists who have generously provided examples of their work for inclusion in this book are Jan Brett, Barry Moser, and the late Edward Gorey (through the kind support of his executors Andreas Brown and Andrew Boose at the Edward Gorey Charitable Trust). Four individuals whose help I would also like to acknowledge are Michael C. Mark, Peter J. Solomon, Michael Price, all of whom provided help in locating Lear

paintings, and Susan W. Paine, who provided extraordinary hospitality during my research at the Houghton Library.

Last but by no means least, I wish to thank my friends and family for their encouragement and support through my long Lear pilgrimage. My wife, Susan, and our children, Matilda, George, and Oliver, have sacrificed much to allow me to work on this project for as long as we have been a family. It is to them that I happily dedicate this book in the hope that it will bring a pleasant reminder of our shared love of nature, and our admiration for all those who celebrate it and work on its behalf.

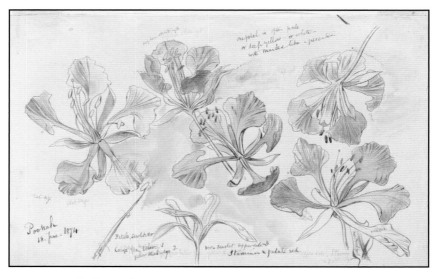

127. Study of flowers from a Royal Poinciana (*Delonix regia*), watercolor over graphite,
June 18, 1874.

LIST OF ILLUSTRATIONS

40. "Peaceable Kingdom" vignette, Houghton Library, Harvard University, (MS Typ 55.27 (fol. 47))

41. Harpy Eagle, lithograph, Zoological Society of London, (4R9U8998)

42. Polar Bear, lithograph, Zoological Society of London, (4R9U9000)

43. Sleeping Lion, lithograph, Zoological Society of London, (4R9U8994)

44. Silhouette of Edward Lear, National Portrait Gallery, London, (MW03828)

45a. Black-throated Magpie-jay or Collie's Magpie-jay, lithograph, Houghton Library, Harvard University, (Typ 805L.39, plate VII);

45b. Elegant Quail, lithograph, Houghton Library, Harvard University, (Typ 805L.39, plate XI)

46a. Lithographic press, *The Boy's Book of Industrial Information*, 1858, private collection

46b. Diagram of lithographic process courtesy of Kyle Luckenbill

47. Lear's lithographic experiment, Houghton Library, Harvard University, (MS Typ 55.9 (16 verso))

48. An uncolored "pull" for Lear's book, Houghton Library, Harvard University, (MS Typ 55.9 (1))

49. Study for Red and Yellow Macaw, Houghton Library, Harvard University, (Ms Typ 55.9 (68))

50. Red and Yellow Macaw, lithograph, Houghton Library, Harvard University, (Typ 805L.32 (A), plate 7)

51. "Green and Red Parrot from China" by George Edwards, Academy of Natural Sciences of Philadelphia, Drexel University, (QL674 E261)

52. "Blew Maccaw" by Eleazar Albin, Academy of Natural Sciences of Philadelphia, Drexel University, (QL674 A33)

53. "Crested Parrot or Cockatoo" by Eleazar Albin, Academy of Natural Sciences of Philadelphia, Drexel University, (QL674 A33)

54. African Grey Parrot by Jacques Barraband, Academy of Natural Sciences of Philadelphia, Drexel University, (QL696 P71)

55. Edward Lear, daguerreotype, private collection, Stephen A'Court Photography

56. Paper wrapper, Yale Center for British Art, Gift of Donald C. Gallup, Yale BA 1934, PhD 1939, (B1997.7.366)

57. Paper wrapper, Houghton Library, Harvard University, (MS Typ 55.9 (84))

58. Greater Sulphur-crested Cockatoo, lithograph, Academy of Natural Sciences of Philadelphia, Drexel University, (QL696 P7L38)

59. Baudin's Cockatoo, lithograph, Academy of Natural Sciences of Philadelphia, Drexel University, (QL696 P7L38)

60. John Gould by T. H. Maguire, lithograph, Academy of Natural Sciences of Philadelphia, Drexel University (coll. 286)

61. Eagle Owl, lithograph, Academy of Natural Sciences of Philadelphia, Drexel University (QL690 A1G6)

62. Flamingo, lithograph, Biodiversity Heritage Library

63. "Mrs. Gould's pet," Houghton Library, Harvard University, (Ms Typ 55.27 (fol. 12))

64. Study of a Lear's Macaw, Houghton Library, Harvard University, (Ms Typ 55.9 (22))

65. Great Auk , lithograph, Academy of Natural Sciences of Philadelphia, Drexel University (QL690 A1G6)

66. Culminated Toucan, lithograph, Academy of Natural Sciences of Philadelphia, Drexel University (QL696 P57)

67. Clipped montage of bird heads (lithographs), Victoria and Albert Museum, London

68. Sir William Jardine by T. H. Maguire, lithograph, Academy of Natural Sciences of Philadelphia, Drexel University (coll. 286)

69. Prideaux John Selby by T.H. Maguire, lithograph, Academy of Natural Sciences of Philadelphia, Drexel University (coll. 286)

70a. Study of a Great Auk, Blacker-Wood Collection, McGill University Library

70b. Great Auk, private collection, courtesy Arader Galleries

71. Moustached Parakeet, private collection

72. Red and Yellow Macaw, private collection

73. Swainson's Lorikeet, private collection

74. Salmon-crested Cockatoo, Houghton Library, Harvard University, (MS Typ 55.9 (25))

75. Lesser Sulphur-crested Cockatoo, Houghton Library, Harvard University, (MS Typ 55.9 (15))

76. Thomas Bell, Academy of Natural Sciences of Philadelphia, Drexel University, (coll. 286)

77. Lear's copy of *A History of British Quadrupeds*, Houghton Library, Harvard University, (Typ 805L.37c, p. 76)

78. European Hedgehog, Houghton Library, Harvard University, (MS Typ 55.12 (fol. 4))

79. Water Shrew, Houghton Library, Harvard University, (MS Typ 55.12 (fol. 14))

80. Leopard tortoise, lithograph, Academy of Natural Sciences of Philadelphia, Drexel University, (QL666 C5B4)

81. Lower carapace of a Radiated Tortoise, private collection

82. Nile Soft-shelled Turtle, License granted by The Rt. Hon. The Earl of Derby, 2016

83. Study of a Rock Hyrax, Houghton Library, Harvard University, (MS Typ 55.12 (fol. 4))

84. Brown's Parakeet, lithograph, Academy of Natural Sciences of Philadelphia, Drexel University, (QL696 P7L38)

PART 2

1. Edward Lear's self portrait, Author's collection

2. Cartoon with Lear's instructions, Houghton Library, Harvard University, (MS Typ 55.14 (119))

3. The Owl and the Pussy Cat dancing by L. L. Brooke, Free Library of Philadelphia, Children's Literature Research Collection

4. The Owl and the Pussy Cat in Beatrix Potter letter to Noel Moore, June 14, 1897, Cotsen Children's Library, Princeton University (CTSN MSQ 21862)

5. The Owl and the Pussy Cat in Beatrix Potter letter to Noel Moore, Feb. 27, 1897, Morgan Library, New York, (299660V-0002)

6. The Duck and the Kangaroo by W. Foster, George A. Smathers Library, University of Florida

7. The Owl and the Pussy Cat by Barbara Cooney, Free Library of Philadelphia, Children's Literature Research Collection

8. The Owl and the Pussy Cat by Barry Moser, courtesy of the artist

9. The Jumblies by Edward Gorey, private collection, courtesy of The Edward Gorey Charitable Trust

10. The Dong with the Luminous Nose by Edward Gorey, private collection, courtesy of The Edward Gorey Charitable Trust

11. The Owl and the Pussy Cat by Jan Brett, Author's collection, courtesy of the artist

12. The Owl and the Pussy Cat, by Jan Brett, Author's collection, courtesy of the artist

13. Ringed Kingfisher by William Cooper, courtesy of the artist

14. Yellow-tailed Black Cockatoo by William Cooper, courtesy of the artist

15. Hartlaub's Turacos by William Cooper, courtesy of the artist

16. Blue and Yellow Macaw by Elizabeth Butterworth, courtesy of the artist

17. Purple Glossy Starling, Blacker-Wood Collection, McGill University Library

18a. Palm Cockatoo by Elizabeth Butterworth;

18b. Lear's Macaw by Elizabeth Butterworth, both paintings courtesy of the artist

19. "Morire de Cara al Sol" Cuban Red Macaw by Walton Ford, courtesy of the artist and Paul Kasmin Gallery, (PK 7198)

20. "Au Revoir Zaire" African Gray Parrot by Walton Ford, courtesy of the artist and Paul Kasmin Gallery, (PK 4293)

21. "Sensations of an Infant Heart" Military Macaw and Red Howler Monkey by Walton Ford, courtesy of the artist and Paul Kasmin Gallery, (PK 4656)

22a. Old man of El Hums, Author's collection;

22b. Old person of Shields, Author's collection

23a. Brown Trout by James Prosek, courtesy of the artist

23b. Miyabe Iwana, a Japanese char by James Prosek, courtesy of the artist

24. "Cockatool" by James Prosek, courtesy of the artist

25. Lesser Sulphur-crested Cockatoo, Houghton Library, Harvard University, (MS Typ 55.9 (15))

26. Cockatooka Superba, Houghton Library, Harvard University, (MS Eng 797.1 (fol. 1))

27. "Parrotfishe" by James Prosek, courtesy of the artist

28. Silver Maple by Tony Foster, courtesy of the artist

29. Study of trees, Barrackpore, Houghton Library, Harvard University, (MS Typ 55.26 (1565))

30. Pinchot Pass by Tony Foster, courtesy of the artist

31. "Mar de Cortes #4" by Tony Foster, courtesy of the artist, January 1994

32. Finale, Italian Riviera, Houghton Library, Harvard University, (MS Typ 55.26 (939))

33. Saint Peter's Basilica and Castel Saint Angelo by John Doyle, courtesy of the artist

34. Dows on the Nile by John Doyle, courtesy of the artist

35. Sunrise at Cuceron, France by John Doyle, courtesy of the artist

36. South-west Coastal Path by Philip Hughes, courtesy of the artist, (PH413)

37. Brookan, the stones, by Philip Hughes, courtesy of the artist, (PH745)

38. Malabar Hill, Bombay, Houghton Library, Harvard University, (MS Typ 55.26 (2396))

39. Ridgeway and Barbury Castle by Philip Hughes, courtesy of the artist

40. Indian landscape (Badagara), Houghton Library, Harvard University, (Ms Typ 55.26 (2304))

41. Old person of Stroud, Author's collection

42. Old person of Stroud (Margaret Thatcher) by Nick Garland, British Cartoon Archive, University of Kent, (ng3621)

43. The Jumblies , Houghton Library, Harvard University, (MS Typ 55.14 (36))

44. The Jumblies by Nick Garland, courtesy of the artist and *Daily Telegraph*

45. Old person of Dundalk, Author's collection

46. Old person of Dundalk (Bill Clinton) by Nick Garland, courtesy of the artist and *Daily Telegraph*

47. Old Man of Peru, Author's collection

48. Mandarin Ducks, License granted by The Rt. Hon. The Earl of Derby, 2016

SELECTED BIBLIOGRAPHY

Altick, Richard D., *The Shows of London*, Cambridge, MA: The Belknap Press of Harvard University Press, 1978.

Blunt, Wilfrid, *The Ark in the Park: The Zoo in the Nineteenth Century*, London: Hamish Hamilton, in association with the Tryon Gallery, 1976.

Colley, Ann C., *Wild Animal Skins in Victorian Britain: Zoos, Collections, Portraits, and Maps*, Farnham, Surrey: Ashgate Publishing Ltd., 2014.

Datta, Ann, *John Gould in Australia*, Melbourne Australia: The Miegunyah Press and Melbourne University Press, 1997.

Davidson, Angus, *Edward Lear, Landscape Painter and Nonsense Poet*, London: John Murray, 1933.

Dehejia, Vidya, *Impossible Picturesqueness: Edward Lear's Indian Watercolours, 1873–1875*, Chidambaram, Ahmedabad: Mapin Publishing Pvt., Ltd., and Middleton, NJ: Grantha Corporation in conjunction with Columbia University, 1989.

Desmond, Adrian, "The Making of Institutional Zoology in London 1822–1836," *Centaurus* 27, no. 3–4, 1984.

Donald, Diana, *Picturing Animals in Britain*, New Haven, CT: Yale University Press, 2007.

Fisher, Clemency, ed., *A Passion for Natural History: The Life and Legacy of the 13th Earl of Derby*, Liverpool: National Museums and Galleries on Merseyside, 2002.

Gunther, Albert E. *The Founders of Science at the British Museum, 1753–1900*, Halesworth, Suffolk, England: Halesworth Press, 1980.

Hofer, Philip *Edward Lear as a Landscape Draughtsman*, Cambridge, MA: Belknap Press of Harvard University Press, 1967.

Hyman, Susan, *Edward Lear's Birds*, Stamford, CT: Longmeadow Press, 1989.

Jackson, Christine E., *Menageries in Britain: 1100–2000*, London: The Ray Society and Scion Publishing, 2014.
 Prideaux John Selby: A Gentleman Naturalist, Stocksfield, Northumberland: The Spredden Press, 1992.
 Sir William Jardine: A Life in Natural History, (with Peter Davis), London: Leicester University Press, 2001.

Lambourne, Maureen, *John Gould Bird Man*, Milton Keynes: Osberton Productions Ltd. and Royal Society for Nature Conservation, 1987.
 The Art of Bird Illustration, London: Grange Books, Quantum Books, 1997.

Levi, Peter *Edward Lear: A Biography*, London: MacMillan and New York: Scribner, 1995.

Maxted, Ian, *London Book Trades 1775–1800*, London: Dawsons of Pall Mall, 1977.

Mayo, Hope, "The Edward Lear Collection at Harvard University," *Harvard Library Bulletin*, Vo. 22, Nos. 2-3, Cambridge, MA: Harvard University Library, 2012.

Montgomery, Michael, *Lear's Italy: In the Footsteps of Edward Lear*, London: Cadogan, 2005.

Noakes, Vivien, *Edward Lear: The Life of a Wanderer*, Stroud, Gloucestershire: Sutton Publishing Ltd., 2004.
 Edward Lear 1812–1888, London: Royal Academy of Arts in association with Weidenfeld and Nicolson, 1985.
 Edward Lear: Selected Letters, Oxford: Oxford University Press, 1990.
 The Painter Edward Lear, London: David & Charles, 1991.

Nugent, Charles, ed. *Edward Lear The Landscape Artist: Tours of Ireland and the English Lakes, 1835 & 1836*, Grasmere: The Wordsworth Trust, 2009.

Pasquier, Roger F. and John Farrand, Jr., *Masterpieces of Bird Art*, New York: Abbeville Press, 1991.

Pitman, Ruth, *Edward Lear's Tennyson*, Manchester: Carcanet Press, Ltd., 1988.

Reade, Brian, *An Essay on Edward Lear's Illustrations*, New York: Johnson Reprint Co., 1978.

Ritvo, Harriet, *The Animal Estate: The English and Other Creatures in the Victorian Age*, Cambridge, MA: Harvard University Press, 1987.

Sauer, Gordon C. *John Gould the Bird Man: A Chronology and Bibliography*, Lawrence: University Press of Kansas, 1982.

Strachey, Lady, ed., *The Letters of Edward Lear*, London: T. Fisher Unwin, 1907.
 Later Letters of Edward Lear, London: T. Fisher Unwin, 1911.

Tree, Isabella, *The Ruling Passion of John Gould*, London: Barrie & Jenkins, 1991.

Vevers, Gwynne, *London's Zoo: An Anthology*, London: The Bodley Head, 1976.

Wilcox, Scott, *Edward Lear and the Art of Travel*, New Haven, CT: Yale Center for British Art, 2000.

INDEX

CREATED BY HELENE S. FERRANTI

COLOPHON

This book has been set in Fournier, a late eighteenth-century design closely modeled on the letters created by the burin then in use to produce the distinctive engraved title pages and images that can be seen in what were probably the greatest decades of the French illustrated book. They, and other designs by his close contemporaries, as well as music, ornaments, vignettes, ornamental capitals and open letters, can be thoroughly enjoyed in Fournier's charming *Manuel Typographique* of 1764 which Updike commends as "a work which no student of French typography can afford to be without." These designs, with their vertical, and rather oblique, stress and clear emphasis on thicks and thins, provided the models for the later, and more extreme characters created by Bodoni in Parma and Didot in Paris.

Like so many classic designs, Fournier was revived in the 1920's by England's Lanston Monotype Corporation under the supervision of Stanley Morison. The book was printed and bound by Four Colour in China, and designed and typeset by Sara Eisenman.